KNOWLEDGE ENCYCLOPEDIA
SPACE

Wonder House

(An imprint of Prakash Books)

contact@wonderhousebooks.com

ISBN : 9789354404436

Table of Contents

Stars & Galaxies

Constellations

Astronomy

Mission Exploration

OUR UNIVERSE

Our Amazing Universe

Have you ever looked up into the night sky and wondered what lies out there in the great universe? So, what is it about the cosmos that bewilders and fascinates us so much?

Today, we know that Earth is a very tiny ball of rock within the vast expanse of the universe. We also know that the birth of the solar system was perhaps only one amongst the many significant events that occurred in a fully developed universe, which is a truly humbling thought.

Wouldn't you like to know how the universe began or what galaxies, comets, or shooting stars are? Read on to explore and understand some of the mysteries of our massive cosmos!

▼ *Stargazing—an act of observing the stars in the night sky, with or without a telescope.*

▲ *The universe is a vast unending expanse of celestial matter and objects*

Studying the Universe

All the matter and energy present everywhere, including in space, and life on Earth, is part of the mighty universe. Human beings have come a long way since ancient times when it was believed that the Sun, the Moon, and Earth were the main celestial bodies of the universe. Today, however, we know that Earth and the solar system are only a tiny part of the vast universe.

⭐ What is the Universe?

Our universe is about 13.8 billion years old. Everything that exists in time and space—including all objects, energy, over hundred billion galaxies containing hundreds of billions of stars, the solar system, the planets, etc., are all part of what we call the universe. The universe is so vast that it really cannot be measured. We can only imagine how big it is by understanding that some celestial objects are so very far away in the universe that light travelling from them takes billions of years to reach Earth!

The universe is also referred to as the cosmos. In astronomy, cosmos is described as the entire physical universe, which is considered as one integrated whole. The word 'cosmos' comes from the Greek word, '*kosmos*' meaning 'order', 'harmony', and 'the world'. **Cosmology** is thus a particular field of study that combines natural sciences, specifically astronomy and physics, in a joint effort to understand the physical universe as a whole.

Space, on the other hand, is a limitless, three-dimensional expanse in which objects and events occur and have relative position and direction.

⭐ What Comprises the Universe?

Our universe is full of light-emitting and light-absorbing sources. It is a complex cosmic structure of stars, galaxies, quasars, and clusters of galaxies. It also contains dust, gas, dark matter, energy, different types of radiation, and also black holes, among other cosmic bodies. It has vast empty spaces in between the structures.

💡 Isn't It Amazing!

There are about 10^{22} to 10^{24} (up to a septillion) stars in the observable universe. Some scientists believe that there are more stars in our universe than there are grains of sand on Earth!

▼ *Most stars in the night sky are bigger and brighter than the Sun*

More about the Universe

We know that the universe is vast and also that human beings do not really know its measure. In fact, the Milky Way galaxy, in which our solar system lies, is only one amongst the hundred billion galaxies which exist in the universe! The Milky Way is part of the Local Group—a group of over 20 or more neighbouring galaxies. With extensive research, we have been able to learn more about the composition and the shape of the universe.

★ Chemical Elements

Matter contains **chemical elements**. A chemical element is any substance that cannot be broken down into simpler substances by ordinary chemical processes.

Hydrogen and helium are the main chemical components of the universe and were produced when the universe first came into existence. Some other 90-odd chemical elements are created in the stars, but these make up only a small percentage of the overall mass of the universe. These other elements are called 'metals' by astronomers, though in ordinary usage we do not refer to elements like oxygen and carbon as metals. The quantity of 'metals' varies depending on how stars were formed in that region.

★ Shape of the Universe

Scientists have concluded that mass causes space to curve. When objects move within that curved space, they are forced to alter or change their direction. If space is curved, then the shape of the universe may be any one of three types—flat, spherical, or saddle-shaped. How significant are these shapes to understanding the universe?

The saddle-shaped surface has negative curvature; the flat, zero curvature; and the spherical surface has positive curvature.

A saddle-shaped space would form an open universe. This universe would have no limits and will keep expanding forever.

A flat universe wouldn't have limits either, but the expansion rate would gradually approach zero.

A spherical universe would be a closed one, where the expansion would eventually stop, causing the galaxies to come closer and result in disintegration.

Recent observations show that the expansion of the universe is speeding up. This strongly implies that the universe is geometrically 'flat'. However, this still remains one of the major unexplained problems in modern cosmology.

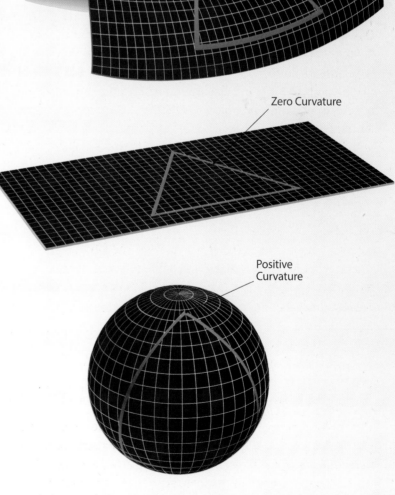

Negative Curvature

Zero Curvature

Positive Curvature

▲ *Scientists believe that the destiny of the universe depends upon its shape or geometry. Some current observations of the speeding up of the expansion of the universe has led them to believe that the universe is flat*

Creation of the Universe

What existed before the universe? How and when was it created? Nobody can really be certain of these answers, but the **Big Bang model** is considered to be responsible for this miraculous creation!

⭐ What is the Big Bang Model?

The Big Bang model is a theory about how the universe was formed and how it evolved. In fact, among the many theories on this subject, the Big Bang is the most popular. The essence of this theory is that the universe emerged from a state of very high temperature and density. This caused a violent collision on an extremely large scale, which is why the model is called the Big Bang. The theory was based on the observation that several other galaxies were moving away from the Milky Way galaxy in different directions and there seemed to be an ancient force responsible for this. Scientists estimate that the Big Bang happened nearly 13.8 billion years ago when the universe came into being.

⭐ Who thought of the Big Bang Model?

In 1927, a Belgian priest and astronomer, Georges Lemaître made a very important discovery—he independently proposed that the universe is expanding. In 1922, Russian mathematician Aleksandr Friedmann had also arrived at this conclusion. Lemaître claimed that the universe began as a single point, that is, it had a finite beginning. It later expanded into its current vastness. He also said that it could keep growing. His formulation of the modern Big Bang theory was based on the work of Albert Einstein. Two years later, American astronomer Edwin Hubble confirmed Lemaître's theory that the universe was, in fact, expanding. He observed that galaxies were moving away from Earth and that the galaxies that were farther away were moving at a faster rate than those nearby. This meant that if things were moving away from each other, then perhaps a long time ago they existed close to each other.

While Dutch astronomer Willem de Sitter had also earlier considered an expanding model of the universe, Lemaître's theory, which was revised by George Gamow and others in the 1940s, remains the principal model of the universe.

▲ The moon crater 'Fridman' is named after Aleksandr Friedmann

▲ Georges Lemaître also had a namesake in the lunar crater 'Lemaître'

⭐ The Theory

According to the Big Bang Theory, the universe started off as a hot and extremely dense point, about a few millimetres wide. Approximately 13.8 billion years ago, this tiny point (or **singularity**) exploded in a violent bang from which all of matter, energy, space, and time were created.

Different theories state that immediately after the Big Bang, there probably was a colossal sea of protons, electrons, neutrons, and other particles. With time, the universe continued to cool, resulting in the decay and recombination of various particles. Protons and electrons may have combined to form neutral hydrogen. The universe may have been opaque before the recombination, due to the scattering of light by the free electrons. Once neutral **atoms** were formed, it became transparent. The atoms joined together and after a very long time formed stars and galaxies. The initial few stars were responsible for creating bigger atoms and also for groups of atoms known as **molecules**. This led to the birth of several more stars. Simultaneously, galaxies were banging against each other and coming together. During this process of formation and dying of stars, things like asteroids, comets, planets, and black holes were created.

Since the theory predicted that the early cosmos was in a very hot state and that the gases cooled with expansion, it would most probably also be filled with radiation or remains of heat from the violent explosion. The remains of this hot dense matter are called **cosmic microwave background** (CMB) radiation. CMB radiation today is very cold and is similar to what is used to emit TV signals through antennae. A lot of information about the early universe can be gathered from CMB, the earliest known form of radiation. CMB was first predicted by Ralph Asher Alpher in 1948, when he was doing research about the Big Bang model along with Robert Herman and George Gamow.

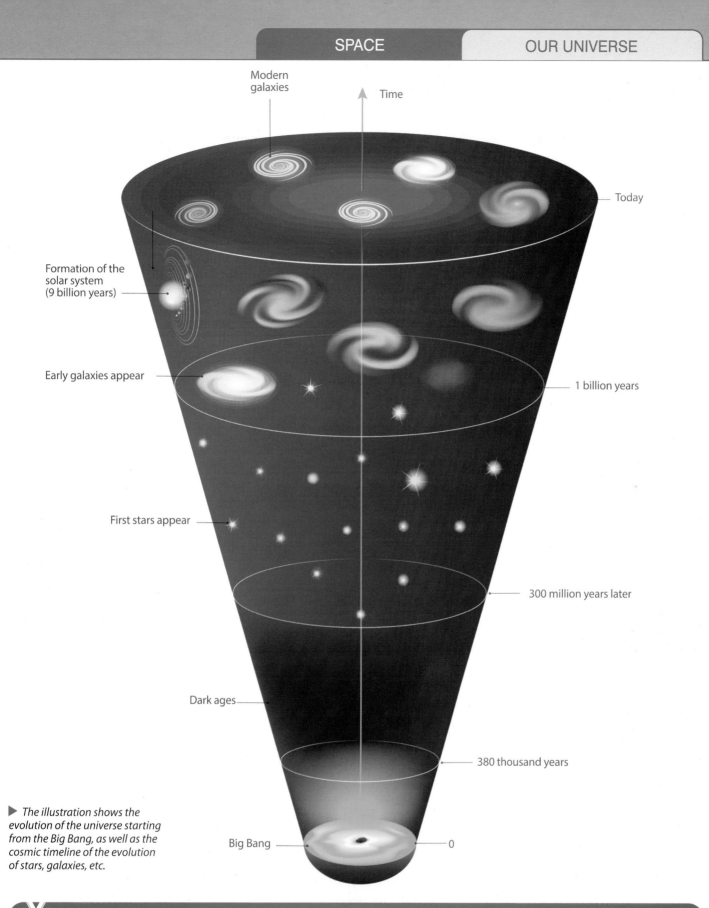

Modern galaxies

Time

Today

Formation of the solar system (9 billion years)

Early galaxies appear

1 billion years

First stars appear

300 million years later

Dark ages

380 thousand years

Big Bang 0

▶ *The illustration shows the evolution of the universe starting from the Big Bang, as well as the cosmic timeline of the evolution of stars, galaxies, etc.*

☉ Incredible Individuals

While Friedmann (1888–1925) and Hubble (1889–1953) proposed the Big Bang theory, it was George Gamow (1904–1968) who took up the task of coming up with a practicable model for this theory. Though Friedmann's theory was brilliant, it was not known by many. Those who had heard it did not believe it. But Gamow and his doctoral student Ralph Alpher (1921–2007) had faith in the theory. At the time, Ralph Alpher was a mathematics student who was working on describing how the universe evolved. Furthermore, the CMB radiation was first noticed accidentally, in 1965, by Arno Penzias (1933–present) and Robert Wilson (1936–present) at the Bell Telephone Laboratories in New Jersey, USA. So, the Big Bang model was the brainchild of several people.

Matter & Antimatter

In our universe, anything that has mass, takes up space, and has volume is called matter. This means that ordinary or regular matter is something we can see, feel, touch, and even taste. Antimatter is the opposite. It is matter made up of antiparticles that have properties opposite those of normal matter. Antiparticles are subatomic particles having the same mass as a given particle, but with an opposite electric charge. To understand antimatter, let us first take another look at what matter is.

⭐ What is Matter?

Everything around us—all solids, liquids, and gases comprise atoms which are the main ingredients of all matter. At the centre of each atom is a nucleus which comprises two different particles—protons and neutrons. The nucleus is surrounded by smaller particles called electrons. So basically, all matter is made up mainly of neutrons, protons, and electrons. Both protons and electrons have an electric charge. Protons are positively charged, and electrons are negatively charged.

When there are two opposite charges—negative and positive—they attract each other, but when the charge is the same, they repel each other. For instance, when you rub a plastic ball against your hair, you see your hair rising up. This is due to the charge created because of friction. When you rub them against each other, the protons and electrons get unevenly distributed over the ball and your hair. This results in the ball getting either positively or negatively charged and it then sticks to anything which has an opposite charge.

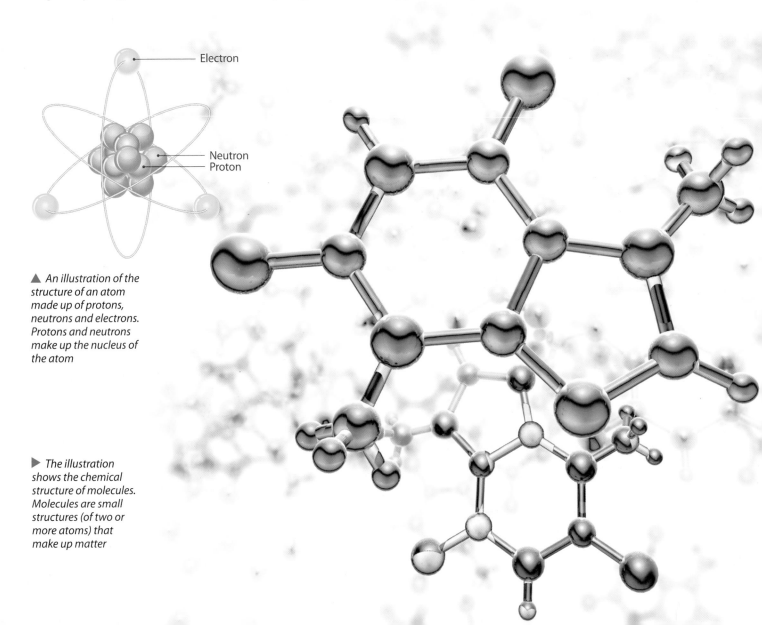

Electron

Neutron
Proton

▲ An illustration of the structure of an atom made up of protons, neutrons and electrons. Protons and neutrons make up the nucleus of the atom

▶ The illustration shows the chemical structure of molecules. Molecules are small structures (of two or more atoms) that make up matter

▲ *An artist's rendition of flying antimatter particles reacting with matter particles in a nebula*

⭐ What is Antimatter?

Antimatter is almost the same as regular matter, but it comprises antiprotons, antineutrons, and antielectrons or positrons. The main difference between the particles of matter versus antimatter is that, in the latter, the corresponding antiparticles have the reverse charge. Anti protons, therefore, are negatively charged, and antielectrons have a positive charge.

So, what happens when particles and antiparticles collide with each other? When an electron and a positron come into contact with each other, the two get destroyed, leaving behind gamma rays or radiation. To put it another way, the mass of the particles is converted into pure energy. The energy released during this process or collision will be equal to the mass of the two particles multiplied by the square of the speed of light, which is a huge amount of energy. Matter and antimatter, therefore, cannot exist close together for more than a small fraction of a second because they will crash against each other and release energy.

Antimatter exists in the universe, but there is not much of it. Cosmic rays found in outer space are a natural source of antimatter. Another source is radioactive decay. Antimatter can also be created artificially in a science laboratory.

Scientists have not yet been able to figure out why there is so little antimatter in our universe in comparison to normal matter.

💡 Isn't It Amazing!

Hydrogen atoms are available in plenty in the universe. These atoms are also the simplest of all the other elements in the universe. The very first anti-atom or antimatter counterpart of a regular atom was created in 1995 by physicists at CERN—the European Organisation for Nuclear Research in Geneva. It was the anti-hydrogen atom. Unlike hydrogen, anti-hydrogen is rare and difficult to produce.

▲ *The Globe of the Science and Innovation Centre at CERN in Geneva is 27 meters high and 40 meters in diameter*

It's a Dark, Dark Universe

Human beings have made great scientific progress in all fields including the exploration of space and understanding the universe. Yet, you may be surprised to know that most of the universe remains a mystery to us. Why is that so? More than 95 per cent of the universe is made up of energy and matter that nobody has been able to understand or study till date.

⭐ Dark Energy

Stars, planets, black holes, asteroids, comets, etc., are only a small fraction of what makes up the universe. Based on their observations and studies of these objects, scientists have concluded that our universe is in a state of expansion. But if it was only made up of galaxies, stars, planets and other objects that we know about, then it should not be expanding. This contradiction led to the belief that something more—or rather some other energy—exists in the universe, which is causing it to expand. This is called dark energy.

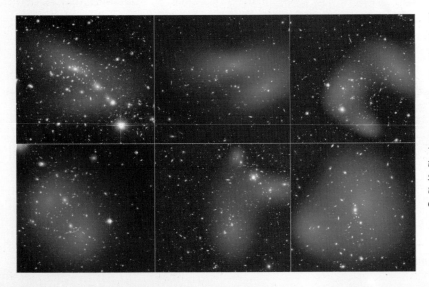

While not much is known about dark energy, we are sure that there is a lot of it present in the universe. In fact, it makes up 68 per cent of the universe.

◀ *A collage compiled from images taken by the NASA/ESA Hubble Space Telescope shows six different galaxy clusters. The images map the post-collision distribution of stars and also of dark matter (coloured in blue)*

▼ *The California nebula in the constellation of Perseus, with the bright star Menkib*

⭐ Dark Matter

Besides dark energy, there is another source of gravity in space. Scientists have been able to observe its pull upon objects like stars, galaxies, and other celestial objects. Yet, it is not what we normally know or recognise as matter; neither is it a black hole. It is something quite different. While we know that it exists, nobody knows what it really is. Scientists have termed this as dark matter. It is a part of the universe whose presence is felt due to its gravitational attraction and not its intrinsic brightness. 27 per cent of the universe is made up of dark matter.

So, this means that over 90 per cent of the universe consists of dark energy and dark matter, both of which are largely unknown to us. All the rest of the visible and ordinary

(or **baryonic**) matter, like energy, light, heat, X-rays, human beings, the solar system, galaxies, etc., makes up 5 per cent of the universe! That is a very small part of the universe which we have been able to observe, study, and figure out.

▲ An artist's rendering of space closed in energy tension, which is the basis for dark matter and dark energy

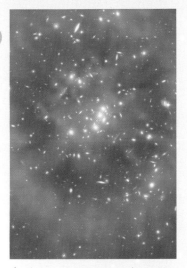

▲ This composite image shows a ring of dark matter seen in a galaxy cluster.

Dark energy and dark matter are important in the study of space and physics. Scientists are trying to understand them through observations and mathematical calculations. Eventually, this will provide us with information about our amazing universe.

⭐ Who Discovered Dark Matter?

Dark matter, originally known as 'missing mass', was first worked out by Swiss-American astronomer Fritz Zwicky in 1933. While studying the mass of stars in the Coma cluster of galaxies, Fritz found that the stars consisted of only about 1 per cent of the mass required to keep the galaxies together. But there was other mass which existed. This was responsible for keeping the clusters together and providing the extra gravitational pull required to hold galaxies together. For several years, the mystery of this missing mass was not solved. In the 1970s, Vera Rubin and William Kent Ford (both American astronomers) confirmed the existence of dark matter by observing a similar occurrence.

◀ Fritz Zwicky (1898-1974) described the dark matter as "dunkle (kalt) Materie"

▶ Vera Rubin (1928-2016) was elected to the National Academy of Science, becoming the second woman astronomer in its ranks.

All about Galaxies

Galaxies are home to stars and other celestial objects. It was only in the early 20th century that the existence of galaxies other than the Milky Way was recognised. Before that, early astronomers labelled them as nebulas, since they appeared to look like hazy clouds. Galaxies are present in every part of space, as observed through powerful telescopes. They differ in shape, structure, and the level of activity within them.

⭐ What is a Galaxy?

A galaxy comprises a large group of hundreds of billions of stars and **interstellar** matter (gas and dust) bound together by gravity. Almost all the large galaxies are also believed to have gigantic black holes at their centres. Galaxies exist in a variety of shapes and sizes ranging from dim dwarf-sized objects to bright, massive, spiral-shaped ones. Almost all galaxies seem to have been formed immediately after the universe came into existence. These beautiful formations are generally found in clusters, some of which form a larger cluster and span hundreds of millions of **light years** across the universe. A light year is the distance travelled by light in one year, at a speed of 3,00,000 km/s.

⭐ Types of Galaxies

There are three main classifications of galaxies—elliptical, spiral, and irregular, as seen in the diagram. Some spiral galaxies are called 'barred spirals'.

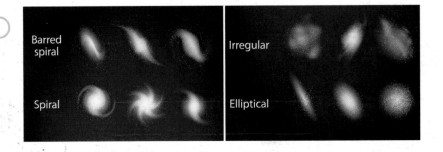

▶ Types of galaxies, The Milky Way is a large barred spiral galaxy.

⭐ Elliptical Galaxies

These galaxies are round, oval, or more like an elongated sphere. Sometimes, they may be so stretched that they look like a cigar. These galaxies generally contain many old stars, but not much dust and other interstellar matter. Like the stars in the discs of spiral galaxies, their stars also orbit around the galactic centre, but in a more disorderly way. Not many stars have been known to have formed in elliptical galaxies. The largest known galaxies in the universe are giant elliptical ones which can be as big as two million light years long. The smaller of these galaxies are known as dwarf elliptical galaxies. Virgo A (or M87) is an example of a giant elliptical galaxy found close to the centre of the Virgo cluster of galaxies.

▲ Seen here are the dust lanes and star clusters of the NGC 1316 giant elliptical galaxy in the Fornax constellation

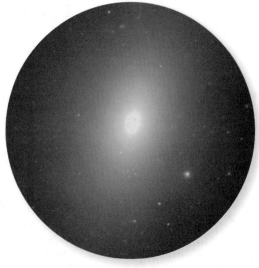

▲ The Messier 59 is an elliptical galaxy. It is also one of the largest elliptical galaxies in the Virgo galaxy cluster

⭐ Spiral Galaxies

Spiral galaxies comprise a flat disc with a bulging centre. These galaxies have long spiral arms that wind towards the centre. The disc comprises stars, planets, dust, and gas, which rotate or spin around the galactic centre in a regular manner, at hundreds of kilometres per second. This spinning motion may result in the matter in the disc taking the shape of a spiral, like a pinwheel.

While many new stars are born in spiral galaxies, the older stars are generally located in the bulging centre of the galactic disc. These discs have a halo around them and astronomers believe that they comprise unknown dark matter.

One type of spiral galaxy is known as 'barred spirals' since the bulge at the centre looks stretched like a bar and the spiral arms come out from the ends of the bar. The Milky Way is a large barred spiral galaxy and is home to our solar system. It is one from a group of galaxies known as the Local Group.

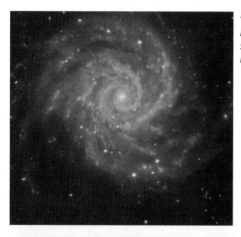

◀ *An infrared picture of M74—a spiral galaxy—as seen by NASA's Spitzer Infrared Array Camera*

▶ *A barred spiral galaxy—NGC 1672 in the constellation of Dorado*

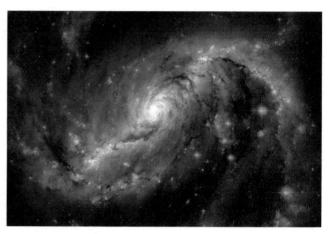

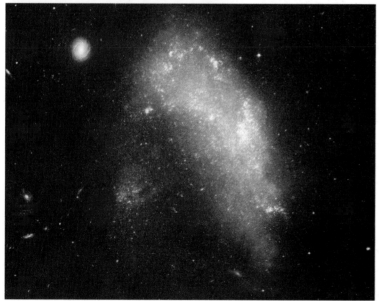

⭐ Irregular Galaxies

Galaxies which do not have any distinct shape, such as spiral, elliptical, or lenticular (resembling lenses), are irregular galaxies. Irregular galaxies—such as the Large and Small Magellanic Clouds—are uneven or out of shape as they are generally under the gravitational influence of other nearby galaxies. Since they are packed with lots of gas and dust, irregular galaxies are a fertile ground for the formation of new stars.

◀ *An image of an irregular galaxy—NGC 1427A*

👤 In Real Life

One of the most important things needed to support and sustain life on Earth and in the universe is water. Water in its solid state (ice), exists in abundance in the universe and is found in interstellar dust clouds as well as in the orangish-red fields of Mars. However, that by itself is not enough to support life. Water, in its liquid state, acts as a crucial lubricant for the molecular or chemical processes for all forms of life such as human beings, plants, and animals. Hence, astronomers always look for signs of water in its liquid state in the universe to see if alien life exists elsewhere.

🎖️ Incredible Individuals

In 1950, Arthur Allen Hoag (1921–1999), an American astronomer, discovered one of the rarest kinds of galaxies, a type of ring galaxy consisting of a symmetrical central core made up of older stars, surrounded by a bright ring of young blue stars with no apparent connection between the two. It came to be known as the Hoag's Object. These rare galaxies comprise less than 0.1 per cent of all observed galaxies in the universe.

Two and a Half Galaxies

The Milky Way galaxy is one amongst the trillions of galaxies found in our universe. However, it is the most important galaxy for us because our solar system lies within it. The Andromeda is another important galaxy, since it is the closest large galaxy to the Milky Way, and it is one of the few that can be seen with the naked eye. The Milky Way also has two satellite or companion galaxies known as the Magellanic Clouds.

⭐ The Milky Way Galaxy

The Milky Way galaxy, named so due to its 'milky' appearance, contains several hundred billion stars. It roughly spans about a hundred thousand light years across and is about a thousand light years in thickness. The solar system (comprising our Sun and its planets) is located in the curved arm of gas and dust of the galaxy, and it is approximately 26,000 light years away from its raging centre.

The Milky Way has a supermassive black hole at its centre and is surrounded by dark matter bigger than the galaxy itself. Even though Earth lies within the Milky Way, astronomers do not know as much about this supermassive black hole as they do about some of the other celestial objects in our galaxy. This is due to a thick layer of dust which prevents optical telescopes from getting a good view.

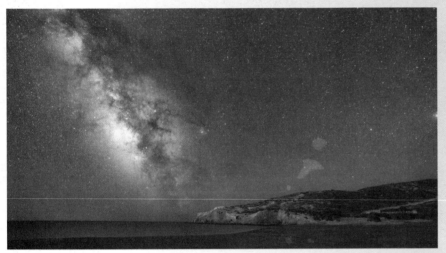

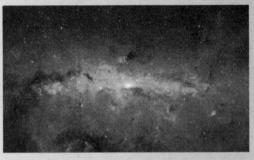

▲ An infrared image taken by NASA's Spitzer Space Telescope reveals the millions of stars clustered together in the centre of the Milky Way galaxy. An ordinary optical telescope would not have been able to view this

◄ Our home galaxy, the Milky Way

⭐ Andromeda: The Gobbling Galaxy

The Andromeda galaxy (or M31) is a pancake-shaped, disc-like barred spiral galaxy. It is a large galaxy nearest to the Milky Way. It was first mentioned in 965 CE in *The Book of the Fixed Stars*.

A long time ago, there existed three large galaxies—Andromeda, the Milky Way, and its smaller sister galaxy called M32p. These three galaxies circulated close around one another and gobbled up matter and other smaller galaxies. Much later, Andromeda collided into M32p, shredding and devouring it, and leaving behind an almost invisible halo of stars.

Andromeda has some unusual features: a dim halo or ring-like pattern of stars orbiting it and a small and dense satellite galaxy called M32.

After the telescope was invented in 1611, German astronomer Simon Marius discovered the Andromeda galaxy. For a long time, Andromeda was considered to be a part of the Milky Way. In 1924, Edwin Hubble concluded that Andromeda was actually a separate galaxy.

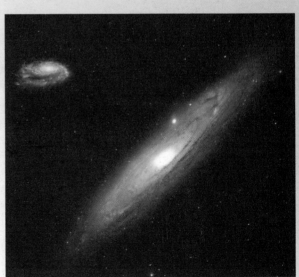

▲ The Andromeda galaxy against the Milky Way (elements of this image are furnished by NASA)

Incredible Individuals

Turkey-born astrophysicist Burçin Mutlu-Pakdil, who is now a postdoctoral research associate at the University of Arizona's Steward Observatory, USA, has a remarkable achievement she can be proud of. She discovered a rare and unknown type of galaxy more than 350 million light years away, which now bears her name and is known as Burçin's galaxy! Being a female astrophysicist in a male-dominated field was not an easy task. While her family encouraged her to fulfil her dreams, she came from a society that shunned women for moving cities in order to study. In spite of numerous such hurdles, she persevered with her passion.

◀ Dr Burçin Mutlu-Pakdil developed a love for astrophysics while she was still in middle school. She was one of only 20 change-makers from all over the world who were selected and invited to become a TED fellow in 2018

▲ Turkish astronomer, Dr Burçin Mutlu-Pakdil at the Subaru Telescope

▲ This photograph was taken at the site of the European Southern Observatory's Very Large Telescope in the Chilean Atacama Desert. It shows the Large and Small Magellanic Clouds glowing brightly on the extreme left.

Satellite Galaxies—
The Magellanic Clouds

Besides the Sun and the other numerous stars, there are smaller galaxies comprising their own group of stars, which also orbit around the Milky Way and are termed as satellite galaxies.

The biggest are the Magellanic Clouds, also known as Nubeculae Magellani—two unevenly shaped galaxies which can be seen in the Southern Celestial Hemisphere—named after Portuguese navigator Ferdinand Magellan. He and his crew discovered them during the first voyage around the world (1519–1522). These companion galaxies, however, were properly recognised only in

▶ The Large Magellanic Cloud is also referred to as a satellite or dwarf galaxy. The image was captured in infrared light as observed by the Herschel Space Observatory and NASA's Spitzer

Three's Company
Quasars, Pulsars, and Magnetars

There are some celestial objects that are lesser-known. That is because they are either too far away from us and difficult to study; they can only be observed under certain conditions; or because of their strong magnetic fields.

⭐ Quaint Quasars

A quasar (pronounced *kwayzar*) is an extremely bright astronomical object similar to a star. It can be a trillion times brighter than our Sun! Quasars give off large quantities of energy. This energy is derived from gigantic black holes which exist in the centre of galaxies where quasars are located. Quasars are very bright. While they outshine all other stars in the same galaxy, they cannot be seen by the naked eye as they are amongst the farthest objects in space. Most quasars are larger than our solar system and emit more energy than 100 normal galaxies combined!

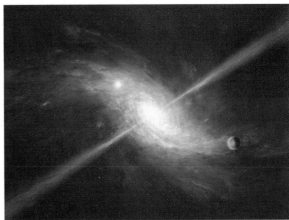

▲ *The term 'Quasar' is a contraction of 'Quasi-Stellar Radio Sources'*

⭐ Pulsating Pulsars

Neutron stars that spin extremely fast and have a regular pulse of **radiation** or **radio waves** are known as **pulsars** or pulsating radio stars. A neutron star is born when the centre of a star explodes violently in what is known as a supernova. Since a neutron star has a solid core and a liquid mantle, it has a magnetic field a trillion times stronger than that of Earth's. It emits high-energy beams at both the North magnetic pole as well as the South. As the neutron star rotates, if at any time a beam points towards Earth, it appears to turn on and off, to pulsate! We can therefore conclude that all pulsars are neutron stars but all neutron stars are not pulsars.

A pulsar is like a lighthouse. Although its light is shining all the time, we can only see the beam of light when it points directly in our direction. Similarly, a beam of light from a pulsar can be seen intermittently only when it crosses our line of vision.

▲ *An illustration of a pulsar, a highly magnetised rotating neutron star*

⭐ Magical Magnetars

A magnetar is another kind of a neutron star. We know that a regular neutron star has a magnetic field which is a trillion times that of Earth's magnetic field. The magnetic field of a magnetar is additionally 1000 times stronger. Magnetars are the most powerful magnets in the universe. It is said that if a magnetar did actually come as close as about 966 kilometres to Earth, the pull would be so strong that it could possibly suck out iron from our bodies!

💡 Isn't It Amazing!

In December 2004, NASA, European satellites, and other radio telescopes observed a powerful flash of light from across the Milky Way galaxy. The light was so strong that it deflected off the Moon, causing Earth's upper atmosphere to light up. The light came from a magnetar called SGR 1806-20 which blew up, and in a tenth of a second it released huge amounts of energy, more energy than the Sun has released in 1,00,000 years!

▶ *The SGR 1806-20 magnetar with magnetic field lines, as conceived by an artist*

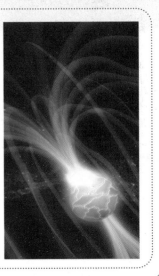

Amazing Asteroids

Besides the planets, the Moon, and the stars, there are several smaller celestial objects in space called 'small bodies'. These include asteroids, meteoroids, and comets.

What is an Asteroid?

An asteroid is a small, rock-like object which orbits the Sun, just like planets. But unlike planets, asteroids are much smaller. They are sometimes called minor planets.

A majority of the several hundred thousand asteroids in our solar system are found in the asteroid belt. It is a flat ring-like region between Mars and Jupiter. Some asteroids are also found in the orbital path of planets like Earth.

Where did Asteroids Originate From?

Asteroids are leftover pieces from the time when the solar system was formed around 4.6 billion years ago! The solar system began with the collapse of a huge cloud of gas and dust, which condensed to form the Sun, planets and their moons. Asteroids are the remains in the asteroid belt that never made it to the Sun, nor could they transform into planets or any other celestial bodies.

Are all Asteroids Identical?

Asteroids are different from each other and were created in different places and at different distances from the Sun. Most have a sharp and uneven shape. Some asteroids are hundreds of kilometres in diameter, but many are the size of a small stone. Asteroids are made up of various types of rock, clay or metal, like nickel and iron. They provide important information regarding our planets and the Sun.

◀ *An artist's conceptualisation of NASA's OSIRIS-REx spacecraft*

👤 In Real Life

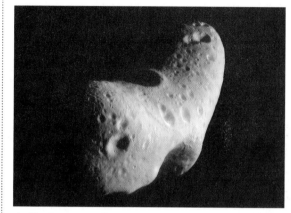

Many space missions have been sent by NASA to observe asteroids.

1998: The NEAR Shoemaker spacecraft went to Eros, an asteroid near Earth.

▲ *The Eros asteroid was named after the god of love from Greek mythology.*

2011: The second-largest object in the asteroid belt—Vesta, a small planet, was orbited and studied by the Dawn spacecraft.

◀ *Vesta was named after the virgin goddess of home and hearth from the Roman mythology*

2012: Nasa's Dawn space probe orbited and studied the dwarf planet Ceres, the largest object in the asteroid belt.

▶ *Ceres was the first asteroid to be discovered in 1801*

2016: The OSIRIS-REx spacecraft was launched by NASA to study Bennu, which is an asteroid near Earth. The objective was also to bring a sample of it back to our planet for study.

Meteoroids, Meteors, & Meteorites

Meteoroids, meteors, and meteorites are all related to the 'shooting stars' we sometimes see streaking across the night sky. We call the same celestial objects by different names, depending on where they are.

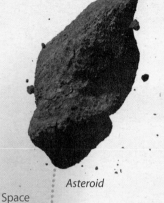

Space

Asteroid

Meteoroid

⭐ What are Meteoroids and Meteors?

When one asteroid bangs into another, it may break into pieces. These pieces are called meteoroids. A meteoroid is a small rocky or metallic natural object that enters Earth's atmosphere. When a meteoroid falls to Earth with great speed, there is a resistance (or drag) of the air on the rock, which heats it up.

As it falls and comes closer to Earth and passes through our atmosphere, it starts to vaporise (becomes gaseous), and a streak of light is seen, which is the hot air left behind by the burning piece of rock. This is a meteor, a streak of light in the sky. Meteors are not really stars, but due to their appearance and streaks of light, they are also known as 'shooting stars'! Meteors are sometimes confused with comets due to the light they both seem to emit. However, Comets are made of ice and dust, not rock.

⭐ Meteorites

Most meteoroids get vaporised by the time they enter Earth's atmosphere, however, some of these rocks do not disintegrate. Instead, they reach the surface of Earth and are known as meteorites. Most meteorites are the size of a small pebble, but some rare ones can also be the size of a large boulder. Since meteorites originate from asteroids, they are useful to scientists, who can gain more information about these ancient rock-like objects.

◀ *The illustration shows the difference between asteroids, meteoroids, meteors, and meteorites*

Meteor

Earth's surface

Meteorite

👤 In Real Life

The Hoba is the largest meteorite found on Earth. Found in 1920 in Namibia, Africa, it weighs approximately 53,977 kg! It is an ataxite, an iron meteorite which contains more than 16 per cent nickel.

▼ *The Hoba fell to Earth less than 80,000 years ago and has never been moved*

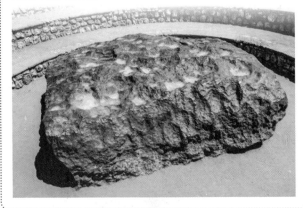

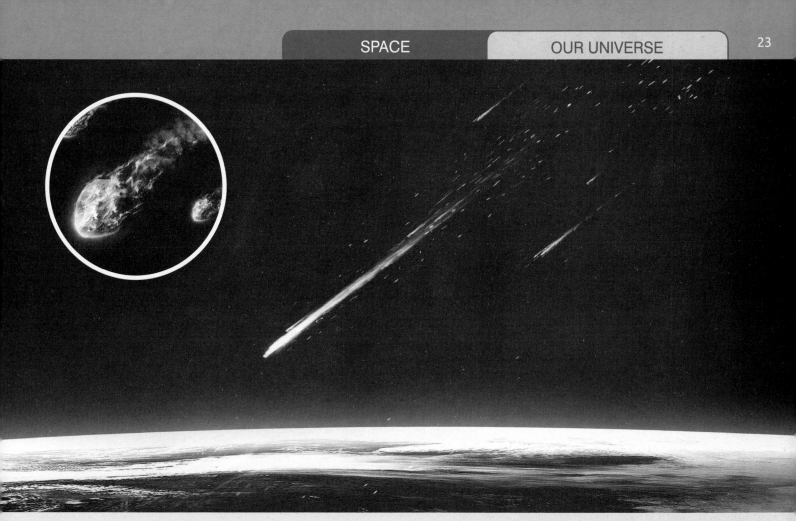

▲ *Meteor showers occur when Earth passes through a trail of debris left by a comet or an asteroid.*

⭐ It's Raining Meteors!

When many meteors fall to Earth at the same time, they are referred to as a meteor shower. Meteors fall at a speed which is 32 times faster than that of a speeding bullet!

A meteor shower is generally named after the constellation from which it appears to be coming. Scientists have estimated that there are nearly 21 meteor showers that occur annually. Listed below are some of the major meteor showers, their constellations, and the months when they can be viewed.

Quadrantids (originally Quadrans Muralis, now Bootes constellation): December/January

Lyrids (Lyra constellation): April

Perseids (Perseus constellation): August

Orionids (Orion constellation): October

Leonids (Lyra constellation): November

Geminids (Gemini constellation): December

▶ *An image of a meteor during the 2009 Leonid meteor shower*

💡 Isn't It Amazing!

More than 45,000 kg of space debris falls on Earth every day. Meteors enter Earth's atmosphere at unbelievably high speeds ranging from over 40,000 km per hour to 2,57,495 km per hour.

In the year 1908, an object as large as a residential building fell from the sky and exploded in the air above Siberia. Known as the Tunguska event, named after a river, this object razed trees in an area spanning nearly 2,072 square kilometres. Luckily, no human being or creature was killed or hurt, but it is one of the most significant events of this kind to ever be recorded in human history. Scientists are not sure of the object's origins and whether it was a comet or an asteroid.

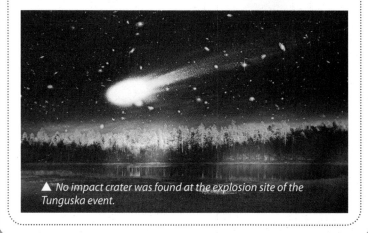

▲ *No impact crater was found at the explosion site of the Tunguska event.*

Captivating Comets

People sometimes confuse a comet with a meteor. However, they are both different in their composition. Besides, unlike a meteor, comets can be viewed even when they are very far from Earth.

⭐ What is a Comet?

Comets, also called 'dirty snowballs' or 'icy mudballs', are a part of the solar system, and are typically icy bodies covered with dark organic material. Like asteroids and planets, they also orbit the Sun.

However, comets have a very long orbit. When a comet orbits too close to the Sun, the ice and dust begin to get destroyed or vaporised. This creates a cloud of comet dust particles around the heart or nucleus of the comet and is known as the coma (see diagram below). The vaporised ice and dust form the tail of the comet. The tail glows due to light from the Sun, and is visible to human beings on Earth.

▼ The most famous comet is Halley's Comet, that is visible from Earth every 76 years

Comets generally have two different types of tails—the white ones are made up of comet dust and the bluish ones, of electrically charged gas.

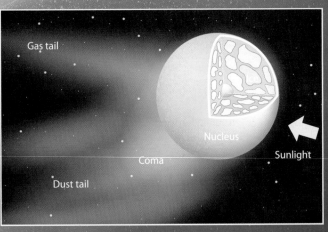

Gas tail

Nucleus

Coma

Sunlight

Dust tail

▲ The diagram shows the structure of a comet with its nucleus, coma, dust, and gas tails

🎖 Incredible Individuals

Caroline Herschel was the sister of a well-known German astronomer named William Herschel. Caroline came from a family of musicians. She was a singer, a mathematician, and an astronomer. While her father encouraged all his children to study French, mathematics, and music, her mother did not consider it important to educate a girl. She made her do all the housework. At age 10, Caroline became sick and disease stunted her growth. She grew no taller than 4 feet 3 inches. In her early adulthood, she lived with her brother William in England, who trained her in singing, mathematics, and astronomy. She often helped him with his work. She learned how to grind glass to make powerful telescopes and began using them to make her own astronomical discoveries.

Three new nebulas (the region where stars are born) were discovered by her. Caroline was the first woman to find a comet; in fact, before she died, aged 98, she had discovered eight of them!

▶ Caroline Herschel (1750–1848) was the first woman to find a comet

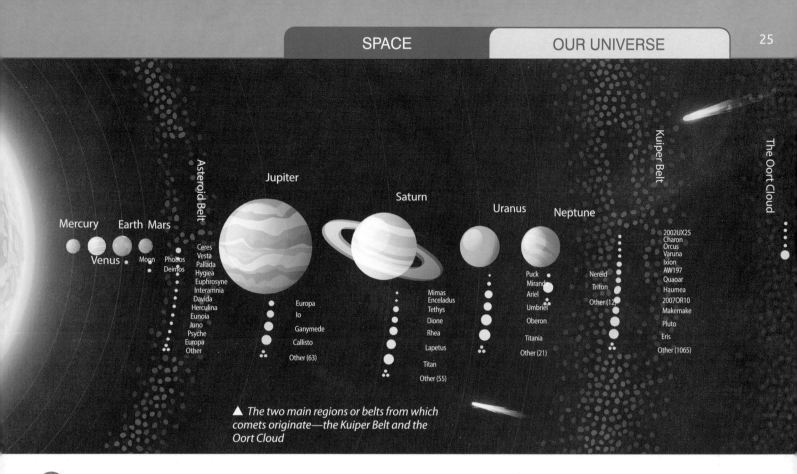

Mercury
Venus
Earth Mars
Moon
Pholos
Deimos

Asteroid Belt

Ceres
Vesta
Pallada
Hygiea
Euphrosyne
Interamnia
Davida
Herculina
Eunoia
Juno
Psyche
Europa
Other

Jupiter

Europa
Io
Ganymede
Callisto

Other (63)

Saturn

Mimas
Enceladus
Tethys
Dione
Rhea
Lapetus
Titan

Other (55)

Uranus

Puck
Miranda
Ariel
Umbriel
Oberon
Titania

Other (21)

Neptune

Nereid
Triton

Other (12)

Kuiper Belt

2002UX25
Charon
Orcus
Varuna
Ixion
AW197
Quaoar
Haumea
2007OR10
Makemake
Pluto
Eris

Other (1065)

The Oort Cloud

▲ *The two main regions or belts from which comets originate—the Kuiper Belt and the Oort Cloud*

⭐ Chasing Comets

While billions of comets can be found in the solar system, most of these originate from two regions—the Kuiper Belt (a ring of icy bodies lying outside Neptune's orbit) and the Oort Cloud (a ring-like region beyond Pluto, on the outer edges of the Kuiper Belt).

Bright comets which are visible on Earth at night appear approximately once every 10 years. Short-period comets, like the Halley's Comet, traverse through the solar system maybe once or twice during a human lifetime. The Halley's Comet takes less than 200 years to orbit the Sun. In 2061, it will return on its regular 76-year journey around the Sun. Long-period comets from the Oort Cloud pass close to the Sun only once in every 100 to 1000 years, and they are less predictable.

Comets generally travel at a safe distance from the Sun, like the Halley's Comet. However, some crash headlong into the Sun or get so close to it that they break up and evaporate—these are known as sungrazers. Comets are generally named after the person or spacecraft that discovered them.

👤 In Real Life

Astronomers now have a much better idea of what makes up a comet's nucleus. NASA's Deep Impact spacecraft's 'smart impactor' blasted out a huge crater from the nucleus of the comet Tempel 1 in July 2005. They found the nucleus to be spongy with lots of holes; some sections of the surface were delicate and weak; and the surface of the nucleus was covered with fine dust.

▲ *A picture of the Halley's Comet taken on 6 June 1910*

Edmundus Halleius

▶ *Halley's Comet is named after the English astronomer Edmond Halley. It is predicted to return to Earth every 76 years. It was last seen in 1986 and will now enter the inner region of the solar system only in 2061. Keep your eyes peeled!*

Amazing Celestial Oddities
Black Holes and Auroras

The mysteries of the universe are unending. Here are two more that are mindboggling; one is the blackest object to be found in deep space, and the other is a celebratory vibrant show of lights seen on Earth!

⭐ What are Black Holes?

What can be darker than space itself? Well the darkest objects to be found in the depths of our universe are also some of the weirdest and strangest things—black holes! A black hole is an area with such tremendous gravity or pull that nothing—not even light—can escape from it. Usually, black holes are formed when a star dies. When the fuel in a star gets depleted or finished, it starts to disintegrate and cave in on itself, resulting in a huge bang. All the matter remaining after the explosion—which is much, much more than the mass of the Sun—falls into a really tiny point. This point where a large amount of mass is trapped is called a singularity. It has a huge impact even though it is small.

You can imagine a black hole as a circle with a singularity in the centre. The gravity in this centre is so great that it sucks in everything, including light. That is why black holes appear so black! A black hole's 'surface' is known as its event horizon that defines the boundary where the velocity needed to escape the hole exceeds the speed of light.

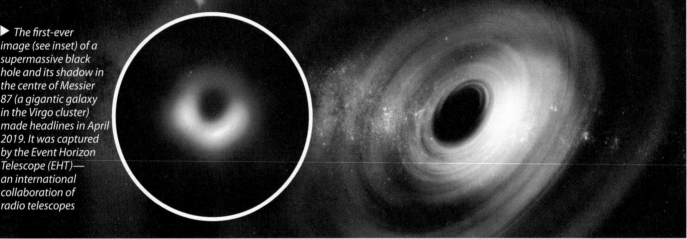

▶ *The first-ever image (see inset) of a supermassive black hole and its shadow in the centre of Messier 87 (a gigantic galaxy in the Virgo cluster) made headlines in April 2019. It was captured by the Event Horizon Telescope (EHT)—an international collaboration of radio telescopes*

⭐ The Aura of Auroras

If you are lucky enough to find yourself near the North Pole or the South Pole, you may want to check out the amazing and exquisite light shows in the sky. These lights are known as auroras. The lights near the North Pole are called Aurora Borealis or the Northern Lights and the ones near the South Pole are referred to as Aurora Australis or the Southern Lights.

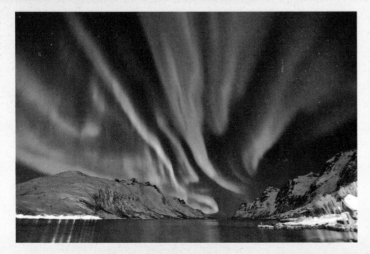

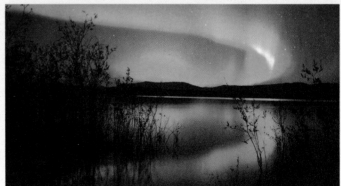

▲ *Brilliant green Northern Lights at Lake Laberge, Yukon, Canada*

◀ *The Northern Lights during winter in Tromso, Norway, in front of a* **fjord**

✪ What Causes Auroras?

Auroras are mostly seen during the night, but they are effects created by the Sun. Besides heat and light, the Sun is responsible for sending us small particles and a lot of other energy. Earth's **magnetic field** protects us from this energy and particles.

Auroras are caused by charged particles that travel between the Sun and Earth along magnetic fields. A magnetic field is the area of influence of a magnet. It covers the whole area in which the attraction or repulsion of a magnet can be felt. Magnetic fields such as that of Earth cause magnetic compass needles and other permanent magnets to line up in the direction of the field.

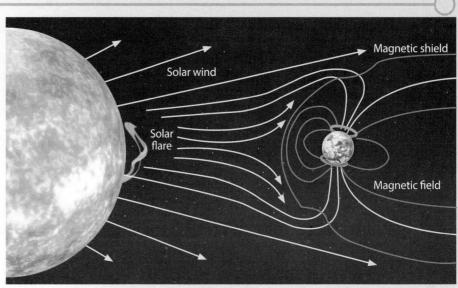

▲ *Auroras are named after the Roman goddess of dawn, who traveled from east to west, announcing the coming of the Sun*

Sometimes, due to **solar winds** and storms, the amount of energy sent by the Sun varies. During one particular type of solar storm, called a coronal mass ejection, the Sun ejects a large bubble of electrified gas which can travel at great speeds through space. When a solar storm like this approaches us on Earth, the energy and small particles move down into Earth's atmosphere along the magnetic field lines at the North Pole and South Pole.

When the particles reach Earth's atmosphere, they engage with the gases in it, and this results in amazing displays of bright lights in the sky. Dazzling green and red lights are seen due to the interaction with oxygen, whereas nitrogen gives off blue and purple hues.

◀ *The Southern lights in Tasmania*

▲ *Aurora Australis over Lake Wakatipu, South Island, New Zealand*

Extrasolar Planets or Exoplanets

For a long time, human beings only knew about the existence of planets within the solar system. It was only in 1992 that planets outside our solar system were also discovered. They were called extrasolar planets or exoplanets. Astronomers now know that exoplanets are a usual occurrence in the universe, and they are aware of more than 3,000 exoplanets. They are also in the process of getting information about an additional 1,000 or more.

⭐ What are Exoplanets?

An extrasolar planet or exoplanet is a planetary body that is outside the solar system and usually orbits a star other than the Sun, unlike the planets in our solar system. They are very hard to view even with telescopes, since they are generally concealed due to the bright glare of the stars that they orbit.

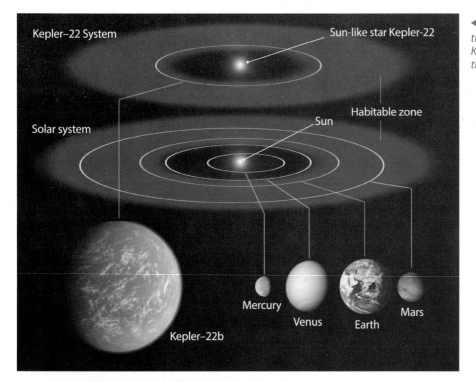

◄ This illustration shows a comparison between the solar system and the Kepler-22 System. Keppler-22b is an exoplanet and Keppler-22 is the star around which it revolves

▲ An illustration of a faraway planet system with exoplanets (elements of this image are furnished by NASA)

▼ Illustration of an exoplanet, with exo-moons orbiting a binary star system

In Real Life

NASA launched the Kepler spacecraft in 2009 to find exoplanets. Kepler searched for such planets varying in size and orbit, and also those whose stars differed in size and temperature. Some exoplanets found by Kepler appear to be rock-like and at unusual distances from their stars. These seem to have a habitable area and may support life. The Kepler space mission has discovered thousands of extrasolar planets.

In 2017, NASA discovered seven Earth-sized planets in the habitable zone of TRAPPIST-1, a single star. All the seven rocky planets seem to have the possibility of having water on their surface. It is a crucial discovery for scientists in their search for life on other planets. After our solar system and planets, scientists know the most about the TRAPPIST-1 planetary system.

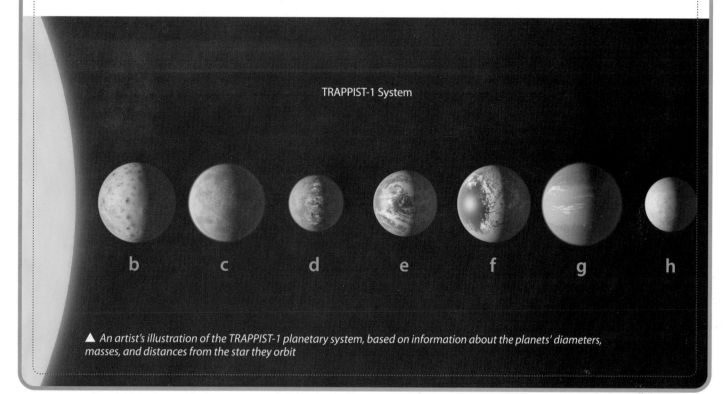

TRAPPIST-1 System

b c d e f g h

▲ An artist's illustration of the TRAPPIST-1 planetary system, based on information about the planets' diameters, masses, and distances from the star they orbit

How can we Spot Exoplanets?

One method to discover exoplanets is to look for unsteady or 'wobbly' stars. Stars which have planets orbiting them tend to appear shaky or wobbly since they do not orbit perfectly around the star's centre. Due to this off-centre orbit, when viewed from a long distance, the star which has planets around it looks like it is wobbling.

While numerous exoplanets have been discovered using this method, it is suitable for the discovery of only large planets like Jupiter, or those larger than Jupiter. Small planets that are the size of Earth or smaller are more difficult to find using this method, since the wobble is so small that it is difficult to detect.

Another method used by scientists to discover exoplanets is the transit method. When a planet passes between a star and its observer, it is known as a transit. When this happens, the planet blocks out some of the star's light. So, a star will look a bit dimmer when the planet passes in front of it. By observing the changes in the brightness of the star during transit, astronomers can figure out the size of the planet. Observing the time taken between transits tells scientists how far the planet is from its star. If the temperature is ideal or right, the planet may have a **habitable zone**.

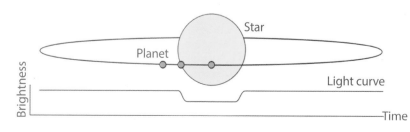

▲ The transit method has helped in the discoveries of 3,343 exoplanets of the total 4,371 exoplanets that have been confirmed till date

Universe or Multiverse?

We have always thought of our universe as unique and one of a kind. In fact, the word itself implies this. Based on an enhanced version of the Big Bang model, a group of four physicists in the 1980s first came up with the idea that there may be other universes or multiverses that also exist.

▼ *According to scientists, our universe may contain up to 100 billion galaxies*

⭐ Multiverse Theory

The term 'multiverse' was first mentioned by American philosopher William James in 1895. There are four physicists, however, who are responsible for suggesting the theory of inflation. They said that when the Big Bang took place nearly 14 billion years ago, within the first few seconds, the universe underwent an expansion, or what is termed as 'inflation'. Satellite measurements of the heat which was left behind by the Big Bang also support this theory. It suggested something quite out of the ordinary. According to this theory, the Big Bang that created the universe may not have been a one-time event; but rather it may have occurred again and again several times. These scientists claimed that each of these big bangs would have possibly created other universes. Therefore, they concluded that rather than one universe, we may be living in a multiverse (many universes).

▲ *American philosopher and psychologist William James (1842–1910) was a professor at Harvard College for several years*

Mathematic calculations revealed that the multiverse may comprise of a variety of universes, some very different from our universe and others with replicas of Earth, including all of us in it. The existence of other universes would also mean that things that can happen in one universe can also happen in the other universes. It is a debatable and controversial idea.

Hence, according to the multiverse theory, our universe, which stretches about 90 billion light years across, would then form a very small part of the multiverse. The multiverse idea has been discussed in the study of cosmology, quantum mechanics, and also philosophy.

Units of Measurement, and Cosmic Forces

How do astronomers and scientists measure distances in the universe? What, in fact, holds our universe together? Read on to find out.

⭐ Astronomical Unit

An astronomical unit (or AU) is a unit of distance. It is approximately the average distance between Earth and the Sun. So, one AU is about 150,000,000 kilometres.

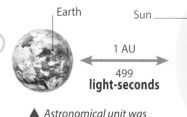

▲ Astronomical unit was first used in 1903

⭐ Light Year

A light year is the distance travelled by light in one Earth year. One light year is approximately 9 trillion kilometres (9×10^{12}). It is used to describe the distance of objects in space.

⭐ Nuclear Fusion

Nuclear fusion is a process by which nuclear reactions between light elements form heavier elements (up to iron). The nuclear fusion process within the core of a star produces a lot of energy, which travels into space in the form of heat and light.

⭐ Gravity

When you throw an apple into the air, why does it fall down instead of floating away into the sky? This is due to **gravity,** a universal and invisible force by which a planet or body attracts objects towards its centre. We would not be able to exist on Earth without gravity; it keeps everything in the universe in place, including planets and even Earth's atmosphere.

▲ Gravity accelerates everything at the same rate, regardless of an object's weight

⭐ What Exerts Gravity?

All objects that have mass have gravity, including human beings. The more the mass, the greater is the gravity. Earth's gravity is possible due to all of its mass, which creates a gravitational pull on the entire mass in your body. This gives you weight. But if you were on a planet or body which had lesser mass than Earth, you would weigh much less and vice versa!

💡 Isn't It Amazing!

When you stand on a weighing scale, it actually measures how hard Earth's gravity is pulling you. On Mercury or Jupiter, it would show you a different figure. Since the planets differ in their weights, the gravity they exert on us is also different.

If you weigh 45 kg on Earth, you would weigh only 17 kg on Mercury and about 115 kg on Jupiter. This is because the weight of Mercury is less than Earth and, therefore, its gravity would pull lesser on your body, whereas Jupiter weighs more, so the pull on your body would be much greater!

17 kilograms on Mercury

45 kilograms on Earth

115 kilograms on Jupiter

▲ A human being has a different weight on different planets

Satellites
Natural and Artificial

We are all familiar with the word 'satellite' and we know that there are both natural and artificial satellites. Natural satellites, like Earth's Moon, are not created by people, unlike artificial satellites. Natural satellites can exist in a variety of shapes, sizes, and types. They are generally solid bodies and very few of them have atmospheres. They were most probably created from the gas and dust moving around planets in the early days of the solar system. Artificial satellites, on the other hand, are made by human beings and have some specific uses.

✪ What is a Satellite?

A moon, planet, or a machine that orbits a planet or star is known as a satellite. Our Earth orbits the Sun and the Moon orbits Earth, hence both are examples of natural satellites.

The word 'satellite' is more commonly used to refer to machines that are launched into space and move around Earth or any other celestial body in space. These are man-made or artificial satellites. They aid scientists in their studies and help them get more information about our universe, solar system, oceans, land, and atmosphere. Artificial satellites are also useful since they are able to take photographs of deep space objects and other phenomena and send them back to Earth. For example, pictures of our planet taken from space help meteorologists forecast the weather and predict natural disasters like hurricanes.

Other types of satellites are used for communication purposes, like those which beam TV and phone signals across the world or those which help us get important and useful information like our exact location.

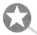
◀ *The Moon is Earth's natural satellite. It takes 27 days to complete one orbit around Earth*

✪ Moons of the Solar System

Our solar system consists of hundreds of moons. Some asteroids have also been found to have small moons. While Earth has only one moon or natural satellite, some other planets have many more, while others have none.

The two planets closest to the Sun are Mercury and Venus. They do not have any moons. Mercury is so very close to the Sun and its gravity, that it would, most probably, not be able to hold on to its moon. The moon would either crash into Mercury or get into an orbit around the Sun, eventually getting sucked into it.

Mars, on the other hand, has two moons. Jupiter, the outer giant planet can boast of 79 moons (53 of them have names, while the others are yet to be officially named)! It also has the biggest moon in the solar system, called Ganymede. Jupiter's moons are so large that they can be viewed with a pair of binoculars on a clear, dark night.

Saturn currently has 53 named moons and may have another nine which are still to be confirmed. If they are confirmed, the Ringed Planet will have 62 moons in all. Coming to Uranus; this planet has 27 confirmed moons so far, some of which are partially made of ice. Neptune, till date, has been found to have 13 moons and may have one more, but it is not yet confirmed.

▶ *The illustration shows the moons of the solar system and their comparative sizes to each other and to Earth*

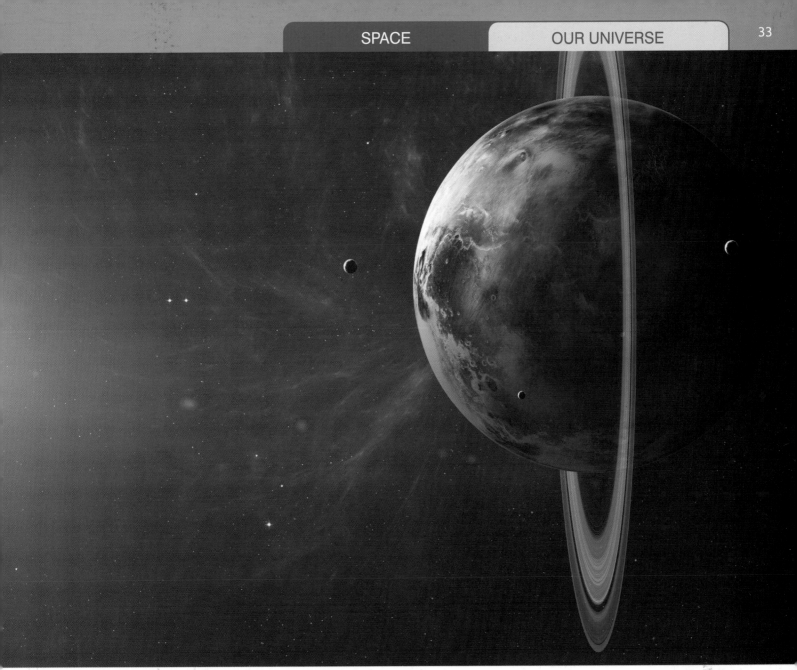

▲ *Uranus rotates on its side, so it is also known as the 'sideways planet'*

⭐ Moons of the Kuiper Belt

The Kuiper Belt, which surrounds the solar system and is the region where Pluto lies, has several planets and moons. Pluto has five moons—Charon, Styx, Nix, Kerberos, and Hydra. Charon is half the size of Pluto and is the closest to it. Nix and Hydra were found by NASA's Hubble Space Telescope in 2005. Two other dwarf planets in the Kuiper belt, Eris and Haumea, have one and two moons respectively.

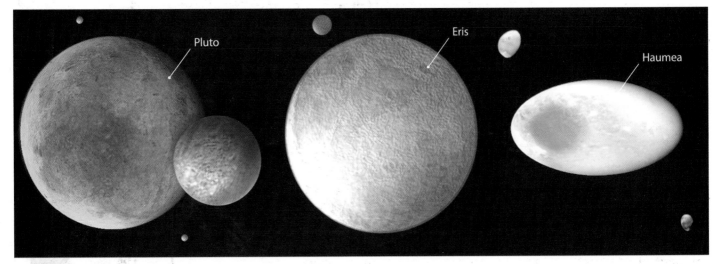

▲ *Dwarf planets Pluto, Eris, and Haumea and their moons. Some astronomers expect the presence of up to 50 dwarf planets in the solar system*

Concepts about the Universe

Cosmology is the scientific study of the evolution of the universe. Cosmologists are interested in understanding the past, present, and the future of the universe. For centuries, human beings have been trying to understand the cosmos. Early concepts about the universe were vastly different from modern-day theories and have undergone several changes.

⭐ Early Concepts of the Universe

Greek philosopher and scientist Aristotle (384–322 BCE) was one of the greatest scholars of the Western world. He proposed that Earth was the centre of the universe, with the Sun, the Moon, and the planets, as well as the fixed stars revolving around it. Aristotle's views about the universe were accepted by a majority of the Greeks in his time.

300 years later, Ptolemy of Alexandria (100-170 CE) was the first astronomer to make scientific maps of the skies. But he too believed in the Earth-centred view of the universe. This was the major belief for about 1500 years.

▲ *Aristotle believed in a spiritual space past the fixed stars, where no human could ever go*

▶ *Ptolemy was a polymath whose studies ranged from astronomy and geography to mathematics, philosophy, literature, and poetry*

⭐ The Copernican Revolution

Nicolaus Copernicus (1473–1543), a Polish monk, challenged this Earth-centred view of the universe in 1543. He suggested that the Sun was at the centre of the universe (the heliocentric theory). Since the Catholic Church believed that Earth was the central figure, Copernicus's theory was met with a lot of hostility. The views and precise studies of Tycho Brahe, (1546-1601) as well as Italian scientist Galileo Galilei's (1564-1642) use of the telescope, eventually led to Copernicus's theory being accepted. In 1609, Galilei developed his own telescope and used it to study the skies. He observed a smaller version of the solar system, as suggested by Copernicus, with moons travelling around the planets. His discoveries revolutionised the science of astronomy.

◀ *Nicolaus Copernicus had completed his work on the heliocentric theory in 1530, but it wasn't published until the year of his death*

⊙ Incredible Individuals

In 1633, Galilei was convicted by the Roman Catholic Church for supporting the Copernican theory, according to which Earth revolves around the Sun. The Church criticised him for going against the sacred writings of the *Bible* as they considered Earth and not the Sun as the centre of the universe. They asked him to withdraw his conclusions and put him on a 13-year trial and investigation. He was also put under house arrest for nearly eight years before he died in 1642.

Ironically, more than 350 years after the Roman Catholic Church condemned Galilei, in 1992, the Vatican issued a note to say that he was right after all and that Earth is not fixed, but it does, in fact, move around the Sun!

▲ *Galileo Galilei has been called the "father of observational astronomy"*

⭐ Modern Astronomy and Science

Both Galilei and British scientist Sir Isaac Newton (1643–1727) laid the foundations of modern science. Newton used mathematics to explain known facts and also made mathematical laws to explain how objects moved in space and on Earth. He explained orbiting planets and concluded that all celestial bodies are always moving, with no limits on space and time. In 1917, Scientist Albert Einstein (1879–1955) described the universe based on his theory of general relativity. According to it, time passes more slower for objects in gravitational fields (like for us on Earth) than for objects far from such fields.

▲ *Two great men: (Top) Galileo Galilei explaining how to use the telescope to the Doge of Venice; and (right) Sir Isaac Newton in his lab, explaining an optical experiment*

Galilei made major contributions to the sciences of motion, astronomy, and the development of scientific method. Newton was a key person during the scientific revolution of the 17th century. He is best known for his three laws of motion, amongst numerous other discoveries and scientific formulations.

Einstein's theory influenced many scientists. Two of them were Willem de Sitter (1872–1934) of Holland and Aleksandr Friedmann from Russia. A lot of cosmology today is based on Friedmann's expansion of Einstein's equations of general relativity, which helped gain a better understanding of the evolution of the universe.

▶ *German-born Albert Einstein was a world-renowned physicist known for developing the special and general theories of relativity. He won the Nobel Prize for Physics in 1921 and is recognised as the most influential physicist of the 20th century*

Another important discovery was made by American astronomer Edwin Hubble in the 1920s. For hundreds of years, astronomers thought that the universe only consisted of the Milky Way galaxy. Hubble was the first to observe the existence of other galaxies that were not part of the Milky Way. He concluded that galaxies were moving away from us at great speeds and that the universe was expanding.

◀ *American astronomer Edwin Hubble was a key figure in establishing the field of extragalactic astronomy. He is considered as the leading observational cosmologist of the 20th century*

SOLAR SYSTEM

THE AMAZING SOLAR SYSTEM

Our solar system consists of the Sun—a star, and all the bodies orbiting around it. These objects mainly comprise the planets, which are the largest bodies in the solar system besides the Sun. Then there are moons, asteroids, meteoroids, comets, and other celestial objects.

The solar system exists within the spiral Milky Way galaxy, which is made up of several hundred billion stars. Although the Sun is extremely important to us and without it, life would be unlikely on our planet, in the larger scheme of the galaxy and the universe, it is just an average-sized star, one of the billion stars in the Milky Way.

The eight planets of the solar system are Mercury, Venus, Earth, Mars, Jupiter, Saturn, Uranus, and Neptune—in order of their distance from the Sun. The first four inner planets are rocky or terrestrial planets. From the four outer region planets, Jupiter and Saturn are gas giants, whereas Uranus and Neptune are ice giants. Pluto, once considered a planet, has recently been given the status of a dwarf planet.

The asteroid belt (lying between Mars and Jupiter), the Kuiper Belt, and the Oort Cloud beyond the orbit of Neptune are the three other regions considered a part of the solar system.

Scientists fascinated by this wondrous and largely unexplored solar system are always looking for ways to reach out to the stars and other bodies in the Milky Way and beyond, so that they get answers to their numerous questions!

Our Celestial Neighbourhood

Have you ever gazed into the sky and wondered what magic and mystery lies beyond Earth's atmosphere in our cosmic neighbourhood? We know that the Sun, the big ball of fire we see during the day, is the heart of our solar system. But how was the solar system created and how did it grow? What is it made up of? What makes our solar system such an amazing, awe-inspiring arena?

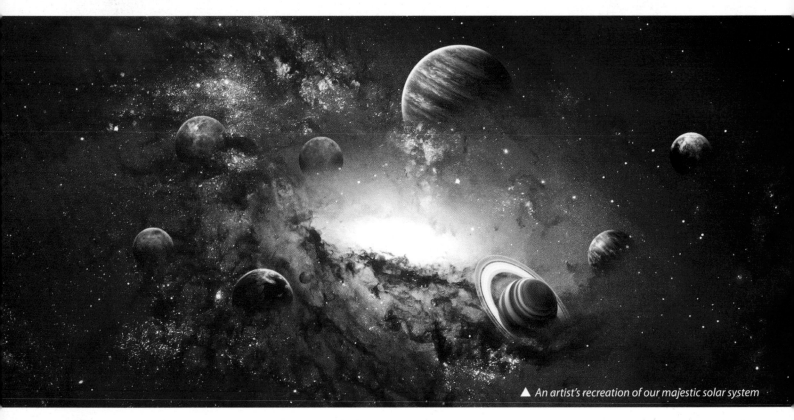

▲ An artist's recreation of our majestic solar system

⭐ Formation of the Solar System

Nearly 4.6 billion years ago, there existed a thin cloud of **stellar dust**, which was part of a larger cloud or **nebula**. One day, the cloud collapsed, possibly due to the after-effects of an exploding star which made it crumble. It fell in upon itself and created a spherical disc of matter which surrounded it. Near its centre, gravity began to pull material inwards so that the immense pressure at the core of the spherical disc that was caused by this material forced hydrogen atoms to merge into helium, which in turn produced a large amount of energy—and voila! The Sun was born. The Sun pulled more than 99 per cent of the matter in the disc towards the centre, but some remained.

Next came planet formation that was rapid. Some of the leftover matter fused together due to gravity. Big objects banged against one another, forming larger objects, until they became huge enough to form spheres or planets, including **dwarf planets**. Earth and the other rocky planets remained close to the Sun, as those with ice and gaseous materials could not exist near such heat. The gas and other giant ice planets, therefore, formed farther away from the Sun. This is how the solar system was formed.

👤 In Real Life

It is very likely that there are tens of billions of other solar systems in the Milky Way. So far, scientists have found more than 2,900 **planetary systems** (stars with confirmed planets) in the Milky Way galaxy.

▶ An artist's rendering of a planetary system. The bright spot at the centre is the Sun

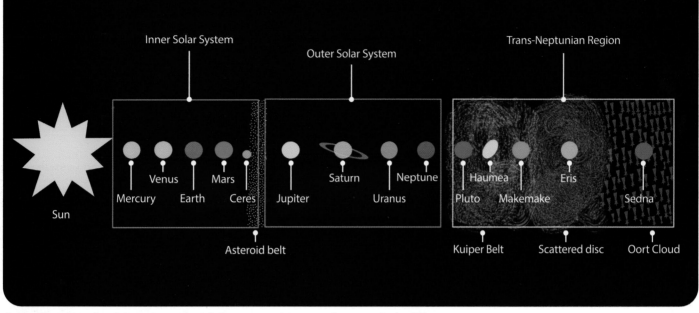

▲ *The illustration shows the various celestial objects comprising our solar system in the different zones*

⭐ Composition of the Solar System

The Sun is the central object within the solar system. It influences the movement of all other bodies due to its gravitational force. Besides the eight major planets that orbit around the Sun, the solar system comprises approximately 170 known moons (or planetary satellites), innumerable asteroids, comets and icy bodies. Asteroids are small, rocky objects leftover from the formation of the solar system. They are sometimes referred to as minor planets or planetoids. Asteroids orbit the Sun and are mainly found in the asteroid belt region between Mars and Jupiter. Most of them are about 1,000 kilometres or less in diameter. Asteroids and comets help us figure out the story of our very busy solar system. Astronomers believe that Jupiter's gravity prevented these pieces from clumping together into a planet. The vastness of the solar system also consists of **interplanetary medium**, thinly scattered matter that exists between the planets and other bodies as well as the forces (e.g., magnetic and electric) that are present in this region of space.

🎖 Incredible Individuals

Hipparchus was a Greek astronomer who helped develop astronomy as a mathematical science. His most significant contribution is his work on the orbits of the Sun and the Moon as well as the measurement of their sizes and distances from Earth. Hipparchus also studied eclipses. He tried to clarify how the Sun is able to travel with a steady speed along a consistent circular path and yet able to cause seasons which are unequal in duration.

▶ *Hipparchus (or Hipparchos) was one of the greatest astronomers of the ancient world and contributed significantly to this field, making several noteworthy astronomical observations*

The Great Debate
Geocentric or Heliocentric?

Ideas about the solar system have been different and have changed several times throughout history. Before the invention of the telescope, astronomers had to depend on gathering information from celestial objects that could be seen with the naked eye. This obviously limited their knowledge about the solar system. For several centuries, Earth was considered the center of the solar system. It was only much later that scientists realised this was not true and accepted the Sun as the center of the solar system.

▲ An early astronomical telescope. The first person to turn the telescope skyward was the famous astronomer Galileo

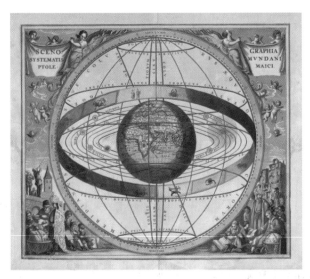

⭐ The Geocentric Model

It is a theory regarding the structure of the solar system where Earth is considered to be at the centre of it all. Ancient Greek and Egyptian astronomers, Aristotle and Ptolemy (2nd century CE)are chiefly responsible for promoting the geocentric model which prevailed for more than 1,000 years!

According to this system, Earth is stationary and is the centre of the universe while the Sun, planets, and stars revolve around Earth.

◀ This ancient chart shows the solar system with Earth at the centre as per Ptolemy's geocentric model of the solar system

⭐ The Heliocentric Model

This system is a cosmological model where the Sun is considered to be at the center of the solar system or the universe. As per this model, Earth and the other bodies revolve around the Sun. Back in the 5th century BCE, a few Greek philosophers had guessed this, but this belief was not recognised until much later, when Nicolaus Copernicus (1473–1543) changed the model of the solar system.

He claimed that the Sun was at the center and argued in favour of Earth and other bodies moving around it. His observations were published in the six books of the seminal work, *On the Revolutions of the Heavenly Orbs* in 1543. Another well-known astronomer named Galileo Galilei supported this model and strongly vouched for it. Observations made by him (and much later by others) through telescopes proved that the heliocentric theory was correct.

▶ A statue of Nicolaus Copernicus in Torun, Poland. Ironically, there is no record of Copernicus ever earning a bachelor's degree

The Majestic Milky Way

A large group or cluster of stars, gas, and dust held together by gravity is known as a galaxy. Galaxies are densely packed with billions of stars and their solar systems. On a dark, moonless night you will be able to see the majestic band of our Milky Way galaxy.

The solar system (of which Earth is a part) is only a small chunk of the Milky Way and lies far out within this galaxy. Just as Earth orbits the Sun, the Sun orbits the center of the Milky Way.

⭐ A Barred Spiral and its Contents

Based on their shapes, galaxies can be classified as spiral, elliptical, and irregular. Our Milky Way is a large, barred spiral and is flat. While most stars in the Milky Way exist alone or in pairs, there are several clearly visible groups of stars, each containing thousands of members. These are classified into **globular clusters**, **open clusters**, and **stellar associations**. The main difference between these groups is in the age and the number of their stars or members.

Globular clusters are the largest amongst all the clusters and mainly consist of very old stars. The Milky Way has over 150 globular clusters or more.

Smaller groups of stars that are not as big as globular clusters, and those which are mixed up along with the other majority of stars in the system, including the Sun, are known as open clusters. In comparison, they are young objects.

Stellar associations are even younger than open clusters and are more loosely grouped together. They are usually not bound together by gravity and so do not form stable groups.

The Milky Way also contains weak clouds of dust and gas called nebulas, which are the birthplace of most stars. It also contains indistinct objects which are the leftovers of the gas spewed out by exploding stars.

▲ Our home galaxy, the Milky Way

👤 Isn't It Amazing!

The Sun and the solar system take 250 million years to complete one full rotation around the center of the Milky Way!

▲ The Milky Way galaxy rises over the MacDonald Observatory near Fort Davis, Texas, USA

The Scintillating Sun

The Sun is four-and-a-half billion years old. It is at a distance of 149,600,000 kilometres from Earth. It keeps the entire solar system together with the help of gravity. With a surface temperature of 10,000 degrees Fahrenheit, it is a source of light, heat, and energy for us on Earth, without which, no life could exist. So what is the Sun made up of and what does it do?

⭐ Structure and Layers of the Sun

The Sun has six layers. Gravitational force helps keep its huge mass together.

The C

It is the innermost layer, where nuclear reactions generate energy. The temperature is about 15 million kelvin (K).

The Radiative Z

It is the zone where energy is released outwards by the process of radiation. Across this zone, temperature usually drops from about 7 million K to 2 million K.

The Convective Z

Here energy is transported outwards by the mechanism of convection currents, which are rising movements of hot gas alongside falling movements of cool gas. Temperature falls from 2 million K to 5800 K.

The Photosph

It emits the light that we see with our eyes. Temperature is around 5800 K.

The Chromosp

It lies above the photosphere and below the corona. From the inside to the outside edge, the temperature is around 4300 K to 8300 K.

The Co

It is the outermost layer and is extremely hot. On the outer disc of the Sun, there are filaments or **prominences,** which are dense, glowing, and intensely hot clouds. Temperature is around 2 million K.

👤 In Real Life

During solar activity, large quantities of energy (as high as 100 million K) and particles are released. Some of this reaches Earth, causing strong electrical currents that can damage satellites, rust pipelines, and harm power grids.

⭐ Size and Distance

The Sun is the largest and brightest object in the solar system. Compared to Earth, it is a giant! The radius of the Sun is 696,340 kilometres, whereas that of Earth is 6,378 km! It would take 1.3 million Earths to make up the entire volume of the Sun.

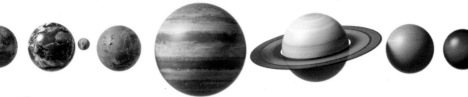

◀ *The solar system was formed 4.6 billion years ago*

⭐ Solar Activity

The Sun is very active. This is particularly true at its surface, where it goes through a solar cycle or phases of being quiet or violently active. Very strong magnetic fields are generated by electrically charged gases that are found on its exterior. Since the gases on the Sun's surface are shifting all the time, they distort the magnetic fields. This distortion creates solar activity including solar wind, sunspots, and solar flares.

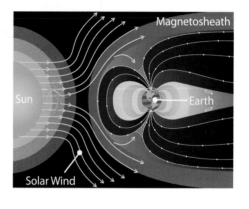

▶ *A diagram showing solar wind activity and Earth's magnetic field*

⭐ Solar Wind

The Sun throws out a steady stream of particles and a magnetic field into space at high speeds known as solar wind. This creates a region around the Sun and the solar system called the **heliosphere**.

⭐ Sunspots and Solar Flares

Dark spots on the surface of the Sun are known as sunspots. They appear dark because they are cooler as compared to the rest of the Sun, though their temperature is 3,800 K!

When the magnetic field lines are disturbed, sometimes it causes an unexpected explosion of energy known as a solar flare, which releases significant radiation into space. Sometimes, solar flares trigger a coronal mass ejection (CME) which are large bubbles of radiation and particles emanating from the Sun. They burst in space at great speeds due to the fluctuations in the Sun's magnetic field lines.

⭐ Solar Eclipse

An eclipse takes place when a planet or a Moon comes in the way of the Sun's light. On Earth we experience two kinds—solar and lunar eclipses. When the Moon comes between Earth and the Sun and casts a shadow on our planet, it is called a solar eclipse. When this happens, it gets dark during the day. Depending on the degree to which it covers the Sun, it can be a partial or total eclipse.

Since the Moon's shadow cast on Earth is not very large, only some people on a small part of the planet will be able to see a solar eclipse. Also, you need to be on the side of Earth that has sunlight when this event takes place and be in the path of the Moon's shadow.

▲ *The longest duration of a total solar eclipse is 7.5 minutes*

Mercury
The Smallest and the Fastest Planet

The smallest planet in the solar system is Mercury. It is slightly bigger than Earth's Moon. It is the nearest planet to the Sun, but not the hottest.

⭐ Structure and Appearance

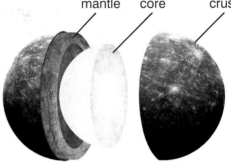

mantle core crust

▲ *The inner structure of planet Mercury*

After Earth, Mercury is the second densest planet of our solar system. It has a huge metallic centre. Part of its core is liquid. Its outer shell is similar to that of Earth, comprising the mantle and crust. Mercury's surface looks like that of Earth's Moon. It has several **craters** (large bowl-shaped depressions) caused due to the impact of meteorites or comets striking its surface. It has stretches of smooth land and cliffs, and appears greyish-brown with bright streaks. Some regions near Mercury's poles never receive sunlight. These permanently shadowed regions are known to have water in the form of ice inside deep basin-like depressions.

👩‍🏫 In Real Life

Some craters and other features of Mercury are named after well-known authors like Dr Seuss, renowned musicians like Sergey Rachmaninoff and other artistes.

▼ *Mercury is a rocky planet and has no moons*

⭐ Unique Feature

Did you know that it takes only 88 Earth days for Mercury to finish one revolution around the Sun? Since it is so close to the Sun, a year on Mercury goes by pretty fast. Mercury's orbit around the Sun is three times closer than Earth's orbit around the Sun.

Like Earth, Mercury spins on its own axis. But it has a slow spin and only completes three rotations on its axis every two Mercury years. One complete rotation takes 59.65 Earth days or two-thirds of a Mercury year. As a result, a day lasts for almost two Mercury years! So, if you were standing on Mercury's surface, the Sun would pass overhead once during two revolutions around the Sun or once every 176 Earth days (*see Earth's movements on pp16–17*).

① Quick Facts

- ⚙ **Distance from the Sun:** 0.4 **astronomical units** (AU). One AU is the average distance between the Sun and Earth i.e., 150 million kilometres
- ⚙ Time taken by light to travel from the Sun to Mercury: 3.2 minutes
- ⚙ Surface temperatures: 430° C (day) -180° C (night)
- ⚙ Atmosphere: None

⭐ Incredible Individuals

British astronomer and mathematician, Edmond Halley (1656–1742) was the first to compute the orbit of a comet, which was later called Halley's Comet, after him. He also noted the movement of Mercury across the Sun's sphere. His **star catalogue** (1678) was the first to identify the precise locations of southern stars obtained using a telescope.

Venus
The Hottest Planet

The second-closest planet to the Sun and the brightest in the solar system is Venus. It is one of the brightest objects (other than Earth's Moon), and so it can sometimes be seen in the night sky. It is slightly bigger than Earth and is also the closest planet to it. Venus is also called the 'Morning Star' or 'Evening Star' because it appears really bright from Earth during sunrise and sunset. However, it does not appear to twinkle. Instead, it glows with a steady light.

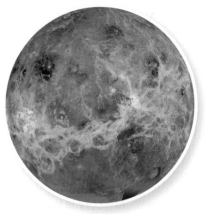
▲ *Venus is the second brightest natural object in the night sky after the Moon*

⭐ Structure and Appearance

The structure of Venus is similar to Earth, with an iron core and a mantle of hot rock with a thin crust-like surface which heaves and moves, creating volcanoes. This is because Venus is the hottest planet even though it is not the nearest to the Sun. Its thick atmosphere does not allow heat to escape; thus, Venus is burning hot. Even metals like lead would melt and become liquid on Venus. It is an active planet with numerous volcanoes, large valleys, and mountains. Maxwell Montes is the highest mountain on Venus, rising to about 11 kilometres above the planet's mean radius. Two of its highland areas are around the same size as Australia and South America!

Due to its thick cloud covering, which reflects and disperses light from the Sun, Venus appears to be bright white in colour when it is viewed from space. But if you were standing on the surface of Venus, then it would look orangish since the same atmosphere filters the sunlight.

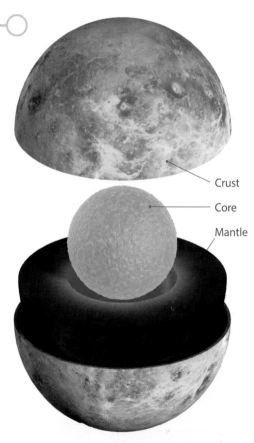

Crust

Core

Mantle

▲ *The internal structure of Venus*

ⓘ Quick Facts

- ✪ **Distance from the Sun:** 0.7 AU
- ✪ Time taken by light to travel from the Sun to Venus: 6 minutes
- ✪ Surface temperatures: 471° C (hence there is no potential for life)
- ✪ Atmosphere: Thick layer of carbon dioxide and clouds of sulphuric acid.

⭐ Unique Features

Venus rotates in a direction opposite to Earth's and the other planets, except Uranus, i.e., from east to west. Like Mercury, it is very slow in its rotation and takes approximately 243 Earth days to spin on its axis once. But because it is near to the Sun, it takes only 225 Earth days to revolve around it.

Since the length of a day and a year is almost the same, the Sun rises twice during a year even though the day has not changed. Since Venus rotates backwards, the Sun rises in the west and sets in the east!

◀ *Maxwell Montes, the highest mountain of Planet Venus*

Earth
The Habitable Planet

Earth, the third planet from the Sun, is the only known planet which is habitable by living beings. Liquid water is a crucial element that supports life, and so far, only Earth, the fifth-largest planet, has water on its surface. Amongst the four inner planets—Mercury, Venus, Earth, and Mars—composed mainly of metal and rock, Earth is the biggest.

⭐ Structure and Appearance

Earth has four major layers—the central core, the outer core, the mantle, and the crust. The solid core, where temperatures are really high, comprises iron and nickel. The outer core surrounding the inner one comprises molten iron and nickel. The mantle is sandwiched between the outer core and a fairly deep layer of crust.

Earth's surface is covered with mountains, valleys, volcanoes, and flat plains. The crust and the upper mantle of Earth form the lithosphere. It is broken up into giant plates. Earthquakes are caused by the shifting of these plates. Seventy per cent of Earth's surface is made up of oceans that contain 97 per cent of the planet's water.

▶ *Sometimes mountains such as the Himalayas are formed due to the plates ramming into each other*

⭐ Unique Features: Potential for Life

Earth has several ideal conditions or features that help support life on the planet. Besides liquid water, Earth's atmosphere is also important as it acts like a protective blanket around the planet. The atmosphere comprises 78 per cent nitrogen, 21 per cent oxygen, and 1 per cent other gases. This is a perfect balance of crucial gases to enable us to live and breathe. The average surface temperature on Earth is roughly 14°C, which is perfect for sustaining life. If there was no atmosphere, the temperature would have been much lower and unsuitable for living things. Water is able to exist in its liquid form for long periods due to the ideal temperature that is maintained by the atmosphere. Besides nourishing life on Earth, our atmosphere also protects us from the harmful radiation of the Sun. Although it is not very thick, it is sufficient to help burn up most of the meteoroids before they impact us on Earth. Another advantage of our atmosphere is that it is conducive for Earth's climate and weather.

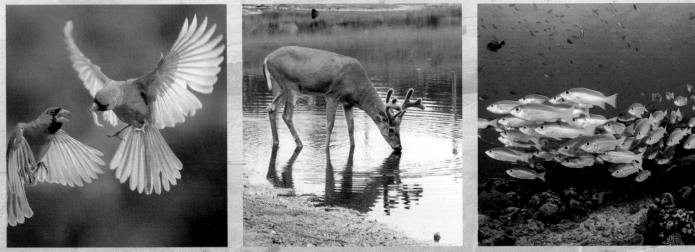

▲ *The planet is home to several diverse species of living beings*

◀ *Earth as seen from space*

ⓘ Quick Facts

- ✪ **Distance from the Sun:** Precisely 1 AU or 150 million kilometres

- ✪ Time taken by light from the Sun to reach Earth: 8 minutes

- ✪ Average surface temperature: 14°C

- ✪ Number of Moons: Unlike some planets that may have multiple Moons, Earth only has one

⭐ Earth's Magnetosphere

The region around a planet that is ruled by the planet's magnetic field is known as a magnetosphere. The magnetosphere of Earth is an extensive, comet-shaped bubble and is an important factor that makes our planet habitable. While the other planets also have magnetospheres, amongst the rocky planets, Earth's magnetosphere is the strongest. The magnetosphere initially helped in developing life on Earth and continues to support and sustain it. It also acts as a protective shield against solar and cosmic radiation and prevents destruction of the atmosphere due to solar winds.

◀ *Earth's magnetic field is mostly caused by electric currents in the liquid outer core*

👍 In Real Life

The first creature or 'earthling' to orbit Earth in 1957 was the dog Laika. She did not survive the journey. Some years later, Belka and Strelka, two Soviet dogs, were the first living creatures to successfully return alive from space. This paved the way for human beings to explore the cosmos.

▲ *Strelka at Moscow's Memorial Museum of Cosmonautics*

Earth's Imaginary Lines

Did you know that Earth has imaginary lines running east-west and north-south to help pinpoint a location on it and tell time? Some imaginary lines are more important than others.

▲ *Prime Meridian (Greenwich)*

⭐ Latitude and Longitude

The horizontal lines which run east-west are called latitudes and those that run north-south are longitudes. Together, using the latitude and longitude, we have formulated a grid system which helps us to find the position or location of any place on Earth's surface. The most important latitude is the equator (0° latitude). It is a circle around Earth, equidistant from the north and south poles. It divides Earth into the northern and southern hemispheres. The other latitudes are a measurement to locate a place north or south of the equator.

Longitudes, also known as meridians, help measure the location of a place lying east or west of the **prime meridian**. The prime meridian is the most important longitude because it is the 0° longitude. It passes through the Observatory of Greenwich and divides Earth into the eastern and western hemispheres. In 1884, it was agreed upon as the prime meridian during an international conference in Washington, USA.

▲ *The Earth's axis*	▲ *Longitude lines*	▲ *Latitude lines*	▲ *Earth's Equator*

⭐ Universal System for Measuring Time and Date

Two longitudes which help establish a standard system for keeping time and date across the world are:

- The prime meridian or 0° longitude, which is the specially designated imaginary north-south line that passes through both the geographic poles.

- The International Date Line (IDL) or 180° longitude, which is another imaginary line running from the North Pole to the South Pole, but located on the opposite side of Earth from the prime meridian.

▼ *Royal Greenwich Observatory, London is the home of time and space*

⭐ International Date Line (IDL)

The IDL is a standard embraced globally. It was established in 1884 and passes through the mid-Pacific Ocean, zigging and zagging to keep nearby nations on their own day and date. When one crosses the IDL, the day and date change.

⭐ Establishing Time Zones

It was important to have a global standard of time and the need was felt particularly in the 19th century with the advent of the railways and other new industries. Sir Sandford Fleming (1827–1915) first created a system of using 24 standard time zones in 1876 and though not recognised by any global official body, by 1900 it led to the refined version and adoption of the time zone system used around the world today. Within each time zone, the clocks would be set at an average time that most closely reflected where the Sun was located in the sky.

The prime meridian serves as the basis for the world's standard time zone system. International time is measured in time zones which are 15 degrees apart (360 degrees divided by 24 hours equals 15 degrees per hour). They are numbered by the hour, starting from the prime meridian. So, the clock in Greenwich shows what is known as Greenwich Mean Time, now called the Universal Time Coordinated (UTC). This system makes it easy to calculate the time in other zones.

For example, Germany, which is one time zone east of Greenwich, will be labelled as 'GMT+1'. So, if the time in Greenwich is 10:00 a.m., the time in Germany will be 11:00 a.m. (10:00+1 hour).

California, which lies eight time zones to the west of Greenwich, will be labelled as 'GMT - 8'. So, the time in California will be 2:00 a.m. (10:00-8 hours).

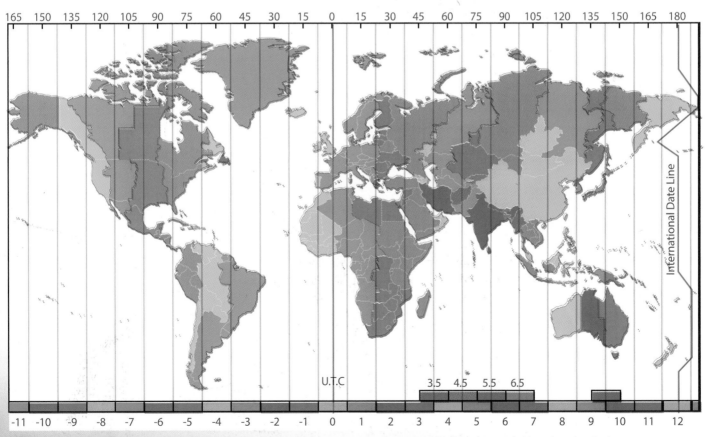

▲ *World time zones mapped on a flat surface. The time zone of each part can be determined by the colour-coded key placed at the bottom*

Earth's Movements

Earth's movement on its axis and around the Sun causes day and night and the seasons we experience. How does this happen?

⭐ Earth's Rotation

All planets rotate or spin on their own axis. Earth's rotation on its axis is what results in the phenomenon of day and night. When Earth rotates, one half of the planet faces the Sun at a particular time. The part that faces the Sun has light and experiences day, while the other half, which is in darkness, experiences night.

If observed from a point above the North Pole, you will see that Earth rotates in a counterclockwise fashion, from west to east. This is known as **prograde rotation**. Due to this direction of Earth's spinning, we see the Sun rising in the east every morning and setting in the west every evening. **Retrograde rotation**, on the other hand, is when a planet rotates in a clockwise direction.

Earth takes 23 hours and 56 minutes to complete one rotation, which makes up 24 hours, or one day and one night. However, since Earth's axis is slightly tilted at an angle of 23.44° and is not at a right angle with the Sun, not all places on Earth receive 12 hours of light and 12 hours of darkness every day.

Due to this tilting of Earth, there is a variation in the amount of daylight some parts of the planet receive. At the equator there is hardly any variation, but it is greatest in the region of the poles. Due to this, the poles never experience complete darkness during summers nor complete light during winters.

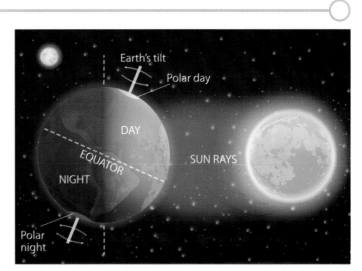

▲ *The illustration shows the 24-hour day-and-night cycle of Earth*

👤✓In Real Life

The word Earth is derived from Old English, Dutch, and Germanic words: eorthe, aarde, and erde respectively. Interestingly, unlike the other planets in the solar system, Earth's name does not originate from Greco-Roman mythology. The symbol often used to denote Earth is ♁.

▲ *The various seasons of Earth: spring, summer, autumn, and winter*

⭐ Earth's Revolution

Earth revolves around the Sun in an elliptical or oval-shaped orbit. It takes nearly 365.25 days to complete one full revolution. Since our calendar year comprises only 365 days, every four years an extra day called the leap day is added to the month of February to make up for the difference. That is why during a leap year, February has 29 days instead of 28.

The four seasons of spring, summer, autumn or fall, and winter are experienced on Earth due to two factors: the tilt of the planet and its rotation. The changing seasons do not depend on Earth's distance from the Sun.

Since Earth's axis is tilted and always points in the same direction, we have seasons. Starting from December for a period of approximately three months, people living in the northern hemisphere will experience winter, since during this time the Sun shines here indirectly. Meanwhile, those living in the southern hemisphere will experience summer, since it receives direct heat and light from the Sun during this time.

The opposite happens in the months beginning from June onwards, which is when the southern hemisphere will experience winter and the northern hemisphere will have summer for the same reasons.

However, you will experience the four seasons only if you are living in the middle latitudes (places which are not near the poles or the equator). If you live closer to the equator, you will experience hardly any change in the seasons and the duration of daylight and darkness will almost be the same the whole year. Such places mostly remain warm throughout the year and typically have alternating rainy and dry seasons.

▲ Fresh snow is typically 90-95% of trapped air

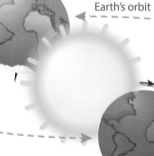

▶ Earth's seasons in the northern hemisphere

Equinox
21 March

Earth's orbit

Solstice
21 June

Solstice
22 December

Equinox
23 September

👤 Isn't It Amazing!

If you look very closely at a snowflake, you will find that it has a very pretty and delicate pattern. Snowflakes are usually hexagonal in shape and are formed by crystals of ice. Their sizes and shapes depend on the temperature and quantity of water vapour available as they grow.

▼ Sunflowers are famous for their heliotropism- the tendency to track the Sun

Earth's Moon

Earth's Moon is the brightest and largest object seen in the night sky from our planet. It plays an important role in making Earth habitable for all life on the planet.

⭐ Formation, Structure, and Appearance

The Moon was formed when a body the size of Mars banged into Earth about 4.5 billion years ago. The debris that was generated collected together to form the Moon. Just like Earth, its Moon has a core, mantle, and crust. It has several inactive volcanoes.

Since the Moon has a very scanty atmosphere, asteroids, meteoroids, and comets constantly strike at its surface and create craters and due to a weak gravity, astronauts on the Moon tend to bounce around.

◀ *Structure of the Moon: crust, mantle, and core. The size of its core is only about 20% the size of the Moon*

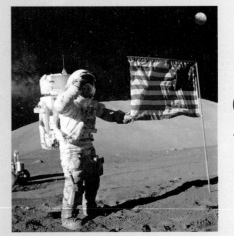

▲ *Neil Armstrong after landing on the moon: 'One small step for man, one giant leap for mankind.'*

⭐ The Importance of the Moon

The Moon is important because:

- It is the only place in space beyond Earth where human beings have landed
- It helps decrease Earth's wobble on its axis and helps create an equitable climate
- It is responsible for causing the tides.

⭐ Lunar Eclipse

A lunar eclipse takes place when Earth comes in the way and prevents the Sun's light from reaching the Moon. So on such nights the full Moon is not visible because Earth's shadow covers it.

At times, the Moon may appear red during an eclipse. This is because Earth's atmosphere absorbs the other colours from the Sun's light while it bends the light in the direction of the Moon.

Although the Moon orbits Earth every month, a lunar eclipse does not take place every month. This is because the path of the Moon around Earth is tilted in comparison to Earth's orbit around the Sun and it does not always get inside Earth's shadow. So, even when the Moon's position is behind Earth, it can still receive light from the Sun.

▼ *Lunar eclipses only occur during a full moon*

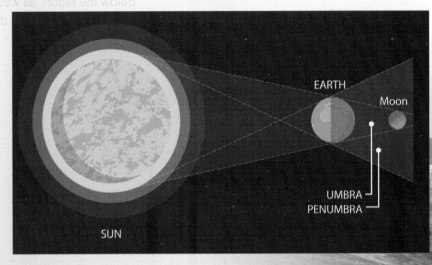

EARTH

Moon

UMBRA
PENUMBRA

SUN

Viewing the Lunar Eclipse

Viewing a lunar eclipse is exciting and also special since it does not happen every month. It is a popular space activity that people go to watch. If you are located on the side of Earth that is experiencing night when the eclipse takes place, you will be able to view it.

To remember the difference between a solar eclipse and lunar eclipse, you should recall their names. Solar means Sun; during the solar eclipse, a shadow is cast on the Sun. Lunar means Moon; during a lunar eclipse, a shadow is cast on the Moon.

▲ Lunar eclipses are more widely visible than solar eclipses

⭐ Oceanic Tides

Tides are the rise and fall in the level of water in the oceans. They are caused because of Earth's rotation and the gravitational pull of the Sun and the Moon. Since the Moon is much closer to Earth, its gravitational pull is much stronger than the Sun's.

Tides are cyclical in nature—as the Moon rotates around Earth and the position of the Sun changes, the water levels in the sea constantly rise or fall. This cycle takes place either once (diurnal) or twice (semidiurnal) in a day.

High tide (when water comes gushing on to the shore) is caused by the gravity of the Moon on the part of Earth directly below the Moon, as well as on the opposite side of Earth. Low tide (when water recedes from the shoreline) takes place on the parts of Earth that are 90 degrees away from the Moon.

▲ The outermost crust of the Moon has endured several asteroid impacts that have led to craters on its surface

▼ Some waves, called Tsunamis, are caused due to underwater earthquakes as well

Phases of the Moon

Did you notice that the Moon appears to be a different shape every other night? Does it seemingly disappear from the night sky? In reality, the Moon does not change shape at all.

⭐ 'Changing' Moon

The Moon does not emit light by itself. 'Moonlight' is actually the Sun's light reflected off the Moon's surface. Since it orbits Earth, different parts of the Moon get illumined by the Sun each night, which is why we see the different shapes.

The Moon completes one orbit around Earth in 27.3 days, but since Earth is also travelling around the Sun at the same time, it takes the Moon 29.5 days to go through the entire 8 phases that make up a lunar month. As it orbits Earth, we see varying combinations of the lit and dark parts of its surface. Specific configurations of dark and light are known as the Moon's phases.

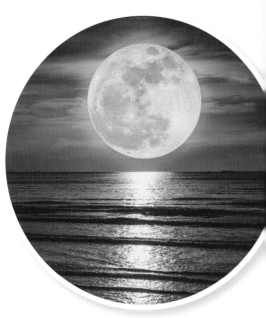

▲ *A beautiful moonlit night*

▶ *Phases of the Moon*

First Quarter

In this phase, one half of the Moon is lit and it looks like the letter 'D'.

Waxing crescent

Waxing means the visible illuminated area increases from one day to the next and when part of the Moon's edge is lit but the rest of the surface appears dark.

Waxing Gibbous

In the waxing gibbous phase, the lit part of the Moon "is greater than a semi-circle but less than a circle."

Full Moon

The full Moon occurs when the Moon is on the opposite side of Earth from the Sun and we can see the complete illuminated round disc of the Moon.

New Moon

The new Moon occurs when the Sun and Moon are on the same side of Earth and we see only the dark side.

Waning Gibbous

Waning means the visible illuminated area decreases daily and the illuminated part of the Moon looks similar to waxing gibbous, but on the opposite side.

Last Quarter

In the last quarter, half of the Moon is illumined, looking like an opposite 'D'.

Waning Crescent

In the waning crescent phase, the illumined part of the Moon looks like the letter 'C' but most of the visible surface is dark.

Exploring Mars: The Red Planet

Mars is half the size of Earth. It is a cold desert world. It has clouds, winds, seasons, polar ice caps, volcanoes, canyons, and approximately a 24-hour day. This variety in features makes Mars one of the most explored bodies in the solar system.

⭐ Structure and Appearance

Its dense core is made up of iron, nickel, and sulphur. Its outer crust comprises iron, magnesium, aluminium, calcium, and potassium. A rocky mantle lies between the core and the crust. Mars appears to be red due to the rusting of iron found in the rocks, soil, and dust. The red dust flies into the atmosphere and makes the planet appear red.

👤 Isn't It Amazing!

For the first time ever, sounds of the winds on the surface of Mars were captured and shared by NASA's InSight (Interior Exploration using Seismic Investigations, Geodesy and Heat Transport) lander in December 2018.

▲ *NASA's InSight lander is the first outer space robotic explorer for Mars*

▶ *The red planet Mars is named after the Roman God of War*

⭐ The Mystery of Mars

Billions of years ago, Mars may have had water and maybe even rivers and oceans. While there is still some water found on Mars, the atmosphere is too thin for it to last for a long time on its surface.

Since water is a prime indicator and essential pillar of life, this question of whether Mars supported microscopic life forms in the past remains a topic of debate.

① Quick Facts

- **Distance from Sun:** 1.5 AU
- Time taken by light from the Sun to reach Mars: 13 minutes
- Temperature: 20° C to 153° C
- Atmosphere: Thin layer of carbon dioxide, argon, nitrogen, some oxygen, and water vapour

⭐ Incredible Individuals

German astronomer Johannes Kepler (1571–1630) is best known for discovering the three main laws of planetary motion. When Kepler discovered them, he did not call them 'laws' but considered them to be 'celestial harmonies' reflecting God's creation and design of the universe. They were recognized as laws after Isaac Newton expanded on them based on general physical principles.

Jupiter
A Giant among Planets

Jupiter is by far the largest planet in the solar system! It is approximately 139,820 km wide at its equator and more than twice the size of all the other planets put together.

⭐ Structure

Like the Sun, Jupiter is composed mainly of hydrogen and helium. Due to an increase in pressure and temperature in the atmosphere, it compresses the hydrogen gas into liquid form. This has resulted in Jupiter having the largest ocean in the solar system made up of hydrogen (not water). Scientists believe that halfway through the planet's centre, the pressure is so high that the liquid core gets charged and becomes a conductor of electricity.

Jupiter rotates very fast (taking about 10 hours to spin around once), and this causes electrical currents in this region. This fast movement is also thought to generate the planet's strong magnetic field. It has not yet been confirmed whether Jupiter has a central core that is solid, or one that is a thick, extremely hot, and dense liquid.

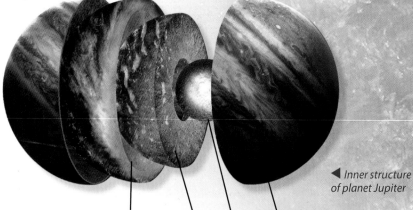

◀ Inner structure of planet Jupiter

Liquid hydrogen metallic hydrogen core cloud layers

⭐ Appearance

Jupiter is a planet with colourful cloud bands and spots. Jupiter's atmosphere comprises three layers of clouds. The top layer is perhaps made of ammonia ice; the middle layer of ammonium hydrosulphide crystals; and the last layer of water ice and vapour. It does not have a solid surface.

Its brightly coloured bands may be caused by gases that contain sulphur and phosphorus, which rise up from the warm interior of the planet. It spins so fast that it generates powerful jet streams which distinguish the band of clouds into dark and bright regions. The planet is also characterised by exceptionally high-speed winds, especially at its equator.

Jupiter is a gas giant, it does not have a solid surface, but mostly comprises spiralling gases and liquids. A spacecraft would not have anywhere to land on Jupiter and would most likely disintegrate if it tried to land due to the planet's extremely hot temperature. The cloud temperature is about -145℃.

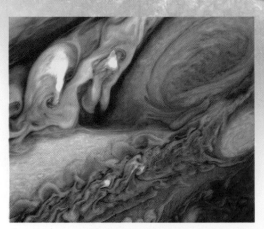

▲ Jupiter's atmosphere from Voyager 1

⭐ Unique Features

Jupiter's cold whirling clouds and stripes made up of ammonia and water floating around in the atmosphere are its distinctive features. It is also known for its 'Great Red Spot'. This is a huge storm that has been swirling around for hundreds of years on the planet's surface. Jupiter is quite similar to a star but it did not get big enough for it to start burning like most stars do.

It has the shortest day in the solar system, lasting only 10 hours; however, it takes 12 Earth years or 4,333 Earth days to revolve around the Sun due to its size and distance from the Sun!

It is believed that by exerting its gravitational force on asteroids in the asteroid belt, Jupiter protects Mercury, Venus, Earth, and Mars and prevents large asteroids from crashing into them.

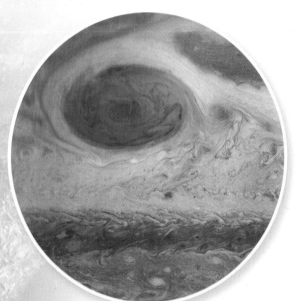

▲ *Jupiter's famous eye-shaped Great Red Spot*

👋 In Real Life

Jupiter's rings were discovered in 1979 by NASA's Voyager 1 spacecraft. Scientists were surprised by this discovery, since they comprised of small, dark particles which are not so easy to see except when the Sun lights it up from the back.

ⓘ Quick Facts

- ✪ **Distance from the Sun:** 5.2 AU

- ✪ Time taken for light to travel from the Sun to Jupiter: 43 minutes

- ✪ Moons: 79 confirmed moons; the four largest being—Io, Europa, Ganymede, and Callisto, also known as Galilean satellites since they were first observed by astronomer Galileo Galilei in 1610 using one of the earliest telescopes. Ganymede is Jupiter's largest moon and also the largest moon in the solar system

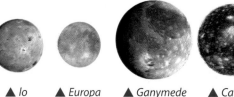

▲ *Io* ▲ *Europa* ▲ *Ganymede* ▲ *Callisto*

Saturn
The Ringed Giant

With a diameter of about 116,460 kilometres, Saturn is the second-largest planet in the solar system. It looks regal and grand because of the icy rings that surround it.

⭐ Structure and Appearance

Saturn, a gas giant, comprises hydrogen and helium and has a dense center of iron and nickel. The speed of wind in the upper atmosphere can reach 1,800 kilometres, which is much greater than the most powerful winds generated by hurricanes on Earth. This is unique to Saturn within the solar system. Saturn's atmospheric pressure is so great that it forces gases to turn into liquid. Saturn has clouds, jet streams, and storms surrounding it and often takes on shades of yellow, brown, and grey.

▶ *The internal structure of Saturn*

▼ *Saturn's rings are made of bits of ice, dust, and rock*

👤 Isn't It Amazing!

The average density of Saturn is less than water. This means that if Saturn were put into a giant bathtub, it would float! Density is the amount of mass in a specified space. The denser an object, the less likely it is to float.

① Quick Facts

- ⚙ **Distance from Sun:** 9.5 AU
- ⚙ Time taken by light from the Sun to reach Saturn: 80 minutes
- ⚙ Moons: 53 confirmed moons and twenty nine more awaiting confirmation

⭐ Unique Features

Saturn has amazing rings comprising billions of pieces of ice and rock covered by dust. Some of these pieces are as large as mountains. The rings orbit the planet at different speeds and extend for nearly 282,000 kilometres from the planet! Most of the rings are fairly close together, except for a gap known as the Cassini Division between rings A and B. Rings A, B, and C are the main rings. Rings D, F, G, and E are fainter.

Saturn's atmosphere has a hexagon-shaped or six-sided jet stream which stretches for around 30,000 kilometres across, consisting of extremely high-speed winds and a swirling storm in the center. This feature is unique to Saturn and is not found anywhere else.

⭐ Incredible Individuals

Italian-born French astronomer, Gian Domenico Cassini (1625–1712) discovered four of Saturn's moons and found the dark gap between Saturn's rings A and B called the Cassini Division. He found the shadows of Jupiter's satellites, the flattening of its poles, and calculated the time taken by Mars for one rotation.

Uranus
The Planet that Spins Sideways

A cold and windy ice giant, Uranus is the seventh planet from the Sun and also the third largest from the Sun.

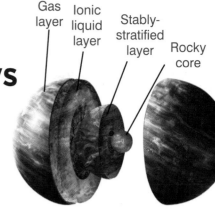

Gas layer | Ionic liquid layer | Stably-stratified layer | Rocky core

▲ *Internal structure of Uranus*

⭐ Structure and Appearance

It has an extremely hot (4,982° C), small rocky core. 80 per cent of its mass comprises a hot dense fluid of 'icy' materials including water, methane, and ammonia. Uranus does not have any land surface but is mainly a body of billowing fluids.

After Saturn, it is the second least dense planet. The atmosphere comprises hydrogen and helium, with small amounts of methane, water, and ammonia. Light from the Sun gets reflected back by the cloud cover of Uranus. The methane gas in the atmosphere absorbs the red part of the light and reflects a blue-green colour. Hence, Uranus appears to be bluish-green.

In a fly-by of Uranus in 1986, the spacecraft Voyager 2 noticed discrete clouds, the Great Dark Spot, and a few small dark spots. Recently, more vigorous clouds and some quick-changing bright features have been seen. Winds on Uranus can reach speeds of 900 kmph. The planet has 13 dim rings.

▼ *Astronomer William Herschel (1738–1822) discovered the planet Uranus*

▲ *After Voyager 1, NASA's Voyager 2 is the second spacecraft to enter interstellar space*

⭐ Unique Features

Uranus rotates sideways on its axis at an almost 90° angle from the plane of its orbit. This unusual tilt makes it seem as if the planet is spinning on its side and causes the most extreme seasons found in the solar system.

Uranus was discovered in 1781 by astronomer William Herschel without a telescope. He thought it was a comet or a star. However, two years later it was recognised as a new planet by astronomer Johann Elert Bode, who gave it its name. Uranus and Venus are the only two planets that rotate from east to west.

▲ *Johann Elert Bode is also known for determining the orbit of Uranus*

ℹ Quick Facts

- ⚙ **Distance from the Sun:** 19.8 AU
- ⚙ Time taken by light from the Sun to reach Uranus: 2 hours and 40 minutes
- ⚙ Planetary atmosphere: A minimum temperature of -224.2° C
- ⚙ Moons: 27 confirmed moons named after characters from the works of William Shakespeare and Alexander Pope

Neptune
The Windy Planet

The last major planet and farthest away from the Sun is Neptune.
It is more than 30 times farther than Earth. It is the only planet which cannot be seen by the unaided eye and was actually discovered through careful mathematical calculations. Neptune has only completed one orbit around the Sun, in 2011, since its discovery way back in 1846. Each orbit takes 165 years to complete.

Mantle

Core

Outer atmosphere

▲ *Inner structure of Neptune*

⭐ Structure and Appearance

Very similar in structure to Uranus, Neptune is mostly made up of dense fluids of 'icy' material comprising water, methane, and ammonia which surrounds a small rock-like core. Neptune is the densest planet amongst the giant ones.

Underneath Neptune's cold clouds, scientists think that there may exist an ocean of extremely hot water which does not boil and evaporate due to the intense high pressure that keeps it locked in. This planet too does not have a solid surface but has an atmosphere of hydrogen, helium, and methane, which is quite extensive. This slowly merges into water and other melted ice lying over a heavy, solid core, whose mass is the same as that of Earth.

Neptune is a cold, dark planet. It is so far from the Sun that during peak midday, the sky looks like it is almost time for the Sun to set. Since it is so far away, light from the Sun hardly reaches it. In fact, the sunlight we see on Earth is 900 times brighter! Unlike Uranus, which looks bluish-green in colour, Neptune appears to be bright blue.

▼ *Neptune is about four times wider than Earth*

⭐ Unique Features

Neptune has supersonic gusts of wind swirling around it. In fact, it is the windiest planet in the entire solar system. Even though it is so far away from the Sun and only receives very low energy inputs from it, the planet's wind speeds are three times stronger than those of Jupiter and nine times stronger than those seen on Earth. Neptune's winds travel at a speed of 2,000 kmph.

The Great Dark Spot, an oval-shaped storm, was discovered in 1989 in the planet's southern hemisphere and was so huge that it could hold the whole of Earth in it. That storm has since died but there are new ones which keep forming in different regions.

Triton, the largest moon of Neptune, is a very icy cold body and is the only large-sized moon that orbits its planet in a direction opposite to the planet's rotation. This indicates that earlier it may have been a separate object but was later seized by Neptune.

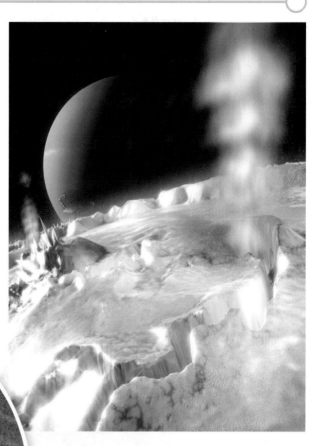

▲ Neptune seen from its moon Triton's icy surface

▶ *The Great Dark Spot of Neptune*

ⓘ Quick Facts

- ✪ **Distance from the Sun:** 30 AU
- ✪ Time taken for light from the Sun to reach Neptune: 4 hours
- ✪ Moons: 14 moons, named after lesser sea gods and nymphs from Greek mythology

👤✓ Isn't It Amazing!

Neptune experiences seasons similar to what we have on Earth since its axis of rotation is tilted at around 28° in relation to the plane of its orbit around the Sun. This is similar to our planet. The only difference is that one year—or the time taken by Neptune to revolve around the Sun—takes 165 Earth years or 60,190 Earth days. The four seasons, therefore, last for more than 40 years on Neptune!

The Kuiper Belt and the Oort Cloud

Beyond Neptune, the farthest planet from the Sun, there exists a ring of icy objects known as the Kuiper (pronounced Kai-pur) Belt. Beyond the Kuiper Belt lies the region known as the Oort Cloud. Comets originate from these regions.

⭐ The Kuiper Belt

The Kuiper Belt, a doughnut-shaped region, comprises pieces of rock, ice, comets, and dwarf planets including Pluto, Eris, Makemake, and Haumea. It is one of the largest structures in the solar system. The floating objects in the Kuiper Belt are known as Kuiper Belt objects (KBOs) or trans-Neptunian objects (TNO).

🔬 Isn't It Amazing!

In January 2019, NASA's New Horizons mission revealed the first detailed pictures of Kuiper Belt object Ultima Thule—the farthest object ever explored. This was a momentous accomplishment in the history of space exploration—no other spacecraft team has been able to trace such a tiny object moving at such great speed, located so far in outer space.

▲ NASA's New Horizons was the first mission to explore the Kuiper Belt. In 2015 it flew past dwarf planet Pluto, which is its most famous object

🎖 Incredible Individuals

Dutch-American astronomer Gerard Peter Kuiper (1905–1973) is well-known for several significant astronomical observations and discoveries. Between 1944 and 1949, he discovered the presence of methane gas in the atmosphere of Titan, Saturn's moon; correctly predicted the presence of carbon dioxide in Mars's atmosphere, and discovered that the rings of Saturn comprised ice particles.

In 1943, Kenneth Edgeworth (1880–1972), an Irish astronomer, had guessed that the solar system's smaller bodies extended beyond Pluto, but it was Kuiper who made a stronger case for their existence in 1951 and proposed the possible presence of this disc-shaped belt of comets orbiting the Sun. This was confirmed in the 1990s and the Kuiper Belt was named after him.

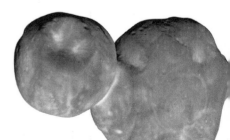

▲ The lobes of Kuiper Belt Object Ultima Thule came together in a gentle collision

⭐ The Oort Cloud

It is a huge spherical bubble surrounding the Sun, planets, and KBOs. It lies very far away; way beyond Pluto, on the outermost edges of the Kuiper Belt. It comprises ice-like bodies that can be larger than a mountain. It was named after Dutch astronomer Jan Oort who first suggested its existence in 1950.

Scientists think that the Oort Cloud may contain trillions of cold icy objects. Sometimes, some force disturbs these bodies and they begin to fall towards the Sun. ISON and Siding Spring are two examples of comets that originated from the Oort Cloud. ISON was destroyed on its way to the Sun, and Siding Spring may not return to the inner regions of the solar system for about 740,000 years.

Since this region is extremely far away, it has never been directly observed or discovered. Numerous comets originating from the Oort Cloud have been studied, but no space missions have been sent there.

🏅 Incredible Individuals

Jan Hendrik Oort (1900–1992) was a Dutch astronomer whose work in the 20th century helped us understand the Milky Way galaxy better. In 1927, Oort was able to confirm the theory that the Milky Way rotates in its plane around the center. He used radio astronomy to calculate the distance of the Sun from the center of the galaxy (30,000 light years). Radio astronomy is the study of celestial objects according to the radio-frequency energy emitted or reflected by them.

▶ The New York Times called Jan Hendrik Oort "one of the century's foremost explorers of the universe"

👤 In Real Life

The Oort Cloud is so far away that it would take the spacecraft Voyager 1 around 300 years to reach the inside of the Cloud, travelling at 1.6 million kilometres per day. It is so thick that it would probably take another 30,000 years to get to the farthest side of the Cloud.

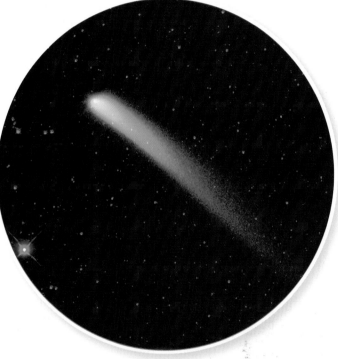

▲ Comet Siding Spring was discovered on 3 January 2013

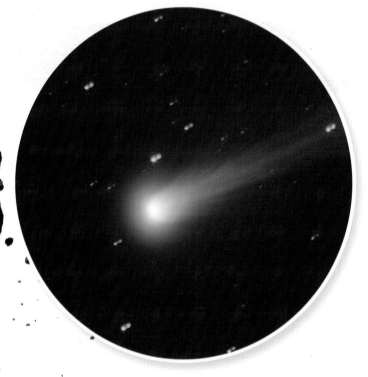

▲ Comet ISON was discovered on 21 September 2012

The Dwarf Planets

Planets which did not quite make the cut of a 'regular' planet are dwarf planets. Pluto, Makemake, Haumea, Eris, and Ceres are dwarf planets. Ceres lies in the asteroid belt between Mars and Jupiter. All the others lie in the Kuiper Belt.

⭐ Pluto

Earlier classified as the ninth planet, Pluto was officially reclassified as a dwarf planet in 2006 by the International Astronomical Union (IAU).

Pluto has multifaceted features including tall mountains, long troughs and valleys, plains, large craters, and perhaps glaciers. It has a rocky core covered with a mantle of water ice. A thin layer of methane and nitrogen ice covers its surface.

It has a thin atmosphere of molecular nitrogen and traces of methane and carbon monoxide. Its atmosphere tends to expand when near the Sun but breaks down when far away. Closer to the Sun, the surface ice sublimates— it changes directly from a solid to a gaseous state. Unusually, Pluto orbits around the Sun on an elliptical path and is tilted.

⭐ Eris

Eris is one of the largest dwarf planets. Scientists are not sure of its structure, but it seems to have a rocky surface and its surface temperatures may range from -217°C to -243°C. Eris is so far away from the Sun that when it travels closer to it during an orbit, its icy atmosphere actually begins to thaw out. Due to the heat from the Sun, the atmosphere of Eris collapses. Then, when its distance from the Sun increases again, the atmosphere becomes frozen and falls to the surface as snow. Again, when it gets closer to the Sun, the atmosphere melts. One revolution around the Sun takes 557 Earth years. This dwarf planet has one moon.

⭐ Haumea

Haumea is approximately the same size as Pluto. It is one of the fastest rotating large objects in the solar system. This spin causes its shape to appear distorted like a football. Not much is known about its structure, surface, or atmosphere, but it may have a rocky surface with a layer of ice. One revolution around the Sun takes 285 Earth years. Since it spins so fast it finishes one rotation in four hours. It has two moons.

Pluto

Eris

Haumea

⭐ Ceres

Ceres is the largest body in the asteroid belt between Mars and Jupiter. It makes up 25 per cent of the region's mass. It is the only dwarf planet which lies in the inner solar system and was the first object to be discovered there in 1801.

Ceres is more like the four terrestrial planets than its asteroid neighbours, only less dense. It has a layered interior, a solid core, and a water-ice mantle. Its crust is rocky, dusty, and has deposits of salts. The surface of Ceres is dotted with numerous small but young craters.

Ceres has a thin layer of atmosphere and there is proof to show that it contains water vapour, which makes it interesting to scientists who are keen to explore it.

Makemake

👤 Isn't It Amazing!

Scientists think that the asteroid belt has a minimum of 40,000 asteroids that are 0.8 kilometres wide! Sometimes planets exert so much gravitational pull on an asteroid that it gets sucked from its belt and begins to orbit around the planet, just like a moon.

⭐ Makemake

Makemake is smaller than Pluto and the second brightest after Pluto, when seen from Earth. Not much is known about its structure. It cannot be studied in detail due to its distance, but it seems to have a reddish-brown colour. Frozen methane and ethane have been discovered on its surface. It may have a thin atmosphere of nitrogen. One revolution around the Sun takes 305 Earth years. One day on it is similar to a day on Earth.

🏅 Incredible Individuals

At the age of 25, Soviet cosmonaut Gherman Stepanovich Titov (1935–2000) became the youngest person to travel to space aboard the Vostok 2 mission in 1962. He piloted the first manned spaceflight of more than one orbit on the Vostok 2 spacecraft.

STARS AND GALAXIES

THE AMAZING WORLD OF STARS

Some of the brightest celestial objects that light up our night skies are the infinite and shining stars. They have fascinated human beings since time immemorial and have played an important role in navigation and the study of our mysterious universe.

How many of these huge luminous balls of gas, composed mainly of hydrogen and helium, exist in the universe? Are they scattered randomly in space, or are they clustered together in dense groups? Besides the Sun, are the other stars really light years away?

The study of stars helps scientists understand the evolution of galaxies and life itself! So studying them and their life cycles is critical and central to the field of astronomy.

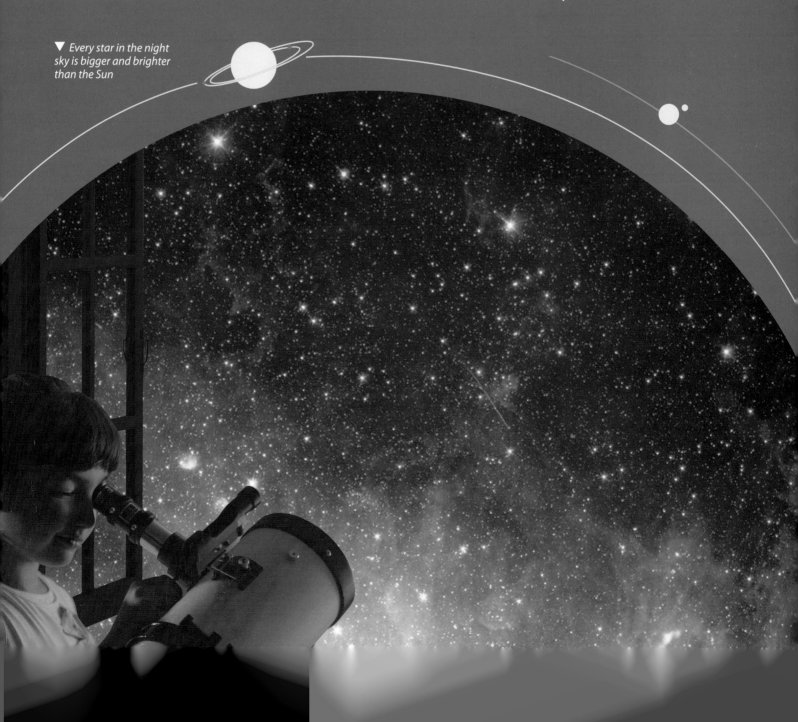

▼ Every star in the night sky is bigger and brighter than the Sun

Starstruck

Stars are the main building blocks of a galaxy. Astronomers and scientists have been studying stars for many centuries. By studying the age, distribution and composition of stars in a galaxy, scientists are able to glean important information regarding the history and evolution of that galaxy. Most of the stars that are observable from Earth lie in our Milky Way galaxy or in the Andromeda galaxy—a major galaxy closest to the Milky Way.

▼ The Sun's energy is produced by nuclear fusion at its core; it passes through the radiative zone and accumulates on the convection zone

Photosphere (6,500–4,000 K)

⭐ How I Wonder What You Are?

A star is a massive **self-luminous** ball made up of very hot gases (mostly hydrogen and helium). Stars shine and release energy by burning hydrogen into helium at their cores through a process known as **nuclear fusion**. Outside the core, energy is released outwards by a process called **radiation**. Closer to the surface, energy moves out by **convection** where hot gases rise, cool down, and then sink back to the surface.

All stars are not the same. They vary in appearance, size, mass, colour, temperature, etc. Stars exist either alone, such as the Sun, or in pairs or clusters. All the countless stars in the galaxies are generally studied and observed in comparison to the Sun.

Core

Radiative zone

⭐ Size

Though the Sun appears large, it is a medium or average-sized star and can also be referred to as an **intermediate-mass star** with a lifetime between 50 million and 20 billion years. Scientists have discovered stars that are less than half the mass of the Sun, called **low-mass stars,** and much bigger stars that are three times the mass of the Sun, called **high-mass stars**. Some stars have a diameter 100 times bigger than the Sun and are enormous, whereas some are one-tenth the size of the Sun. Stars are thus classified depending on their size into: dwarfs (low-mass—less than half the mass of the sun), giants (intermediate-mass—about 0.8 to 10 times the mass of the Sun) and supergiants (high-mass—more than 10 times higher than that of the Sun).

Wolf 359 The Sun Sirius

💡 Isn't It Amazing!

Scientists believe that the current age of the Sun is around 4.6 billion years. They believe that after 4.6 billion more years, the Sun will have used up all of its hydrogen fuel and the temperature of its core will increase by 100 million degrees!

⭐ Colour

All stars are hot, but they vary in the degree of their hotness. The temperature of stars determines their colour or appearance. The hottest stars appear white or blue. Stars with an orange or yellow hue are cooler in comparison and red stars are cooler still. Our Sun is classified as a yellow star on this spectrum.

Convection zone

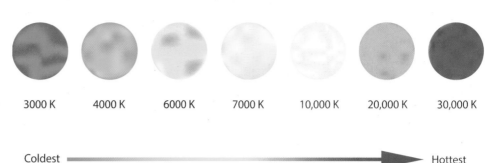

| 3000 K | 4000 K | 6000 K | 7000 K | 10,000 K | 20,000 K | 30,000 K |

Coldest ⟶ Hottest

▲ *Stars behave roughly according to the physics of blackbody radiation (changing colour as the temperature rises)*

⭐ Shining Bright

The brightness of a star depends on its **luminosity**, which is the amount of light emitted by an object in a unit of time. Luminosity depends on the radius of the star, its surface temperature, and its distance from Earth. Scientists use a luminosity scale of grades to distinguish stars. According to the luminosity scale, grade I is for supergiants, grade II for bright giants, grade III for normal giants, grade IV for subgiants, and grade V for main sequence or dwarf stars.

Flare

▲ *These luminous balls help scientists navigate the universe*

👤 In Real Life

In 2011, scientists discovered a brown dwarf star (CFBDSIR 1458 10b) and found that it was the same temperature as a freshly made cup of coffee! At a distance of 75 **light years**, with a surface temperature of 97° C, it is the coldest brown dwarf seen since then. It was also noted to be a failed star since it had heat and chemical properties like regular stars, but not enough mass for nuclear fusion at its centre.

⭐ Hot, Hot Star

Astronomers since the 1860s have classified stars and put them in an order depending on their spectral characteristics. The scheme of ordering stars based on their temperature and luminosity is referred to as a **stellar classification.** For example, the Sun is a yellow dwarf star with a surface temperature of about 5,500° C and is designated as G2 V, with G2 standing for the second hottest star of the yellow G class and the V representing the luminosity grade of a main sequence or dwarf star.

The Science Behind Stars

There are trillions of stars in the sky. These stars are massive in size and are made up of extremely hot gases. They have a long lifespan and do not burn up until after millions or billions of years in a slow process of evolution. They begin to burn up after all their fuel is used up. A star like our Sun would have a lifespan of about 10 billion years. So what are the scientific principles that keep a star together and can we really know how many stars exist in our universe?

⭐ Staying Intact

Stars produce tonnes of energy by burning a large amount of nuclear fuel within their cores. Have you ever wondered then, how such hot objects continue to shine for billions of years without exploding? Heat from the nuclear fuel burning in the star's core generates outward-moving pressure. On the other hand, each star's gravity exerts an inward force, trying to squeeze it into a small, tight ball. Therefore, a star is kept intact due to these two opposing forces.

A neutron star can remain intact even under rapid rotation. It does not break apart. Even a **black hole** would remain intact under such rotation, but it would not send any signal. 'Dead' stars are those that have used up all of their nuclear fuels. Sometimes they can actually produce more energy when they are dead than they did when they were 'alive'.

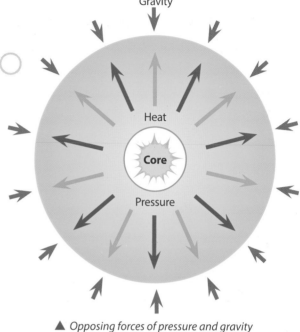

▲ *Opposing forces of pressure and gravity prevent a star from collapsing*

⭐ Stars Galore

Although there are trillions of stars in the observable universe, only a fraction of these are visible to the naked eye and we can never really count the number of stars that exist. On a clear and dark night, we can probably see only 3,000 stars without the use of a telescope.

In fact, our universe is so vast and expansive that it has more than 100 billion galaxies and each of these galaxies is most likely to have more than 100 billion stars!

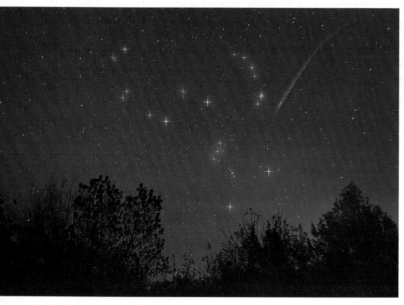

▲ *There are more stars than the collective grains of sand on all the seashores on Earth*

👤 In Real Life

Stargazing is an exciting and interesting hobby that can be taken up by anyone who wants to learn more about the stars. One does not necessarily need binoculars or a telescope (though these would help) to admire celestial objects or to view astronomical phenomena. A star atlas is also a handy tool.

Some stars can be seen by the naked eye. Once you get familiar with the star patterns or **constellations**, you can easily identify them. Well-known constellations like Orion the Hunter or the Little Dipper are two such star formations. If you are lucky, you may even be able to see the Andromeda galaxy—the most distant celestial object which can be seen by the unaided eye!

Ornaments in the Sky

Stars are so far away from Earth that they appear like tiny, shining diamonds in the night sky. But do stars really twinkle? Do planets twinkle? Why can we not see stars during the day?

⭐ Twinkle, Twinkle Little Star

Despite what the popular children's poem says, stars do not actually twinkle. Stars are located at such great distances that, even from a telescope, they appear as pinpoints of light in the night. Since all the light from a star comes from a single point, it only appears to twinkle when seen from Earth due to the effects of our planet's atmosphere. Atmospheric winds and differences in temperatures and densities affect starlight when it enters our atmosphere, causing the light from the star to twinkle when seen from the surface of Earth. This is known as astronomical scintillation.

▲ The Hubble telescope has managed to get clear images of stars because there is no atmosphere in space

▲ Planets can be seen as discs only through a telescope

⭐ Do Planets Twinkle?

Planets are closer to Earth than stars. When seen from a telescope, stars look like pinpoints, but planets appear as tiny discs. The light from planets is also distorted by Earth's atmosphere as it travels toward our eyes. But while the light from one edge of a planet may travel one way, the light from the opposite edge of the planet might go in the opposite direction. This refraction (slight change in direction) of light from different edges of a planet is such that planets appear to shine steadily. They do not twinkle.

⭐ Morning Sky

The gases and particles present in the atmosphere scatter sunlight in all directions. Blue light travels as shorter and smaller waves and is scattered more than the other colours. Blue light is much brighter than the dim light coming from the stars, and hence we cannot see the stars even though they are still glowing. If you were on the Moon, however, you would be able to see the stars all the time since the Moon does not have any atmosphere to distort the light originating from the stars.

▼ During the day, seeing a star in the blanket of photons from the Sun is like spotting a single snowflake in a blizzard

💡 Isn't It Amazing!

Did you know that stars in the sky 'make music' and they never stop playing this celestial concert? Stars have an umpteen number of different sound waves or different 'notes' bouncing around inside them. Bigger stars make lower and deeper sounds like a double bass, whereas smaller stars have higher-pitched tunes, like flutes. Unfortunately, you cannot hear this music with your ears; scientists are able to listen to these harmonies or sound waves using very powerful and sensitive telescopes. These harmonies help them in understanding various characteristics of the stars, such as their composition, size, age, and contribution in the evolution of the Milky Way galaxy. NASA's Kepler space telescope, which has now run out of fuel, and NASA's Transiting Exoplanet Survey Satellite (TESS) are two such pieces of equipment that can detect these stellar sound waves and vibrations.

Star Systems and Clusters

Galaxies are home to the stars. The Milky Way and the Andromeda galaxy consist of millions of them. Generally, stars exist in the universe either in pairs called a **binary system** or in clusters. Some stars, like the Sun, exist alone.

⭐ Binary Star System

A binary system is when two stars are bound together by gravitational forces and orbit around a common centre of mass. A large number of stars, perhaps one-half of all stars in the Milky Way galaxy, are either binaries or part of a complex multiple system.

▲ *These star systems often appear as a single point of light to the naked eye*

🏅 Incredible Individuals

Friedrich von Struve (1793–1864) was born in Germany but fled his country in 1808 in order to avoid getting enlisted for war by Napoleon's army. He first went to Denmark and later to Russia, which is where he spent most of his life. He is one of the great astronomers of the 19th century and the first generation of accomplished astronomers in his family.

He established and pioneered the study of binary stars. In 1824, he acquired a telescope which was far more advanced in technology than anything seen before. He used it for his unmatched survey of binary stars. In fact, he surveyed 1,20,000 stars in the Northern Hemisphere and measured 3,112 binaries, more than 75 per cent of which were still unknown at that time. His catalogue on binary-star astronomy, published in 1837, is a well-known classic.

⭐ Star Clusters

Star clusters are mainly classified into **open** and **globular clusters**. A star cluster is bound together by the mutual gravitational pull of its members and is physically related through a common origin.

The year 1847 marked the beginning of the study of star clusters in external galaxies. It was started by Sir John William Herschel (1792–1871) at the Cape Observatory in South Africa. He published a list of these clusters found in the Magellanic Clouds, the **dwarf galaxies** orbiting the Milky Way galaxy. In the 20th century, with the help of a large reflector and specialised equipment like the Schmidt telescopes, it was possible to extend this study and identify such clusters in more remote galaxies.

▼ *There are about 150 known globular clusters and over 1,000 known open clusters in the Milky Way galaxy*

⭐ Open Clusters

They are groups of young stars, usually containing a dozen or up to a few hundred members. They are generally found in asymmetrical arrangements.

The Pleiades and Hyades in the constellation of Taurus; Praesepe (the Beehive) in the constellation of Cancer and Coma Berenices ('Berenice's Hair' in Latin) are four such **open clusters** known to us from the earliest of times. The Pleiades has historic significance since people from some early cultures determined the start of their year with the rising of this cluster.

▲ The open star cluster of Pleiades is also called Seven Sisters or Messier 45

💡 Isn't It Amazing!

For centuries, astronomers and space lovers have hungered to see and understand the mysteries of the universe. The Hubble Telescope launched by NASA in 1990, helped astronomers achieve this goal. Hubble orbits Earth and since it is situated above our atmosphere, it is able to get a bird's eye view of the universe and send back thousands of useful images to Earth, without the distortions that would otherwise be seen if viewed from a telescope on the ground.

Hubble, which is nearly the size of a large school bus, is one of NASA's most successful and longest lasting missions. The photographs sent by Hubble have been vital in answering many questions that astronomers have had and continue to have about the universe.

◄ A model of the 3D Hubble Space Telescope; the Hubble orbits Earth at the speed of 17,000 miles per hour

▲ The Seagull nebula, a cosmic cloud, is one of the many sites of star formation in our galaxy

⭐ Globular Clusters

These, on the other hand, comprise older star systems containing hundreds of thousands of stars which are closely packed in a symmetrical, roughly spherical form.

Omega Centauri and Messier 13 in the constellation of Hercules are two examples of globular clusters visible to the naked eye as fuzzy patches of light. By the early years of the 21st century, over 150 globular clusters were discovered in the Milky Way galaxy. The study of open and globular clusters helped scientists

⭐ Associations

These are other groups of stars which are also recognised and are made up of a few dozen to hundreds of stars of similar type and common origin whose density is less than that of the surrounding field. Knowledge of the characteristics and motions of individual stars dispersed over a large area helped scientists in the discovery of stellar associations. In the 1920s, it was found that young, hot blue stars apparently grouped together. A Soviet astronomer, Victor Ambartsumian (1908–1996), suggested in 1949

The Birth of a Star

Like animals and human beings, stars also have births and deaths. However, stars live for and evolve over billions of years. If all of us lived for billions of years, like stars do, we would need numerous Earth-like planets to fit everyone in! Luckily, our universe has no such 'space' problems; moreover, it is constantly expanding. It is vast enough to contain billions and trillions of celestial objects and systems including stars, planets, and galaxies.

▼ *Space is colourful. It contains numerous colourful, nebulous stars and galaxies*

⭐ A Stellar Journey

The journey of a star is intriguing! Just like human beings go through major life stages like childhood, adolescence, and so on, the life cycle of a star also starts from birth, until it attains maturity, and then finally dies.
A star matures differently depending upon its size and the matter it contains. The larger the mass of a star, the shorter its lifespan.

⭐ The Beginning

Stars are born in the universe in a cloud of gas (consisting mostly of hydrogen and helium) and dust known as a **nebula**. Later, stars get scattered all across the galaxies.

Initially, the gas and dust in a nebula are spread far apart, but an invisible force called gravity starts pulling them together. It is this force by which planets or other bodies draw objects towards the centre or towards each other.

As these clumps of gas and dust get bigger and bigger, the gravitational force also gets much stronger, and finally, this cloud gets so big that it collapses from its own gravity. This cave-in causes the material at the centre of the cloud to become extremely hot and it begins to glow.

▲ *The Carina nebula in which you can spot several clusters of stars, including new stars*

▲ *Our galaxy has over 200 billion stars, and enough dust and gas to make billions more*

⭐ A Star is Born

A chemical reaction that converts hydrogen into helium takes place in the core of the cloud when the temperature reaches 15,000,000° C. This hot centre or core, known as the **protostar,** is the beginning of a new star and is the first step in its evolution. The glowing protostar keeps on accumulating more and more mass, depending on how much matter is available in the nebula. Once the mass has stabilised and it can take no more mass, it is known as a **main sequence star**. At this stage, the star will continue to glow for billions of years.

⭐ The Middle

Just like a car runs out of fuel, a star nearing its end almost runs out of fuel when most of its hydrogen has been converted into helium. This causes the star's core to become unstable and it starts to contract, while the outer shell (consisting mostly of hydrogen) begins to expand. Due to this expansion, the star begins to cool and glows red, becoming a **red giant star.** All stars evolve in the same way until the red giant phase.

▼ *A red giant star is either a low or intermediate-mass star*

⭐ The End

When a star becomes old and the red giant phase of its life is at an end, it begins to throw away layers of gas from its surface, leaving behind a hot and compact **white dwarf**. Generally, low-mass or **intermediate-mass stars** end up as white dwarfs. Not all stars follow the same evolutionary path. Instead, they go out with a big bang or **supernova**. These violent explosions leave behind a tiny core that may either become a **neutron star**, or a black hole. The highest mass stars become black holes, while stars with slightly lower mass become neutron stars.

The Life Cycle of Stars

Stars take different paths in their evolutionary cycles. Their life cycles are determined by their mass. We can roughly classify stars into two types—average stars and massive stars. The greater the mass, the shorter the life cycle.

Massive star

Red supergiant

Supernova

⭐ Main Sequence Stars

Like babies need their food to grow into adults, young stars or protostars develop into main sequence stars by gathering mass from the clouds where they are born. This is the main phase of a star when it actively generates energy. A star can glow and remain in this stage for a few million years to billions of years, depending on its mass and rate of conversion of mass into energy. Generally, very high-mass stars have a faster rate of converting mass into energy and hence they have a shorter lifespan. For example, a very luminous high-mass star in its main phase can burn energy 1000 times faster than the Sun. Its lifespan will be shorter in comparison to a low-mass star.

💡 Isn't It Amazing!

One sugar cube of neutron star material would weigh about 1 trillion kilograms on Earth—almost as much as a mountain!

Black hole

Neutron star

⭐ Stellar Black Holes

Stellar black holes are created when the core of a really massive dying star (having 20 times the mass of the Sun), collapses upon itself, causing a supernova. A black hole is a place in space where the pull of gravity is so strong (because matter is squeezed into such a minute space) that even light cannot get out. Since light cannot escape, black holes are invisible and cannot be seen directly. They can only be viewed through space telescopes with special tools.

When the core of a high-mass star collapses, it crushes electrons and protons to form neutrons, creating a neutron star. A neutron star is one of the densest objects that can be viewed directly by astronomers. Imagine an object the size of the Sun pressed into the size of a planet like Earth! Due to this, the gravitation on its surface is tremendous. A neutron star also has a very powerful magnetic field.

▼ *Neutron stars live up to around 100,000 to 10 billion year*

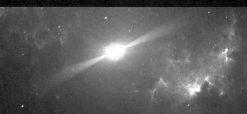

▲ *One black hole can pack more than thrice the mass of the Sun into the diameter of a city!*

▼ The light from stars takes millions of years to reach Earth. So some of the stars that we see in the sky may already be dead!

Average star

Red giant

As a star continues to glow and hydrogen is converted into helium at its core through nuclear fusion, the centre becomes unstable and starts to contract. The outer layer of the star (still mostly hydrogen), begins to expand. When this expansion happens, the star reaches the red giant phase, i.e. it cools and starts to glow red. It is red since it is cooler than the protostar and it is a giant because its outer shell has expanded. Almost all stars evolve the same way up to the red giant stage.

▲ Red giant fate of the Su 5 billion year

When all the hydrogen gas contained in the outer shell of a star blows away, it forms a ring around the core or centre and is called a planetary nebula.

r nebula

Planetary nebula

▲ Planetary nebulae were so nam early astronomers thought they loo planets through a small telescope

White dwarf

In the case of stars like the Sun, when only the hot stellar core is left behind and the outer layers have all gone, the burning and dense core is called a white dwarf star. This is the fate of only those stars with a mass up to 1.4 times the mass of the Sun. Did you know that the Sun will become a white dwarf billions of years later?

▲ White dwarf stars will live longer than their host galaxies

ⓞ Incredible Individuals

Stephen Hawking (1942–2018) was a much-admired English theoretical physicist of the late 20th and early 21st century. His best-selling book published in 1988 (also a motion picture)—*A Brief History of Time: From the Big Bang to Black Holes*—made him a celebrity. Hawking's main work revolved around the study of black holes, the remains from the collapse of giant stars. He also worked in the areas of general relativity, thermodynamics, and quantum mechanics in his attempt to understand how the universe was formed.

His achievements are all the more praiseworthy due to his battle with a degenerative muscular disease, which damaged his nerves and muscle system. The illness left him without the ability to write and he could barely speak. It forced him to be confined to a motorised wheelchair. Despite these setbacks, Hawking continued to pursue his pioneering work in the field of astronomy and popularised the subject.

▶ Doctors told Stephen Hawking that he wouldn't live past his early 20s

Nebulas: The Birthplace of Stars

Stars are born within nebulas found in interstellar space (region between stars). Astronomers have studied different nebulas in the Milky Way galaxy using powerful telescopes. They look like beautiful, delicate paintings with a vibrant array of colours.

▼ *The cloud associated with the Rosette nebula, a stellar nursery about 5,000 light years away from Earth*

⭐ What is a Nebula?

A nebula is a giant cloud of gas (hydrogen and helium) and dust from which stars are born. No two nebulas (or nebulae) look the same. They differ in appearance due to variations in temperature and density of the material observed and also on how the material is situated in space in relation to the observer.

Nebulas are often referred to as 'star nurseries' because they are regions where a new star starts to develop. Other nebulas are formed from the gas and dust which is generated when a star dies in a massive explosion known as a supernova.

Based on their appearance, nebulas are classified into dark nebulas and bright nebulas. The dark ones are irregularly shaped black patches in the sky and block out the light of the stars that lie beyond. The bright nebulas are fairly luminous, glowing surfaces either emitting their own light or reflecting light from nearby stars.

👥 In Real Life

Celestial photography or astrophotography is an interesting hobby or career that one can pursue. It involves clicking photographs of objects in space, such as stars, planets, comets, galaxies, and also events like eclipses, meteor showers, etc. Beautiful landscapes of the magnificent night sky can be captured on camera when it is less polluted. Many photographs which we get to see of the Milky Way and of star trails are taken by astrophotographers. Often, photographs clicked by astrophotographers give us an artistic view of the night sky and are such visual treats that they help generate excitement and interest in astronomy and the universe.

The Veil Nebula

National Aeronautics and Space Administration's Hubble Space Telescope discovered the Veil nebula, an exquisite remnant of one of the best-known supernovas caused by the explosion of a massive star 20 times bigger than the Sun. The star exploded between 10,000 and 20,000 years ago. The nebula gets its name from its elegant and beautiful structure and resides in the constellation of Cygnus, the Swan, about 2,400 light years away.

▼ *The Veil Nebula was first discovered by William Herschel, the same astronomer who coined the term 'planetary nebulae'*

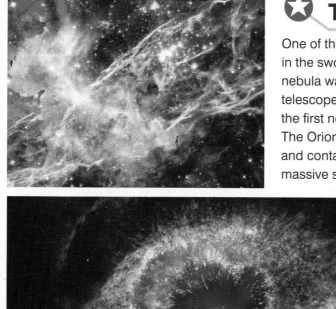

The Orion Nebula

One of the earliest observed nebulas was the Orion nebula, located in the sword of the hunter's figure in the constellation of Orion. The nebula was discovered in 1610, two years after the invention of the telescope, by French scholar Nicolas-Claude Fabri de Peiresc. It was the first nebula to be photographed in 1880 by Henry Draper in US. The Orion Nebula is approximately 1,350 light years away from Earth and contains hundreds of very hot young stars clustered around four massive stars known as the Trapezium.

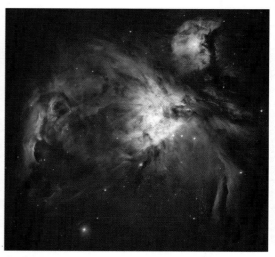

▲ *The Helix Nebula is nicknamed the 'Eye of God' because of its striking appearance*

▲ *The Orion Nebula is easy to find, even in moderate light-pollution*

The Helix Nebula

The Helix nebula is closest to Earth and is the largest known planetary nebula which is located in the constellation of Aquarius. It is nearly 700 light years away, so it would take a human being travelling at the speed of light about 700 years to reach there!

The Crab Nebula

In 1054 CE, Chinese astronomers recorded a bright supernova that gave rise to the Crab Nebula. The nebula, however, was first discovered by English astronomer John Bevis in 1731. It gets its name from the fact that its shape resembles a crab and it is filled with mysterious, thin thread-like structures. This nebula is about 6,500 light years away in the constellation Taurus.

◀ *The Palomar Observatory in California is home to the famous Hale Telescope, that has proved instrumental in cosmological research*

What's a Supernova?

High-mass stars die in a huge explosion called a supernova and finally end up either as neutron stars or as black holes. Supernovas are extremely important for scientists to study because they tell us more about how the universe was formed.

⭐ Another Star Bites the Dust

Supernovas are a class of violently exploding stars whose luminosity, after eruption, suddenly increases several million times. The term supernova comes from nova (meaning 'new' in Latin). Supernovas are characterised by a tremendous, rapid brightening which lasts for a few weeks, and then slowly dims down. A supernova explosion is catastrophic for a star and ends its active or energy-generating life. Massive amounts of matter, equal to the material of several Suns, may get blown into space when a star 'goes supernova'.

▶ *A supernova close enough to Earth could cause a mass extinction*

⭐ Supernova of a Single Star

There are two types of supernova. One occurs at the end of a single star's lifetime, when the star begins to cool down and runs out of its nuclear fuel, resulting in some of its mass flowing into its core, or in other words, the force of gravity takes over. The star cannot withstand its own gravitational force and collapses. This cave-in happens in a matter of 15 seconds and is so fast that it causes tremendous shock waves, resulting in the explosion of the outer part of the star. This leaves behind a dense core and an expanding cloud of dust and gas. If the star is a supergiant, its supernova can also create and leave behind the densest object in the universe—a black hole.

◀ *Stellar mass black holes are known as collapsars*

⭐ Supernova of a Binary Star System

Another type of supernova takes place in a binary system of stars when two stars orbit the same point and at least one of those stars is a white dwarf. If one white dwarf strikes against the other or if one of them sucks out or gobbles up too much matter from the nearby star, the white dwarf explodes, causing a supernova.

It is easier to spot and see supernovas in other galaxies rather than in our own Milky Way galaxy, since dust obstructs our view.

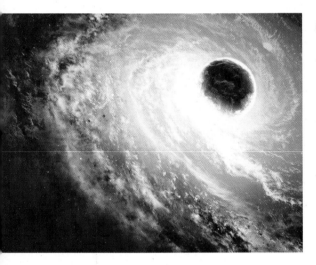

◀ *An illustration showing a white dwarf pulling matter from a companion star*

🎖 Incredible Individuals

In August 2018, NASA awarded its highest honour, the Distinguished Public Service Medal, to astronomer Yervant Terzian (1939–2019). He was honoured with this recognition for his dedicated contribution and impact on education, public service, and scientific research. He has played a huge role in inspiring young students as well as the public at large.

Much to his credit, Terzian had been part of eight NASA committees, including the Hubble Space Telescope Fellowship Committee. He is famous for his studies of stellar evolution and the discovery of regions of hydrogen gas between galaxies. This discovery indicated the presence of unseen matter in intergalactic space. He has authored and co-authored over 235 scientific publications!

▲ *A binary star system with a red dwarf and a blue giant*

⭐ Star Dust

Supernovas can lead us to a lot of important information. Supernovas involving white dwarfs are used to measure distances in space. Studying these stellar explosions also helped scientists in learning that stars are like factories of the universe, manufacturing vital chemicals within their cores like carbon, nitrogen, and oxygen—all life-forming elements that make up our universe.

Massive stars create elements like gold, silver, uranium, and platinum, which also aid the universe in creating generations of stars, planets, etc. Human beings carry some remains of these explosions in their bodies. In fact, everything in the universe is created from scattered star dust!

⭐ Studying Supernovas

Scientists at NASA use different types of telescopes to study supernovas. For example, the NuSTAR (Nuclear Spectroscopic Telescope Array) mission uses X-ray vision to investigate the universe.

◀ *A visual representation of the NuSTAR (Nuclear Spectroscopic Telescope Array) . The telescope was successfully launched on 13 June 2012*

💡 Isn't It Amazing!

Supernovas cast off or eject matter into space at a speed of 15,000 to 40,000 kilometres per second.

Homeless Stars

Galaxies are home to the stars. However, intergalactic (situated in or relating to the spaces between galaxies) stars do not have a home in a galaxy, although at one time they may have belonged to one. Some of these stars display unusual traits which make them stand out from the rest. Yet others streak across space at tremendous speeds.

⭐ What are Intergalactic Stars?

Rogue stars are created due to galaxy interactions and mergers which take place in the early phase of a galaxy cluster. During such interactions, stars are torn away from their home galaxies and thrown into intergalactic space, where they roam free from the gravitational pull of a galaxy.

Astronomers were able to learn more about these rogue stars by observing their motion and that of nearby galaxies. The motion of such rogue stars is governed by the gravitational field of the entire cluster, rather than the pull of any one galaxy. Therefore, scientists concluded that these stars are in between galaxies or 'intergalactic'.

▼ *Stars get sucked into a black hole due to the extreme pull of its gravity*

⭐ Outcast Stars

The Virgo cluster is the closest large cluster of galaxies. It is so huge that it contains over 2,000 galaxies! With the help of NASA's Hubble Space Telescope, scientists have so far discovered 600 such outcast stars in the Virgo cluster, which is 60 million light years from Earth. All of them are bright red giants.

▲ *Virgo cluster of galaxies has a diameter of 15 million light years across*

💡 Isn't It Amazing!

Despite travelling at hypervelocities, it would take a rogue star about 10 million years to travel from the centre hub of the Milky Way galaxy to the spiral's edge, 50,000 light years away!

⭐ Speedy Gonzales

A **hypervelocity** (extremely high speed) star is one which is kicked out from its galaxy at a speed exceeding the galactic escape velocity. Although it is not at all easy for a star to be ejected from its home, this happens when it gets extremely close to a supermassive black hole. This black hole lies in the centre of the galaxy. The star hurtles out with such force and travels at such high speeds that it escapes from the clutches of its galaxy's gravity.

In 2005, astronomers discovered the very first hypervelocity star. Much later, 16 other such hypervelocity stars were identified. In 2012, astronomers reported a group of more than 675 such rogue stars found on the periphery of the Milky Way galaxy. They claim these are hypervelocity stars which have been thrown out from the galactic core. These particular stars were selected by them due to their unusual red colour and their location in intergalactic space between the Milky Way galaxy and the Andromeda galaxy.

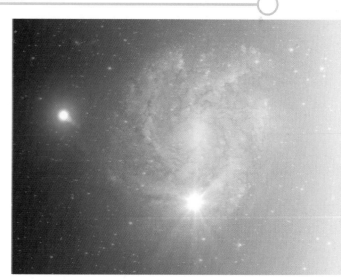

▲ *The bright spot on the top-left is a hypervelocity star. About two dozen such stars have been found leaving the Milky Way.*

⭐ Rogue Stars

Astronomers now know for a fact that massive black holes exist in the core of many galaxies. The Milky Way galaxy's black hole, in fact, is estimated to have a mass of four million solar masses. The gravitational pull around such huge black holes is so strong that they propel stars to hypervelocities.

Normally, for stars to go 'rogue' or attain hypervelocity, a binary pair of stars is required. When the pair gets entangled in the grip of the black hole, one star gets sucked in, while the other is flung out at great speed—much like what happens to a stone in a slingshot, but at a much, much faster speed.

Sometimes, a central black hole eats up another smaller black hole. Any star that comes too close to them will then encounter a hypervelocity kick.

▶ *A supermassive black hole is the largest type of black hole with mass millions to billions of times the mass of the Sun*

Starry Facts

Is the Sun the most important star in the universe? How does it compare with other stars? Almost all the stars that you see in the dark night sky are bigger and brighter than the Sun. A few of the faint ones are about the same size and brightness.

⭐ Sunshine

The star nearest to us is the Sun. The next closest star to Earth is nearly 250,000 times farther away. For us on Earth and for the solar system, it is the most important object. The Sun provides us with life-giving light, heat, and energy.

⭐ How Big are Stars?

Although the Sun is impressive, compared to the billions of other stars in the universe, it is not as special. The largest of stars may be as much as 3,218,688,000 kilometres away. If such a huge star were in the centre of our solar system, it would perhaps gobble up all the planets, including Earth! In comparison, the Sun is about 1,392,000 kilometres in diameter. This makes the Sun 109 times wider than Earth. Yet, it is an average-sized star in the universe.

▶ Betelgeuse, a red giant is about 700 times bigger than the Sun

Sun

Aldebaran

Rigel

Antares

⭐ Far, Far and Away

How far are the Sun and the other stars from Earth? They are very, very, very far away… much farther than you can ever imagine! The Sun, which is the closest to us, is 150 million kilometres from Earth. All the other stars are much farther away!

▶ *Earth orbits the Sun within the 'Goldilocks zone', where the temperatures are just right for water to remain liquid*

⭐ Hottest Objects

Stars are amongst the hottest objects found in space. The hottest stars can be almost 39,726° C. This big number shows us that stars are much hotter than anything we will ever experience on Earth. The Sun is about 5,504° C. So, in comparison to the hottest stars, it is much cooler, but still extremely hot. Much hotter than the temperature in an oven! And these temperatures are only at the surface. The cores of stars are even hotter. The mindboggling large numbers above give you an idea of how extremely hot stars like the Sun can get. Can you imagine what would happen if people got too close to the Sun?

The heat from a star also impacts the planets orbiting it. The closer the planets orbit near a star, the hotter they will be. In the case of our solar system, for example, Mercury and Venus are closer to the Sun than Earth, and are, therefore, much warmer than Earth. On the other hand, Earth is closer to the Sun than Mars and hence warmer than Mars. If a planet is too hot, all the water on it will evaporate. Imagine if that were the case on Earth, how would we live without water? If the planet is too far, it would be too cold to sustain life. Are we not lucky to be living on a lovely planet which is at just the right distance from the Sun? It keeps us warm and yet not too hot!

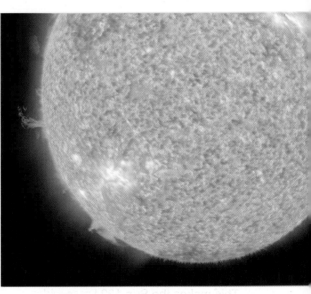

▲ *The Sun photographed by NASA's Solar Dynamics Observatory*

▲ *Betelgeuse*

💡 Isn't It Amazing!

If you were to visit the Sun and drive all the way around it in a car at a speed of about 97 kilometres per hour, without a break, it would take you five years to complete one round!

Stories from the Andromeda and the Milky Way

The Andromeda galaxy has a special significance in relation to the Milky Way galaxy. Not only is it a large and major galaxy closest to the Milky Way, but is also getting closer with time. The Andromeda galaxy is richly populated with stars that can be seen with the naked eye on moonless nights.

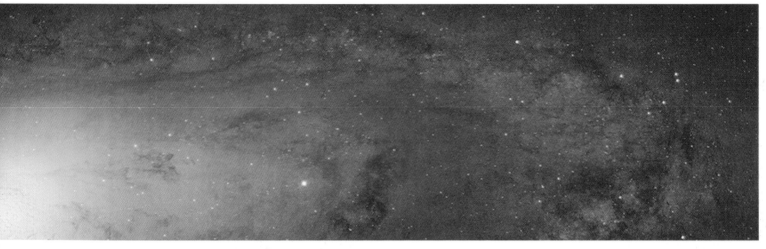

▲ *The largest image of the Andromeda galaxy taken by the Hubble Telescope.*

⭐ Star-packed Andromeda

Scientists have found densely packed stars in the innermost core of the galaxy. The outer disc was found to have far fewer stars. A majority of the stars in the centre of the galaxy are the cooler yellow ones (lower left side in the picture above). The outer blue, ring-like formation which extends from top-left to the bottom-right is the spiral arm of the Andromeda galaxy. It comprises numerous clusters of young, blue stars and star-forming regions. In January 2015, NASA's Hubble Telescope revealed that Andromeda has over 100 million stars and thousands of star clusters!

⭐ The Milky Way-Andromeda Collision

Scientists have found that the Milky Way galaxy and the Andromeda galaxy are moving towards each other at a very high speed, and are likely to collide eventually. However, the collision will not happen during our lives. The two galaxies will merge only four billion years from now, but is unlikely that the stars from Andromeda will hit our planet. We are told that the stars are very far apart from each other and will merely go past. Since galaxies are also made up of gas and dust, when the clouds collide with one another, they will create new stars.

◀ *The Andromeda galaxy is 2.537 million light ...s away from the Milky Way*

⭐ Incredible Individuals

Edwin Hubble (1889–1953) studied law only to please his father, who insisted upon it. After his father died in 1913, he followed his passion and studied astronomy in Chicago. He also served in the US army during both World Wars. Between 1923 and 1925, he was responsible for identifying a particular class of stars (Cepheid variables) in three nebulas and definitively proving that these were outside the Milky Way galaxy. This demonstrated that our galaxy is not the universe and that other galaxies exist outside the Milky Way. Hubble's study of galaxies also helped in developing a standard classification system of elliptical, spiral, and irregular galaxies which are spread out evenly at great distances. NASA's well-known Hubble Space Telescope is named after him.

◀ *The asteroid 2069 Hubble has also been named after Edwin Hubble*

Ancient Ideas and Uses of Stars

Have you ever looked up at the sky and felt a sense of wonder mixed with curiosity about the Sun, the stars, and the universe? You are not alone. For centuries, human beings have looked to the skies with a sense of mystery. Our ancestors used stars and **constellations** for several different reasons throughout history.

⭐ Stars and Religion

Probably the very first uses and ideas revolving around stars and constellations were religious. People thought that the Gods lived in the heavens and so, they must be responsible for making them.

Several cultures believed that the position of the stars was one way for God to tell them stories. Therefore, they started imagining shapes and giving names to star groups and telling stories about them. Most of our constellation names are derived from Greek culture and are named after mythological Greek heroes and legends. Different cultures gave different meanings to the same constellations.

💡 Isn't It Amazing!

Did you know that when you look out into space, you are actually looking back in time? This is because light emitted by very far-off objects, like stars and galaxies, takes a long time to reach us. By the time it does, we are actually seeing what the objects looked like a while ago and not what they look like in real time.

▲ *Ancient people looked to the Sun, stars, and planets for religious purposes, to foretell seasons, and for navigation*

⭐ Stars helped in Navigation

Long before radio navigation, radar, and global positioning system (GPS) technologies were invented, early seamen or mariners sailed using the Sun and the stars to guide them. Polynesians were able to sail across thousands of miles in the Pacific Ocean using their knowledge of stars and constellations. Ancient Minoans who lived on the Mediterranean island of Crete did the same. Polaris (the North Star) was often used to navigate since it was easy to locate in the Little Dipper constellation.

⭐ Stars and Agriculture

Early men used stars and constellations to decide what was the best time for sowing and harvesting. Constellations helped them gain information about each season. For example, they knew that when the Orion constellation was completely visible, winter was coming soon.

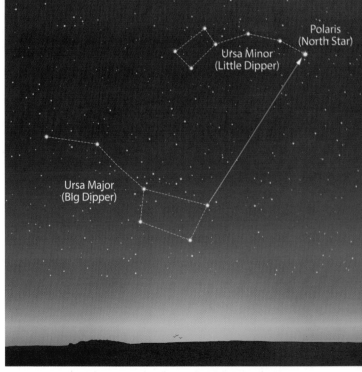

▲ *The Polaris or North Star helped early seafarers to navigate*

Stargazers

The theories about the laws of nature and how celestial bodies exist and function are numerous and as vast as our universe. Over centuries, with improvements in technology and the invention of sophisticated equipment like powerful space telescopes, better cameras, etc., more accurate studies have been possible than in the early days before such equipment was invented.

1546–1601

Tycho Brahe

Brahe was a Danish astronomer known for developing astronomical instruments and measuring and fixing the accurate positions of 777 stars.

1572: His discovery of a 'new star' brighter than Venus led him to upturn the then prevalent theory of inner and continuous harmony of the whole universe. This harmony was ruled by the stars, which were thought to be perfect and unchanging. Brahe's study of the dramatic changes in stars challenged this age-old law.

1573: He published his observations of the new star in *De Nova Stella*.

1730–1817

Charles Messier

He was a French astronomer who worked under Joseph-Nicolas Delisle, another noted French astronomer.

1758–1759: He was the first in France to spot the Halley's Comet and thus began his passion to look for new comets. He was responsible for locating 13 comets.

1760: He started making a list of nebulas to help differentiate them from comets. Many of them are referred to by using his catalogue system. He was the first to compile such a catalogue.

1738–1822

Sir William Herschel

Herschel was a German-born British astronomer and composer.

1781: He became famous for his discovery of the planet Uranus—the first planet to be located since prehistoric times.

1784–1785: He first suggested that nebulas are composed of stars and developed the theory of stellar evolution.

Edward Emerson Barnard

Barnard was a leading American astronomer of his time and a pioneer in celestial photography.

1889: He started photographing the Milky Way with a more technologically advanced camera, which helped reveal new data.

1892: He discovered 16 comets and Jupiter's fifth satellite.

1916: He discovered the star (Barnard's Star) that has the greatest known **proper motion** (motion of an individual star relative to other stars).

1919: He published a catalogue on dark nebulas.

Hans Albrecht Bethe

Bethe was a German-born American theoretical physicist who helped shape quantum physics.

1938: He studied and provided conclusive answers to the problem of energy generation in stars and explained how stars could burn for billions of years by specifying and analysing the nuclear reactions responsible for this.

1967: He was awarded the Nobel Prize based on his 1939 paper on energy generation in stars which helped create the field of nuclear **astrophysics**.

1857–1923 **1900–1979** **1906–2005** **1910–1995**

Cecilia Payne-Gaposchkin

Cecilia was a British-born American astronomer who discovered that stars are mainly made of hydrogen and helium. She also established that stars could be classified according to their temperatures.

1925: She published a thesis on stellar atmospheres.

1930: She studied the luminosity of stars and published a book titled *Stars of High Luminosity.*

Subrahmanyan Chandrasekhar

1931: Chandrasekhar said that a star with mass more than 1.44 times that of the Sun does not, in fact, form a white dwarf. Instead, it continues to collapse, blowing off its gaseous covering in a supernova explosion and becoming a neutron star. An even bigger star continues to collapse and becomes a black hole. His calculations contributed to our understanding of supernovas, neutron stars and black holes.

1983: He won the Nobel Prize in Physics for his theories on the evolution of stars.

Modern Star Discoveries

The study and science of astronomy is vast and never-ending. Every day, there are new discoveries being unravelled by scientists around the world. Here are some which will amaze you!

⭐ Silica Remnants Detected in Distant Supernovas

The next time you pick up a glass of water or walk down a road, remember that the materials used to make them were incubated billions of years ago by exploding stars!

Observations made by NASA's Spitzer Space Telescope have helped a new study reveal that silica—a key ingredient in sand and glass—is formed when massive stars exploding in a supernova. 60 per cent of Earth's crust is made of it. Besides in the manufacture of glass and sand-and-gravel mixtures for construction, silica has numerous other uses.

◀ *This image of the supernova remnant (G54.1+0.3) includes radio, infrared and X-ray light*

⭐ The Farthest Star Ever Spotted

Thanks to a rare and peculiar natural phenomenon that helped greatly magnify (by approximately 600 times) the star's feeble glow, astronomers were able to discover the farthest star ever seen. Helped by NASA's Hubble Space Telescope, the star (nicknamed Icarus) is located more than halfway across the universe. If not for this quirk of nature, this gigantic blue star would have been too faint to detect even with the world's largest telescopes. This discovery made in April 2018 has paved a new path for astronomers to study individual stars in far-off galaxies.

⭐ Star Cluster Spied in Nearby Galaxy

A gorgeous, diamond-studded cluster of stars was captured on camera in October 2018 by NASA's Hubble advanced-technology cameras. This globular cluster lies towards the centre of the Large Magellanic Cloud, a dwarf galaxy and one of Earth's closest neighbours. The galaxy is richly populated with numerous star clusters, making it an astronomer's dream lab for studying star formation. This cluster was first discovered in November 1834 by British astronomer John Herschel (1792–1871) and has been studied extensively since then.

▼ *A magnificent and glittering ball of stars lies in the centre of the Large Magellanic Cloud.*

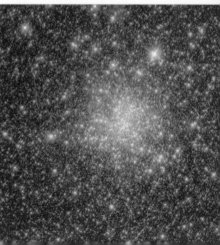

⭐ Mystery of Exploding Stars Solved

Scientists have now been able to solve the puzzle of what causes exploding stars which are used to measure the fast-paced expansion of the universe. An international study at the Australian National University (ANU) observed a small-sized star hurtling through our galaxy at breakneck speed. They concluded this star to be a fragment from a massive explosion that took place millions of years ago.

The supernova explosion took place in a binary system, where a super-dense white dwarf had run out of fuel and sucked mass from its giant star companion. The mass it gathered created a chemical reaction, causing a star piece to run away. The violent explosion also resulted in the destruction of the binary system. This runaway star caught the attention of scientists because it was hurtling around in the galaxy at an extremely high speed and seemed to have an unusual chemical composition.

▲ An artist's recreation of the Spitzer Space Telescope. It is an infrared space telescope that was retired in January 2020

◄ Supernova explosion of a white dwarf star around a giant red star. This is known as a Type Ia (one-A) supernova

⭐ Sub-Saturn like Planet Discovered around a Sun-like Star

The Indian Space Research Organisation (ISRO) discovered a sub-Saturn or super-Neptune sized planet having a mass of approximately 27 times that of Earth and a radii six times bigger, orbiting a Sun-like star. Till date, only 23 such planetary systems (including this one) are known. This discovery is crucial to understanding how such super-Neptune or sub-Saturn kind of planets, which are too close to the host star, are formed, as well as how planet-formations occur around Sun-like stars. With this study, India became one of the few countries which have managed to discover a planet around a star beyond the solar system. The apparatus used to make this discovery and to measure the mass of a planet with such precise measurements was designed in-house and is the first of its kind in Asia.

The Lucky Ones

An infinite number of stars exist within our universe. Some of them are better known than others because they are more easily visible with the unaided eye and are perhaps the brightest objects in the celestial sky. Most of them, therefore, also have been observed and studied for many years. So which are some of these lucky stars that have received so much attention and left human beings star-struck?

▲ *The Guiding Star or Polaris is 433 light years away from the Earth (North pole)*

★ Polaris

Polaris is the present North Star. It is so called because if you extend Earth's rotational axis from the North pole, it points towards the Polaris. Since it is the closest star to the North Pole, it has been used as a tool for navigation in the northern hemisphere and is also known as the Guiding Star. Due to the wobbling of Earth's axis, it will slowly start pointing away from the Polaris towards a new North Star around the year 14,000 CE.

▲ *Alpha Centauri is 4.3 light years away from the Sun*

★ Alpha Centauri

The Alpha Centauri is a triple star system and is the closest to the Sun. It consists of Proxima Centauri (its dimmest component) and its brighter components— Alpha Centauri A and B. When seen from Earth, it is the third brightest star after Sirius A, and Canopus. It lies in the southern constellation Centaurus. Alpha Centauri was designated as Rigil Kentaurus by the IAU in 2016; the word is of Arabic origin and means 'foot of the Centaur'.

▲ *Betelgeuse is one of the largest stars currently known.*

★ Betelgeuse

Betelgeuse is one of the most luminous stars seen at night and the second-brightest in the Orion constellation. It is a red supergiant and it sure is humungous, being nearly 950 times larger than the Sun! Its name comes from the Arabic word 'bat al-jawz', which means 'giant's shoulder'. Betelgeuse can be easily spotted due to its position in Orion and its deep red hue.

▲ *Sirius or the Dog Star—the brightest star seen from Earth.*

★ Sirius

Sirius is one of the most significant stars in the universe. It is the brightest star amongst all other stars seen from Earth. Ancient Egyptians called it Sothis and believed it to be the cause of the Nile floods, which always seemed to coincide with the first rising of Sirius in the year. It is a binary star in the constellation Canis Major. It has a radius 1.71 times that of the Sun. The name 'Sirius' is Greek for 'glowing' or 'scorching'.

▲ *Vega, as seen by NASA's Spitzer Space Telescope. It is also known as Alpha Lyrae*

★ Vega

Vega is the fifth-brightest in the night sky and the brightest star in the northern constellation, Lyra. It is located at a distance of approximately 25 light years, which makes it one of the Sun's closer neighbours. Vega is surrounded by a sphere of dust similar to the solar system's **Kuiper Belt**. Its claim to fame one day in the future will be that it will become the next North Star by 14,000 CE.

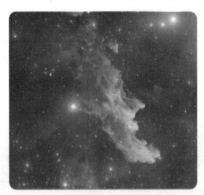

▲ *Rigel and the Witch Head nebula. The name 'Rigel' is Arabic for 'the left leg of the giant', referring to the constellation Orion*

★ Rigel

Rigel is one of the brightest bluish-white supergiants in the Orion constellation. It is 47,000 times more luminous than the Sun and is located at about 870 light years from it.

What's in a Name?

Stars have been named and catalogued since prehistoric times. The naming and cataloguing of stars plays an important role in the science of astronomy. It helps scientists and enthusiastic stargazers to accurately locate stars from anywhere on Earth. There has also been a tradition in both the scientific world and the general public to pay tribute to a person by naming a star after them.

▶ *The book written by Bayer catalogued stars visible to the naked eye*

★ History of Star Catalogues

For centuries, various cultures and civilisations all over the world have labelled and given names to the stars in the night sky. Many of these names have their origin in Greek, Latin, and Arabic cultures. Some of these names are in use even today. With the development of astronomy over the years, there was felt a need to have a universal cataloguing system, whereby the most-studied and brightest stars were referred to by the same labels, regardless of the country or culture from where the astronomers came.

The earliest known 'cataloguing system' which is still popular today, was created by Johann Bayer (1572–1625) in 1603, in his book *Uranometria*, a star atlas. He used lowercase Greek letters to label stars in each constellation roughly in the order of their observable brightness. So, according to this labelling system, the brightest star was generally labelled Alpha (though not always) and the second brightest was Beta and so forth. For example, the brightest star in Cygnus (the Swan) is Alpha Cygni. However, this cataloguing system ran into problems—the Greek alphabet had only 24 letters and was not enough to name the thousands of stars found in constellations; often due to inaccurate estimates and other irregularities, this system did not always work precisely.

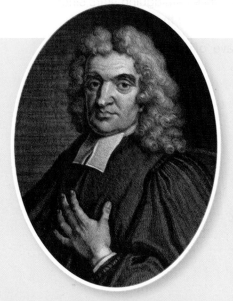

Nearly 200 years later, English astronomer John Flamsteed (1646–1719) started another naming scheme. From his observations at Greenwich, Flamsteed made the first main star catalogue (published in 1725, after his death) with the help of a telescope. The Flamsteed numbers as we know them now, however, were not assigned by him but by a French astronomer, Jerome Lalande (1732–1807) in his French version of Flamsteed's catalogue published in 1783.

◀ *John Flamsteed was the first Astronomer Royal of the Sovereign of the United Kingdom*

⭐ Incredible Individuals

Edward Barnard (1889–1953) began his career as a poor photographer. Much to his credit, he later became a well-known astronomer. He made his own telescope and discovered several comets. He went on to discover Amalthea, the fifth known moon of Jupiter. He studied the physical features of planets, comets, nebulas, and novas. One of the most important contributions made by him was the introduction of wide-field photographic methods to study the Milky Way. He also discovered, amongst other things, the star with the largest known proper motion, which has been named Barnard's Star after him.

▶ The Barnard star is a red dwarf 6 light years away from Earth

⭐ The Christening of Stars

To promote and safeguard all aspects of astronomy including research, communication, education, and development through international cooperation, an organisation was founded in 1919 known as the International Astronomical Union (IAU). The IAU consists of 13,701 individual members, who are professional astronomers from 102 countries; and 82 national members, that are professional astronomical communities representing their countries' affiliation with IAU. It is the internationally recognised authority for naming and giving designations and surface features to celestial bodies.

▼ An illustration of the Merz and Mahler refracting telescope at the Cincinnati Observatory in Ohio, USA

Very few stars which have cultural, historical, and astrophysical importance have proper names (e.g. Vega, Polaris, Betelgeuse). In the professional community, however, stars are assigned designations which are alphanumerical (e.g. HR 7001). This makes it easier to locate, describe, and discuss them.

These alphanumerical designations are usually sorted by the position of the star. This system has made it much easier to look them up in catalogues. Accurate positions found via catalogue numbers help facilitate precise identification and are beneficial especially while cataloguing stars since there are billions and trillions of them.

In fact, stars did not have 'official' names until 2016, which is when the IAU approved 227 common names for stars. Another 86 names drawn from other cultures like Australian Aboriginal, Hindu, Chinese, Mayan, South African, and a few others were added to this list in 2017.

💡 Isn't It Amazing!

The Ara constellation has a star known as Cervantes named after the Spanish author Miguel de Cervantes who wrote the famous novel *Don Quixote*.

CONSTELLATIONS

THE AMAZING WORLD OF CONSTELLATIONS

'Over the edge of the World now comes forth
Great Orion...
Hunter of the Stars...
Behold the gleaming star-fire of his sword!'

—Henry Wadsworth Longfellow, American poet

The poem refers to one of the famous star groups or constellations named after a Greek mythological character—Orion the Hunter. The symbolism and imagery in the poem reflect the importance given to stars and constellations in our culture. For centuries, people from the ancient and the modern world alike have been inspired by the stars and studied the constellations. They did this across the boundaries of countries and cultures.

Constellations were first studied for religious reasons. People believed that stars and constellations revealed important messages and stories about their Gods and Goddesses. Today, constellations are helpful to astronomers in identifying the stars located in the sky. They also provide hours of pleasure to stargazing enthusiasts.

▼ *Stargazing helps us appreciate the vastness of the universe*

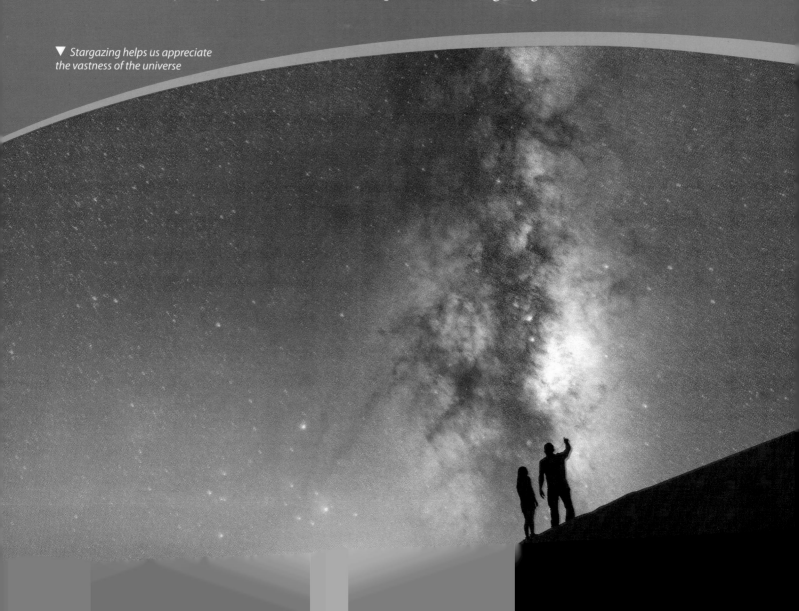

Constellations in the Sky

Since ancient times, human beings have gazed at the stars and looked to them for help in navigating across the mighty oceans. Stars were also used to predict the seasons and prepare plans for sowing seeds and harvesting crops. In order to easily recognise and gather information from this 'celestial calendar' in the skies, stars (brighter ones in particular) were grouped together as constellations and named according to their apparent shapes.

▲ The Canis Major constellation with Sirius, its brightest star

⭐ What is a Constellation?

In astronomy, a constellation is defined as a group of stars. They are not exactly real; in order to easily pick out the different stars in the night sky, people made up patterns of stars and named these patterns according to the apparent shapes that they took. These patterns might display objects, creatures, or mythical people. So, these star groups or constellations are named after those apparent shapes. For example, there are groups of stars which seem to take the shape of a big bear or a lion and a hunter.

⭐ Importance of Constellations

Constellations help in locating stars and mapping the night sky. For example, if you know enough about constellations, you might spot Orion one evening, by identifying three of the bright stars that form the Hunter's belt. Remember that Canis Minor and Canis Major are nearby. Without constellations, finding a speck of a star in the vastness of the night sky would be very difficult.

Constellations are also known to play a role in farming, agriculture, and navigation. Earlier, when there were no calendars, constellations and stars were the only way to identify the harvesting and sowing seasons. Besides, the position of the North Star allowed travellers to find their exact location and travel across the globe.

⭐ How many Constellations are there?

Officially, there are a total of 88 constellations, out of which 48 were identified by the ancient Greeks. Since some of the main constellations include more than one form or creature, the total number of shapes and images formed in these constellations is more than 88 and includes 9 birds, 2 insects, 19 mammals, 10 water creatures, 1 constellation shaped like a historical figure's hair, a serpent, a flying horse, a dragon, 2 centaurs (a mythological creature that is half-man and half-horse), 1 river, 29 inanimate objects, and 14 men and women.

⭐ Christening the Constellations

In ancient times, people named constellations after mythological creatures or characters, or even objects. Some were named after religious beliefs. Most of these star patterns do not exactly represent the names that were given to them. The names are suggestive. They were meant to be indicative, not representative.

▲ Ursa Major or the Great Bear constellation. Ancient Greeks associated the constellation with the nymph Callisto, who was positioned in heaven by Zeus in the form of a bear

APPROXIMATELY 20°

▲ *The Big Dipper as measured by its angle or distance between the two stars at the end of the constellation*

⭐ Measuring Constellations

When we discuss the size of a constellation, we are referring to how big it looks to us from Earth. But how much space does it occupy in the sky? Generally, astronomers use angles to measure the size and distance of a constellation. As an experiment, if you have two sticks which are joined together at one end, spread them apart so that each stick is pointing to the stars at the two ends of a constellation. Measure the angle in between them to get the angular distance between the two stars at the ends of the constellation. This is not an exact or accurate measurement. Take the example of the constellation shown in the diagram. You can see that the angle between the two lines is approximately 20°, which is the size of the Big Dipper, a bowl-shaped constellation.

⭐ Incredible Individuals

Friedrich Wilhelm Bessel (1784–1846) was a talented man with many astronomical accomplishments. Despite being born into a poor German family, he pursued his dreams and interest in travel, languages, and navigation. This led him to astronomy and mathematics. Impressed by his 1804 paper on the Halley's Comet, German astrologer Wilhelm Olbers recommended that he join the Lilienthal Observatory. Bessel had to make a tough decision—he could either stay with the company that had employed him and make a good living, or pursue a career in astronomy but remain in poverty. He chose the latter!

Bessel made many important contributions, including noting the precise measurements or positions of approximately 50,000 stars with his meticulous methods of observation. He thus established a new level of precision in astronomy. He was responsible for building Germany's first big observatory in Konigsberg.

▲ *Friedrich Wilhelm Bessel was the first astronomer to determine reliable values for the distance from the Sun to another star*

A Brief History

Who were the first people to think of or imagine the star patterns in the sky? Nobody can tell when and where constellations originated. Once there was a widespread belief that the ancient Greeks were responsible for the naming and identification of constellations. However, this belief has now been disproved. So, who exactly is responsible for coming up with constellations?

⭐ Who Made them Up?

The earliest systematic detailing of constellations was found in the poem, *Phaenomena*, written by a Greek poet named Aratus in 270 BCE. He described 43 constellations and named five stars. However, the system of naming and labelling constellations had started long before this. It was devised by the ancient Babylonians and Sumerians. The information about the constellations travelled to Egypt and was picked up by ancient Greeks, who began writing about them. The ancient Greeks were responsible for our contemporary system of constellations.

⭐ Major Contribution of the Greeks

While it is untrue that the ancient Greeks came up with the system of constellations, they were responsible for finding and naming many of them. Ptolemy was an Egyptian astronomer and mathematician of Greek origin who published the *Almagest* in 150 CE. Besides other astronomical information, it included a catalogue of 1,022 stars organised into 48 constellations. This was the most important list of constellations and stars. It laid the foundation of the modern constellation system. The remaining 40 constellations, of the total 88, were contributed by a few European astronomers.

▲ This picture is from the Epitome of the Almagest (1496), and shows Ptolemy and Regiomontanus. During the Renaissance, the book was one of the most important sources on ancient astronomy

◄ Claudius Ptolemy, the famous Egyptian astronomer and mathematician. Messier 7 is sometimes known as Ptolemy Cluster, an open cluster of stars in the constellation of Scorpius

How were Stars Named in Constellations?

The Greeks named and referred to stars by their location in a constellation. However, this was not always practical and could be quite a complicated practice. While describing the Aldebaran star, for example, Ptolemy mentions it as 'the reddish one on the southern eye'. In the 10th century, new star names were introduced by Al-Sufi, a well-known Arabic astronomer, in his version of the *Almagest*.

Nomadic Arabs often gave names to bright stars, for example Aldebaran and Betelgeuse (some were translated from Ptolemy's book). Much later, the works of Ptolemy and other Greek books were translated from Arabic into Latin and again introduced in Europe by Arabs. We are more familiar with Ptolemy's work due to the Arabic translation of his book into Latin. Therefore, we have a Greek system of constellations with Latin names and stars that have Arabic names!

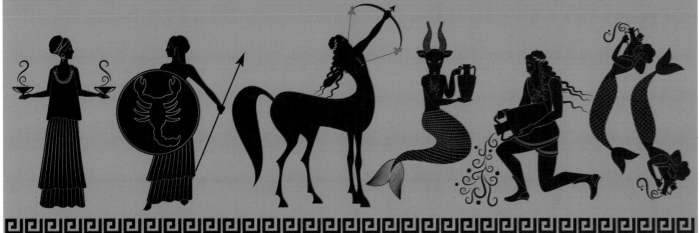

▲ *This illustration of a decorative border depicts the Greek myths associated with the last six signs of the zodiac*

⭐ Other Cultures and Constellations

People from many cultures and countries have visualised patterns in the stars; however, they often interpreted or saw them differently. For example, the Big Dipper is an asterism. An asterism is a smaller pattern of stars that might belong to a bigger constellation. Sometimes an asterism has stars that belong to more than one constellation. The Big Dipper is an asterism or a small pattern of seven stars, which is a part of the larger Ursa Major constellation. Different cultures tell different stories about them. The British seem to visualise it as the Plough. In the South of France, they call it a saucepan (la casserole). In Ancient India, the stars were referred to as the 'Saptarishi' or seven wise men and so on.

⭐ Incredible Individuals

French astronomer Nicolas Louis de Lacaille (1713–1762) is best known for mapping the constellations which are seen from the southern hemisphere. He is responsible for naming several of them. He was a professor of mathematics in Paris, but in 1741, he joined the Academy of Sciences. During 1750–1754, he headed an expedition to the Cape of Good Hope in South Africa. Here, within a short span of two years, he was able to pinpoint the positions of about 10,000 stars—many of them are referred to by using the numbering system in his catalogue even today. He returned to France in 1754 and worked alone on all the data he had gathered. It seems overwork and exertion were responsible for his death. In 1763, his *Coelum Australe Stelliferum* or *Star Catalogue of the Southern Sky* was published.

▲ *Nicolas Louis de Lacaille observed more than 10,000 stars using just a half-inch refractor*

Spotting Constellations

Some constellations are seasonal, but some can be seen year-round and appear to be fixed in place. The constellations that people can view also depend on the place and time when they are being viewed. Do you ever wonder why this is the case and why constellations appear to rise and set?

 ## Which Constellations can you Spot?

▲ *An old illustration depicting the constellations visible from the northern hemisphere and the southern hemisphere*

People in different parts of the world are able to view different constellations, depending on whether they live above the Equator or below it. All places above the Equator are part of the northern hemisphere, and all places below it are part of the southern hemisphere.

People living above the Equator will only be able to see the constellations that appear in the sky above the northern hemisphere. Similarly, people living below the Equator will only be able to see the constellations that appear in the sky above the southern hemisphere. If you live near the Equator, then you will be able to view some constellations from both the hemispheres.

Why do Stars Seem to Move Across the Sky?

Sometimes, stars seem to move across the night sky. To understand why it appears so and why everyone on Earth cannot see all constellations, we need to understand Earth's motions—its rotation on its own axis and its revolution around the Sun.

As Earth rotates, one side of it faces the Sun and the other side faces away from the Sun. So, the side facing the Sun receives light causing day, while the side facing away from the Sun does not receive light causing night. Though stars are always present in the sky, they are visible only at night, when Earth is facing away from the Sun's glare.

Earth's revolution around the Sun causes the seasons, such as monsoon, summer, and winter. Both aspects—the seasons and night and day, cause people in different parts of Earth to view different parts of the night sky during different seasons. This makes people think that stars are moving when, in fact, it is Earth that is moving.

▲ *Earth's rotation and revolution make stars appear to move across the skies, and hence not everyone can see all constellations all the time*

⭐ Circumpolar Constellations

Due to Earth's movement around its axis and around the Sun, most stars and constellations seem to rise and set. Hence, they shift in the night sky. However, in the northern hemisphere, a few constellations close to the North Star (Polaris), like Ursa Major, Ursa Minor, and Cassiopeia, are visible in the night sky on most days of the year. Even though they appear to spin a full 360° around Polaris during the night as Earth rotates around its axis, they will still always be visible above the horizon. These are known as **circumpolar constellations**. The stars farther away from Polaris will be visible above the horizon only for some part of the night, as they rotate in wider circles. In the southern hemisphere, the equivalent circumpolar constellations are Crux (Southern Cross) and Carina.

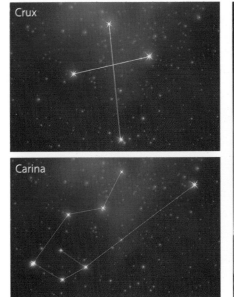

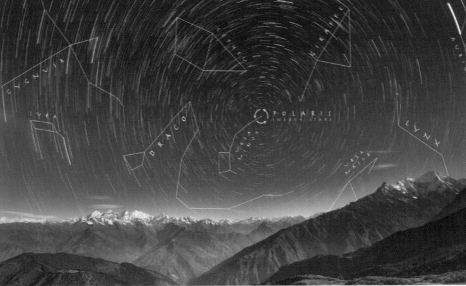

▲ The pictures show two circumpolar constellations of the southern hemisphere, Crux and Carina

▲ Circumpolar constellations in the northern hemisphere rotate around Polaris and can be viewed all through the year

In the northern hemisphere, constellations such as the Summer Triangle appear only in the summer season. This is because the Sun's glare makes them difficult to view during winters.

▲ The Summer Triangle in the northern hemisphere: Lyra or the Harp constellation with Vega, its brightest star; Aquila or the Eagle constellation with Altair, the brightest star which forms the eye of the Eagle; and Cygnus or the Swan constellation with star Deneb in its tail

💡 Isn't It Amazing!

For stargazing enthusiasts and astronomers, the year 2022 will be historic. For the very first time, scientists have been able to predict the birth of a new star. It will be born in the Cygnus constellation, which is the most visible one in the night sky. This extraordinary astronomical event is going to be a once in a lifetime experience, as people will be able to witness it without a telescope.

Star Maps

Star maps help astronomers and stargazers easily locate stars, constellations, and other celestial bodies. There are different types of maps. In ancient times, globes were more commonly used for the purpose. Star maps were also drawn, carved, and painted. Present-day maps are based on a system similar to geographic latitudes and longitudes. These maps are created from photographs taken by Earth-based equipment, or from images from satellites and spacecrafts.

▲ *Star maps served as important tools for navigators at sea*

 ## What is an Astronomical Map?

An **astronomical map** is a scientifically drawn map of stars and galaxies, but it also includes planets and their moons in the night sky. A typical map shows the relative positions of the stars and their brightness. To accurately locate stars and constellations, you need to have the correct map, depending on where you are located and the season when you are observing them.

 ## How to Find the Appropriate Map?

Generally, there are four different star maps—one for each season—winter, summer, spring, and autumn. The time of observation at night is also important. This is because stars are not stationary. In addition, Earth's revolution and rotation are factors that make it seem like the stars are moving across the sky. For example, if you plan to observe the sky at 9 pm, you should select a map that shows you the stars that will appear during that hour.

(star map illustration with labels: Ursa Minor, Ursa Major, Leo, Cancer, Gemini, Canis Minor, Canis Major, Orion)

🛡 In Real Life

Did you know that the art and science of creating maps is known as **cartography**? It is a branch of geography.

 ## ⭐ How to Use a Star Map?

Once you have been able to get a map aligned to the season and the time of your observation, you need to figure out the direction and match it to the sky. Most maps will indicate the directions north, south, east, and west. First, look for star patterns. Then find the brighter stars, which will be shown as big dots. The dimmer stars will be shown as tiny dots.

★ A Brief History of Star Maps

The very first Western maps of the skies above the northern hemisphere and the southern hemisphere depicting stars and constellations date back to the year 1440. They are currently preserved in Vienna. It is likely that these star maps were based on two charts from 1425, which are now lost. Well-known German painter Albrecht Durer drew the first printed star maps in 1515. In 1540, Alessandro Piccolomini came out with the first book of printed star charts, called *De le stele fisse*.

Till the end of the 16th century, star charts only comprised the 48 constellations recorded by Ptolemy. Later, in 1595, Pieter Dircksz Keyser added 12 additional constellations in the southern skies. Some of them are named after birds like the toucan, peacock, and the phoenix. In the 1600s, other astronomers were responsible for introducing the southern constellations through different forms of maps like globes and plates, including the one in the *Uranometria*, which is a star atlas by Johann Bayer, produced in 1603.

Cepheus

Cassiopeia

Pegasus

Aries

Pisces

◀ Some of the important constellations visible from the northern hemisphere in January

▲ Johann Bayer's Uranometria was the first star atlas. The illustration shows the constellation of Orion on a copperplate engraving from his book

▶ The Titan Atlas was condemned by Zeus to hold up the sky for eternity

💡 Isn't It Amazing!

The Farnese Atlas, a 2nd century AD Roman marble statue of the Titan Atlas, is the oldest surviving statue of the Olympian god. This oldest known depiction of the celestial spheres and the classical constellations has been kept in the National Archaeological Museum in Naples. The very first solid celestial globe was made in the 6th century BCE by Thales of Miletus.

Constellations in the Northern Hemisphere

Each of the two hemispheres have different celestial objects and constellations for you to marvel at. Some stars and constellations can be seen more clearly from the northern hemisphere. In the southern hemisphere, they would be quite low on the horizon, or not visible at all. The star map in the centre shows the constellations of the northern hemisphere.

◀ *A star map showing the constellations with their perceived shapes*

⭐ Polaris and the Three Circumpolar Constellations

One of the most popular and well-recognised patterns in the northern sky is that of the seven bright stars which form the Big Dipper, part of the Ursa Major or Great Bear constellation. The two stars (Dubhe and Merak) at the end of the bowl of the Big Dipper are also known as the pointer stars. If you draw a straight line through them, they will point you to Polaris or the North Star. It is located in the tail of the Little Bear or at the end of the Little Dipper in the Ursa Minor (Small Bear) constellation close by. If you extend that straight line from Polaris, you will see a constellation which looks like a 'W'. That is the constellation of Cassiopeia. Ursa Major, Ursa Minor, and Cassiopeia are circumpolar constellations. The extremely bright Polaris is one of the most striking sights in the northern skies. Incidentally, Ursa Minor is the third largest constellation in the sky.

▲ *Ursa Minor*
▼ *Ursa Major*

Mythology: The Big Bear and Little Bear originate from a Greek myth. The Greeks considered the two bears to be Callisto and her son Arcas. They were turned into bears by Zeus. They could also be referring to the two bears who saved the life of baby Zeus from his cannibalistic father. The long tails of the bears were said to have been the result of Zeus swinging them far up in the sky.

▶ *Constellations of the northern hemisphere*

▲ *The Andromeda constellation*

⭐ Andromeda

From Cassiopeia, if you look down to the right, you will find the Andromeda galaxy and close to it you will be able to identify a huge rectangle, which is the constellation Pegasus. Follow the left star at the base of the rectangle and you will be able to spot the Andromeda constellation. Alpheratz, which means 'the horse's navel' in Arabic, is the brightest star in this constellation. If you are lucky, you may even be able to spot a fuzzy oval in the sky, which is the amazing Andromeda Galaxy, the large galaxy closest to Earth.

Mythology: Andromeda represents the princess of Ethiopia who, according to the Greeks, was saved from a sea monster by Perseus.

💡 Isn't It Amazing!

It is believed that the luminosity of the Antares star—the brightest star in the Scorpius constellation in the Southern hemisphere—is 10,000 times greater than the Sun's luminosity.

▲ *The Cepheus constellation*

⭐ Cepheus

This constellation represents a king and is a dimmer constellation compared to many others. However, it is easily recognisable, being shaped like a stick house. In August and September, you will find Cepheus located on the upper right side of Polaris. The top of the roof generally points towards the Pole Star. If you are able to locate the more well-known Cassiopeia constellation, then you can spot Cepheus, which is a close neighbour. Alderamin is the brightest star in this constellation.

Mythology: It is named after the King of Ethiopia and father of Andromeda. He was forced to sacrifice his daughter to a sea monster.

Constellations in the Southern Hemisphere

No study of the constellations is complete without observing those in the sky above the southern hemisphere. When viewed from the south, northern constellations will appear upside down. Also, the northern circumpolar constellations like the Big Dipper, Cassiopeia, etc., become seasonal and Polaris cannot be seen at all.

Even if you think you know your constellations well, it isn't easy to spot them after a change in hemispheres. For instance, in the southern hemisphere, the Summer Triangle becomes the Winter Triangle and similarly, some of the other constellations point in different directions, compared to how you would see them in the northern hemisphere.

⭐ Canis Major and Sirius

If you look high up into the north-eastern sky, you will be able to find Canis Major to the right (south-east) of Orion. Also known as the Greater Dog, Canis Major can proudly boast of a star called Sirius, which is the brightest star in the dark sky. It is also the fifth-nearest to Earth. The Canis Major dwarf galaxy is also part of the Canis Major constellation and is the dwarf galaxy nearest to Earth. A dwarf galaxy is small when compared to other galaxies like the Andromeda or Milky Way. It consists of about a hundred million or a couple billion stars. On the other hand, the Milky Way galaxy consists of about 200–400 billion stars.

Mythology: Canis Major was considered to be Orion's hunting dog.

▲ Canis Major with Sirius, the brightest star in the night sky

⭐ Carina and Canopus

The second brightest star, Canopus is also found in the south in the constellation of Carina. You can spot Canopus by looking at an angle of 35° from Sirius. It can generally be viewed from October to May and is almost always seen when Sirius is visible. Earlier, Carina was part of a larger constellation called the Argo Navis. It was divided into three different constellations—Carina, Puppis, and Vela—by French astronomer Nicolas Louis de Lacaille.

Mythology: Carina was earlier a part of the Argo Navis constellation, named after the ship Argo. In an old Greek myth, Jason and the Argonauts went on this ship to rescue the Golden Fleece.

◀ Carina or the Keel constellation

⭐ Crux or the Southern Cross

The Southern Cross is the most familiar and well-known pattern in the southern hemisphere. It is the most striking feature of the Crux constellation with its five bright stars roughly forming the shape of a cross. Crux is the smallest constellation amongst all the constellations. Two of its brighter stars are Acrux and Gacrux, which point towards the southern celestial pole. A dark nebula, the Coalsack Nebula is also part of this constellation.

◀ *Crux or the Southern Cross*

⭐ Alpha Centauri: The Nearest Star System

It will be well worth your while to visit the southern hemisphere in order to see the closest star system to Earth, the Alpha Centauri. It also happens to be the third brightest star system in the night sky. Being circumpolar, you can see Alpha Centauri all through the year if you live south of the Equator. Sometimes in May, Alpha Centauri can be seen a few degrees above the southern horizon. It is part of the constellation Centaurus.

▲ *The Alpha Centauri star system is about 4.3 light years from Earth*

▲ *Constellations in the southern hemisphere*

👤✓ In Real Life

Interestingly, the five stars of the Crux appear on the flags of countries like New Zealand, Papua New Guinea, Samoa, Australia, and Brazil. They are also part of the national anthems of the latter two countries.

▶ *The Australian and Papua New Guinean flags depict stars from the Southern Cross*

Finding Stars & Constellations

Wouldn't it be fun if you could find and recognise stars and constellations in the night sky? One way of spotting them is by getting familiar with their names and remembering their shapes and relative sizes. You can begin by trying to identify constellations which can be seen by the naked eye. Some of them are Orion, Aquarius, Aquila, Aries, Canis Major, Cygnus (or Northern Cross), Leo, and Scorpius.

⭐ I Spy Cassiopeia, the Queen

An easy to find constellation consisting of five bright stars, roughly in the shape of a 'W', is Cassiopeia the Queen. Another way of spotting it is to see five stars that make up one narrow angle and one wide angle. Like Ursa Major, it rotates around the north celestial pole, and so it may appear as an upside-down 'M', during some parts of the year.

Mythology: Cassiopeia was a beautiful but vain Queen of Ethiopia. To punish her, Poseidon ordered that her daughter Andromeda be killed at the hands of a sea monster. Perseus managed to save Andromeda, but Cassiopeia plotted to kill him. To avenge himself, Perseus turned Cassiopeia into stone.

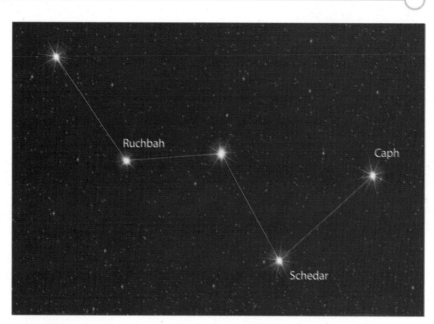

▲ *Cassiopeia or the Queen constellation in the northern sky during winter*

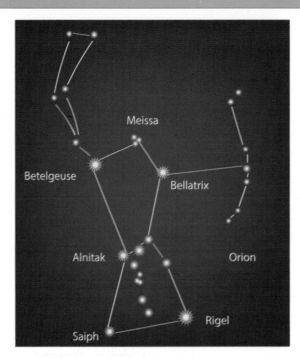

⭐ I Spy Orion, the Hunter

Orion is one of the easiest constellations to spot if you can see its distinctive belt formed by three stars in a straight line. The constellation is roughly in the shape of the letter 'H'. The shoulders have one star each. The first is Betelgeuse (meaning 'armpit of the giant') and the other is Bellatrix (meaning 'warrior'). He also has two stars in the feet, called Rigel and Saiph. From the belt, if you draw a line to the left, you will come to the star Sirius. Orion is usually seen in the standing position.

Mythology: Orion was a brave and mighty hunter who fell in love with Artemis, the Moon Goddess. Out of jealousy, her brother Apollo sent Scorpius (the scorpion) to fight with Orion. Both died during the fight. It is said that Zeus put Orion in the winter sky and Scorpius in the summer sky so that they could not fight any more.

◀ *Orion, the mighty hunter, with a few of its main stars*

⭐ I Spy Taurus, the Bull

To spot this constellation, look for the horns of the Bull which form a 'V' shape and try to find his bright red eye, which is the Aldebaran star.

Mythology: In ancient Greece, Zeus was considered to be the ruler of heaven. According to legend, he kidnapped Europa on the sly by turning himself into a large white bull and hid her on the island of Crete, where she bore him numerous children.

By learning techniques to spot Orion, Cassiopeia, and Taurus, each differently shaped (H, W, and V) and sized, you might have got the hang of recognising constellations in the sky!

▼ *Taurus, the Bull constellation*

💡 Isn't It Amazing!

The Serpens or Serpent constellation is the only constellation divided into two parts—Serpens Caput, which refers to the head of the serpent, and Serpens Cauda, meaning tail of the serpent. They are both part of the serpent that Ophiuchus the giant seems to be holding.

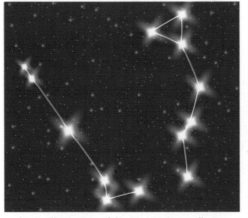

▲ *An illustration of the Serpens constellation*

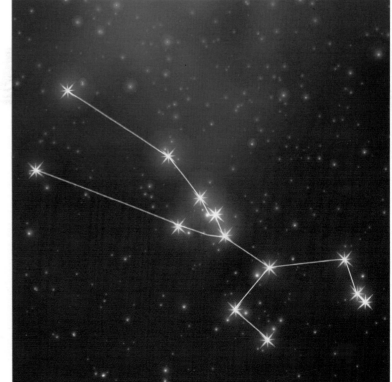

The 'C' Constellations

Interestingly, there are 22 constellations which begin with the letter 'C'. Some of them are the Corona Borealis, the Crater, the Corvus, and so on.

⭐ Corona Borealis

Corona Borealis, also called the Northern Crown, is found in the northern hemisphere. It is fairly small in fact it ranks 73rd in size in the total list of 88 constellations. Corona Borealis is in the shape of an open and irregular semicircle. It has four bright stars and lies in between the constellations of Boötes and Hercules. Alphecca is the brightest star in this constellation.

Mythology: It gets its name from the crown that the Greek God Dionysus gave to Ariadne, the Cretan princess.

▲ In Latin, Corona Borealis means the Northern Crown

▲ The Crater or Cup constellation

⭐ Crater

Crater is a constellation in the southern sky, also called the Cup. It is quite faint and ranks 53rd in terms of its size. Crater has seven stars with planets and its brightest star is Delta Crateris.

Mythology: This constellation is connected to Corvus (Crow) and Hydra (Water Snake). The Greek God Apollo sent a crow to bring a cup of water for a ritual. The crow got distracted and failed to bring the cup of water to him. Instead, it returned with a water snake and blamed it. Apollo got angry and threw all three—the crow, the cup, and the water snake—up into the sky.

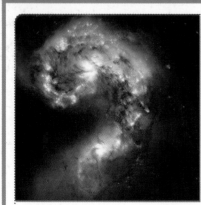

⭐ Corvus

Corvus means 'crow' or 'raven' in Latin. This is a constellation from the southern hemisphere. Hydra, Virgo, and Crater are its neighbouring constellations. In size, it is the 70th constellation. The brightest star in Corvus is Gienah.

Mythology: In Greek mythology, Corvus is the sacred bird of Apollo.

▲ Corvus or the Crow constellation

💡 Isn't It Amazing!

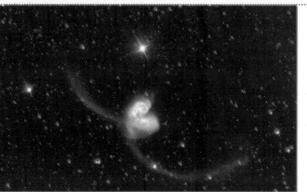

The Corvus constellation is 60 million **light years** away. Corvus houses two large galaxies which have collided, causing many new stars to be formed. Since these colliding galaxies look like the arcs of an antenna, they have been named the Antennae galaxies.

▲ The two large Antennae galaxies (NGC 4038 and NGC 4039) in Corvus. The picture on the right shows the collision

Legends of the Horses

Two well-known constellations are associated with fascinating creatures such as a winged horse and a centaur. The Pegasus constellation is in the shape of a winged horse, while the Centaurus constellation is in the shape of a centaur—a creature that is half-horse and half-man.

⭐ Pegasus or the Winged Horse

This constellation is one of the biggest in the northern sky and also the seventh-largest overall. It is best known for the 'Great Square' of Pegasus, a well-recognised asterism in that part of the hemisphere. Pegasus is also known for some of its bright stars and **deep-sky objects**.

Some of the constellations nearby are Andromeda, Aquarius (Water Bearer), Cygnus (Swan), Delphinus (Dolphin), Equuleus (Little Horse), Lacerta (Lizard), Pisces (Fish), and Vulpecula (Little Fox).

Mythology: Pegasus—or the winged horse—was born from the blood of Medusa's severed head. Bellerophon was a Greek hero who captured Pegasus and rode on him during his fight with a fire-breathing female monster. He tried to flee to heaven on Pegasus's back but was killed (some accounts say he was wounded) during the escape. The horse became a constellation and a servant of Zeus.

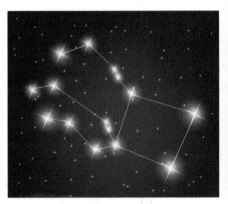
▲ The Pegasus constellation

▲ Pegasus

⭐ Centaurus

Centaurus lies in the southern sky and is the ninth-largest constellation. It is home to the two stars nearest to Earth—Proxima and Alpha Centauri (also the fourth-brightest in the sky). It also contains Beta Centauri, the 11th-brightest star.

Mythology: This constellation is linked with the centaur Chiron. Chiron was wise and peaceful, unlike most other centaurs who were aggressive. According to lore, it was Chiron who taught other Greek heroes and invented the constellations.

▼ A centaur's rough outline traced in the Centaurus constellation

💡 Isn't It Amazing!

The constellation Draco or Dracon is named after a Greek lawgiver from the 7th century BCE. Draco was known to give very severe punishments in Athens, and often gave the death sentence. The word 'draconian', which originated from his name, is now commonly used to describe extremely strict and oppressive laws.

A Tale of Two Giants

There are two giants among the constellations. One is named after a figure known for his strength and valour; the other is a constellation that is notorious for being left out from the zodiac constellations, even though it lies in the same region as the others.

▲ Plate 11 of Urania's Mirror, a set of cards illustrating various constellations, depicts Hercules and Corona Borealis

⭐ Hercules—the Giant

Hercules, sometimes referred to as the Kneeling Giant, is the fifth-largest constellation. It is situated between two bright stars—Arcturus (in the Boötes constellation) and Vega (in the Lyra constellation). A square figure in the middle of the Hercules constellation, known as the Keystone, is one of its more noticeable aspects. Besides Boötes and Lyra, some of the other neighbouring constellations are Aquila (Eagle), Corona Borealis, Draco, Lyra (Lyre), Ophiuchus, Sagitta (Arrow), Serpens Caput (Head of the Serpent), and Vulpecula (Little Fox).

Mythology: In the 5th century BCE, Hercules was first identified as Heracles, a well-known Greco-Roman hero and the son of Zeus borne by Alcmene. Zeus was eager for Hercules to become the ruler of Greece, but his jealous wife Hera tricked him and got her sickly son to become king. Hercules grew up and suffered at the hands of Hera. His first victory was as an infant, when he slayed two serpents that Hera had sent to kill him. He is often depicted holding a club and wearing lion skin.

◄ A star chart showing Hercules, the constellation referred to as the Kneeling Giant

⭐ Ophiuchus—the Other Giant

The name 'Ophiuchus' has Latin origins and refers to a serpent-bearing man. This constellation stands out for several reasons. The 'feet' of this constellation overlap with a part of the Scorpius constellation. It is located on the **ecliptic**. When the Moon crosses the ecliptic, we see solar or lunar eclipses. Ophiuchus has not been included in the 12 zodiac constellations lying in the same region. The second-nearest star to the Sun, the Barnard's Star is located in this constellation.

Mythology: Ophiuchus (son of Apollo, the God of healing, truth, and prophecy) symbolises the Greco-Roman God of medicine and is seen holding a serpent, which is considered to be a symbol of renewal.

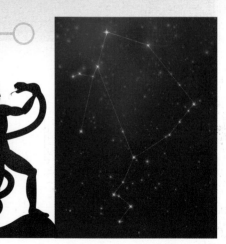

▲ In some cultures, the Ophiuchus constellation is considered to be the 13th zodiac constellation

Water Creatures

There are 10 water creatures represented in the long list of constellations. Two of the important water constellations are shaped like a water snake and a clever dolphin.

⭐ Hydra—the Water Snake

Hydra is a constellation seen in the southern hemisphere. This constellation is the largest in the night skies. It consists of several ordinary stars, the brightest of which is Alphard, whose name means 'brightest star' in Greek, as it is derived from the word 'alpha'. The constellation seems to have been created to mark the Equator in around 2800 BCE. In Greek mythology, the number of Hydra's heads changes from 5–100 depending on who is telling the story. However, the Hydra constellation has only one head.

Mythology: Hydra is linked to the Corvus (Crow) and Crater (Cup) constellations. The water snake was thrown into the sky by Apollo, along with the cup and the crow due to its disobedience.

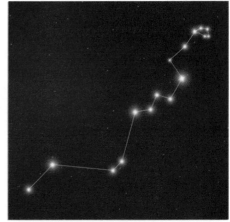

▲ *The constellation of Hydra*

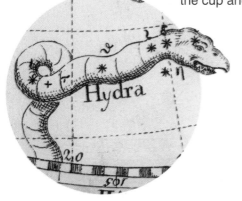

▲ *Hydra—the water snake*

🌟 Incredible Individuals

Although the Southern Cross or Crux has been written about since ancient times, the first to document it as a constellation, in a set of star maps in 1679, was the French architect and cartographer, Augustin Royer. He also added two more constellations. Royer split some part of the Canis Major constellation and named it the Columba (Dove) by including some stars from the Centaurus constellation in it.

⭐ Delphinus—the Dolphin

Delphinus is a small constellation in the northern hemisphere. Rotanev is its brightest star. It consists of an asterism called 'Job's Coffin', which is shaped like a diamond.

Mythology: Delphinus has two mythological roots. He was the messenger of Poseidon, the Sea God. In another account, he was the dolphin that saved the poet Arion from drowning.

▲ *Delphinus or the Dolphin constellation*

👤 In Real Life

We know about air, water, and land pollution, but have you heard about **light pollution**? It hampers our view of the night skies. Hong Kong is believed to be one of the most light-polluted cities in the world. In the last 100 years or so, light pollution has made it very difficult for stargazers and astronomers alike to study the skies due to the intense glare it creates. Organisations like the International Dark-Sky Association have been fighting against light pollution and struggling to preserve the dark skies for future generations. They support and propose 'smart lighting' designs.

The Zodiac

There are 12 constellations which lie in a region of the sky known as the zodiac. The word 'zodiac' comes from ancient Greek. Since most of the constellations in this area represented animals, the Greeks called it *zodiakos kyklos* (circle of animals), or 'ta zodia' (the little animals).

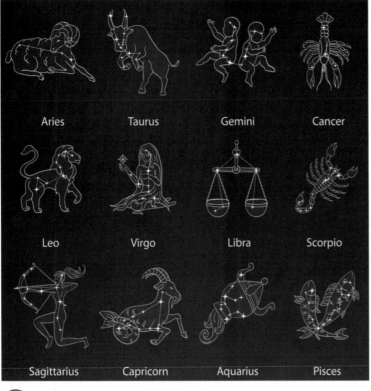

◄ *The 12 zodiac constellations form a belt around Earth*

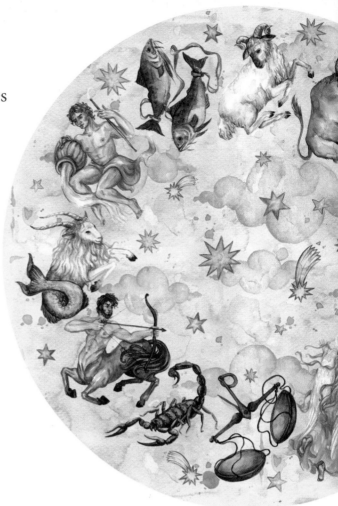

▲ *The zodiac constellations are mostly shaped like animals but some feature human figures and objects*

⭐ What is the Zodiac?

In astronomy and astrology, a particular belt or area in the sky extending 9° on both sides of the ecliptic (an imaginary line in the sky, marking the annual path of the Sun) is known as the zodiac region. The orbits of the Moon and the main planets also lie completely inside this region.

It were the early astronomers who noticed that the Sun travels through the signs of the zodiac throughout the year and stays for about a month in each of them. Think of a straight line that is drawn from Earth, passing through the Sun and moving out beyond our Solar System to where the bright stars are. As Earth orbits around the Sun, the line also rotates and points to different stars over a period of a year, which is one complete rotation. The constellations through which the line passes are in the zodiac.

These 12 constellations lying in the zodiac belt are known as the zodiac constellations. For believers of astrology, each of these correspond to and govern a period in the calendar. So, for example, a person born between 21 March and 19 April will have Aries as their zodiac sign. Each of the other 11 signs are similarly associated with specific periods and dates.

⭐ Why is Aries Considered to Be the First Zodiac Sign?

Mid-March (around the 20th or 21st) marks the beginning of spring. It brings relief after a harsh winter and is an important time in agriculture. Springtime is hence celebrated in several cultures all over the world. Almost 4000 years ago, even ancient Babylonians celebrated this period to mark this rebirth and the beginning of a new year. Similarly, in 600 BCE, people living in Iran celebrated Nowruz (New Day), most likely as part of the Zoroastrian religion. The Romans considered the beginning of spring as the start of the year. It is for this reason that Aries, the zodiac representing the beginning of spring, is considered to be the first constellation or sign of the zodiac. It reflects the importance that various cultures ascribed to routine astronomical phenomena.

Aries: the Ram

Location: Northern sky between Pisces and Taurus

Period: 21 March– 19 April

Brightest star: Although the Aries constellation does not have any bright stars, the brightest star within it is called Hamal, which means 'sheep' in 'Arabic'.

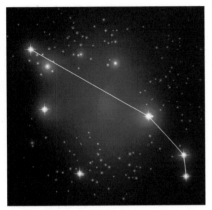

▲ The Aries constellation

Taurus: the Bull

Location: Northern sky between Aries and Gemini

Period: April 20–May 20

Brightest star: Aldebaran (meaning 'the follower' in Arabic) is the brightest star in the Taurus constellation. It is the 14th brightest star found in the sky.

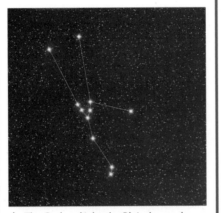

▲ The Crab nebula, the Pleiades, and the Hyades star clusters are also found within the constellation of Taurus

Gemini: the Twins

Location: Northern sky between Cancer and Taurus

Period: May 21–June 21

Brightest stars: Castor and Pollux are the brightest stars in the Gemini constellation. Pollux is brighter than Castor and is the 17th brightest star in the sky.

▲ The Gemini constellation contains Geminga, an isolated pulsar

Cancer: the Crab

Location: Northern sky between Leo and Gemini

Period: 22 June–22 July

Brightest star: Al Tarf (meaning 'the end' in Arabic. It indicates the end of one of the crab's legs), although a fairly dim star, it is the brightest star in the Cancer constellation.

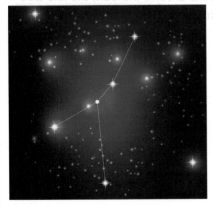

▲ The well-known star cluster known as Praesepe or the Beehive is found in the constellation of Cancer or the Crab

Leo: the Lion

Location: Northern sky between Cancer and Virgo

Period: 23 July–22 August

Brightest star: Regulus, which means 'little king' in Latin. It is also known as Alpha Leonis, and is one of the brightest stars in the night skies.

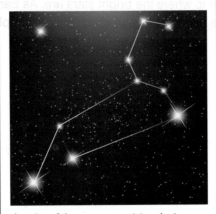

▲ A lot of the stars comprising the Leo constellation form an asterism known as the Sickle

Virgo: the Virgin

Location: Southern sky between Leo and Libra

Period: 23 August–22 September

Brightest star: Spica, which means 'head of grain' in Latin. It is also referred to as Alpha Virginis. It is the 15th brightest star in the entire sky.

▲ The Virgo cluster, the closest large cluster of galaxies, is located in the constellation of Virgo

Libra: the Balance

Location: Southern sky between Scorpius and Virgo

Period: 22 September–23 October

Brightest star: The stars in Libra are faint, but amongst them, the brightest is Zubeneschamali. The name means 'northern claw' in Arabic.

▲ Libra is represented by a balance scale or a woman holding a balance scale

Scorpius: the Scorpion

Location: Southern sky between Libra and Sagittarius

Period: 24 October–21 November

Brightest star: Antares, also called Alpha Scorpii, is the brightest star in the Scorpius constellation. It is a large star much bigger than the Sun.

▲ Within the constellation of Scorpius lies Scorpius X-1, the brightest source of X-rays in the sky

Sagittarius: the Archer

Location: Southern sky between Capricornus and Scorpius

Period: 22 November–21 December

Brightest star: Kaus Australis is the brightest star in the Sagittarius constellation. The word 'Kaus' means 'bow' in Arabic and 'Australis' is 'southern' in Latin.

▲ Many stars in the constellation of Sagittarius form the well-known asterism known as the Teapot

Capricornus: the Goat

Location: Southern sky between Aquarius and Sagittarius

Period: 22 December–19 January

Brightest star: This constellation's stars are faint but Deneb Algedi (meaning 'kid's tail' in Arabic) is the brightest amongst them.

▲ Capricornus means 'goat-horned' in Latin

Aquarius: the Water Bearer

Location: Southern sky between Capricornus and Pisces

Period: 20 January–18 February

Brightest star: Sadalmelik or Alpha Aquarii is the brightest star in the Aquarius constellation. It means 'lucky stars of the king' in Arabic.

▲ Aquarius, the Water Bearer

Pisces: the Fishes

Location: Northern sky between Aries and Aquarius

Period: 19 February–20 March

Brightest star: Eta Piscium refers to the cord that connects the two fish in the Pisces constellation.

▲ The Pisces constellation has only dim stars with no outstanding grouping

What is Astrology?

Astrology is the practice of interpreting the movements of celestial bodies to predict their influence on human life. Since ancient days, human beings have observed and interpreted the Sun, the Moon, the planets, and stars in order to try and figure out their impact on people, events, and life on Earth.

⭐ Astrology is not the Same as Astronomy

Astrology and astronomy are completely different. Astronomy is the scientific study of everything in outer space. Astronomers and other scientists know, for a fact, that the stars, the Sun, the Moon, and planets have no influence on the day-to-day activities and lives of human beings. Astrology, on the other hand, is unscientific; nobody can prove its impact on people. Although astrology is based on superstition, it is still a popular part of multiple cultures. This shows that many civilisations were able to spot these astonishing patterns of stars in the skies and attributed various meanings to them. Humans often looked to the heavens for phenomena that science could not explain at the time.

▲ *An astrological clock with zodiac symbols, in Prague*

⭐ The Zodiac and Astrology

A **horoscope** is a detailed chart that supposedly shows what impact celestial bodies have on the life of a person born at a particular time. The zodiac sign under which a person is born is an important consideration in such predictions, as is the position of the planets. Each of the zodiac constellations is considered to be the 'home' of one or more planets. The zodiacs are believed to have a strong or weak influence on the person. However, such an influence or correlation does not exist within the realms of modern science. It is very important to learn to differentiate between science and superstition, and not fall prey to any misleading claims.

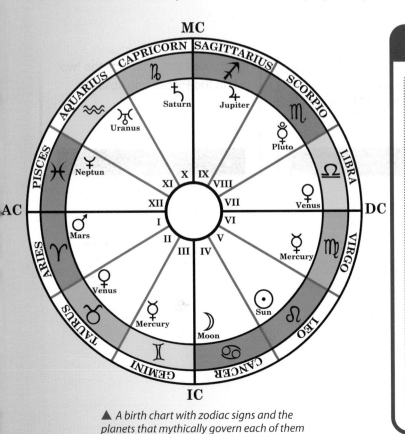

▲ *A birth chart with zodiac signs and the planets that mythically govern each of them*

⭐ Incredible Individuals

American astronomer Benjamin Apthorp Gould (1824–1896) was a child prodigy with exceptional abilities. When he was just three years old, Gould was able to read aloud, and at age five, he could compose Latin poems! One of Gould's most significant contributions as an astronomer was his work on star catalogues, which helped fix the list of constellations in the southern hemisphere. Gould had studied mathematics and the physical sciences at Harvard University. In 1848, he became the first American to earn a doctorate degree in astronomy from the University of Göttingen in Germany. In 1849, he started *The Astronomical Journal*, the first of its kind in the US, based on professional astronomical research.

▶ *Benjamin Apthorp Gould also founded the Argentine National Observatory and the Argentine National Weather Service*

Chinese Constellations

Astronomy had a royal role to play in ancient Chinese culture. Emperors hired astronomers to record astronomical events, precisely record time, and calculate the calendar. Chinese astronomers developed their own methods and ways, which were different from the ones used in Europe and elsewhere. Rather than theorising, they were more interested in making improvements in the accuracy of their measurements and in individual events like sightings of comets, novae, meteor showers, solar eclipses, and sunspots (the last of these were first discovered by the Chinese long before the Europeans).

⭐ Imperial Importance of Chinese Constellations

Stars and constellations were particularly significant to the Chinese, since they believed in the harmony of the heavens, Earth, and human beings. In fact, events within Chinese dynasties were closely correlated to the stars. The Emperor was considered to be the 'Son of Heaven' and was supposed to have been given heavenly instructions to rule the country. Constellations were also important in Chinese culture because most of them were linked to the hierarchy within the dynasties on Earth and were considered to be a replication of the same in the heavens. By around 220 CE, which marked the end of the Han Dynasty, Chinese court astronomers had already named 283 constellations by grouping 1,464 stars. Predicting events accurately and with attention to detail was important so that they could advise the Emperor.

▲ *The Chinese zodiac wheel and symbols*

⭐ 3 Enclosures, 4 Symbols, and 28 Mansions

The Chinese had a very different method of naming stars and constellations. They considered the north celestial pole to be the centre of heaven since the stars revolved around it. This area around the pole was segregated into three enclosures or sectors—the Purple Forbidden Enclosure (紫微垣, Zǐ Wēi Yuán); the Supreme Palace Enclosure (太微垣, Tài Wēi Yuán), and the Heavenly Market Enclosure (天市垣, Tiān Shì Yuán). These sectors represented the organisation of the dynastic hierarchy on Earth. The Purple Forbidden Enclosure was the most important of them all.

Chinese astronomers also assigned four symbols spread in the region of the ecliptic zodiac and the lunar orbit, which corresponded to the four cardinal directions. Each symbol was represented by an emblem—The Azure Dragon for the east; the White Tiger for the west; the Vermilion Bird for the south; and the Black Tortoise for the north. Each of these four symbols was divided into seven sections, which were known as mansions. There are 28 mansions in total. Most of the important Chinese constellations are situated within these mansions.

⚙ Incredible Individuals

Luoxia Hong (130–70 BCE) was a Chinese astronomer during the Han dynasty. Hong was well-noted for introducing a new calendar in the court of Emperor Wu-ti, who had invited proposals from astronomers across his empire.

In ancient China, it was believed that the emperor or ruler was given the right to rule by the heavens. When there was a change of emperor, and particularly if there was a change in the ruling dynasty, changing the calendar was not just an obligation of the ruler, but it was done to show the emperor's link with the heavens. The new calendar served to establish a new regime with new heavenly influences.

The calendar developed by Hong and his colleague Deng Ping was selected as the best from among 18 others by emperor Wu-ti. Hong's calendar was put to use in 104 BCE and incorporated both the Sun and the Moon into a common system. Hong also predicted eclipses and the positions of the planets based on accurate observations which were possible due to a special equipment he used for this purpose.

Dragon: East	Tiger: West	Vermilion Bird: South	Tortoise: North

Dragon	Tiger	Vermilion Bird	Tortoise

角 (Jio) Horn	奎 (Kuí) Legs	井 (Jng) Well	斗 (Du) Dipper
亢 (Kàng) Neck	娄 (Lóu) Bond	鬼 (Gu) Demon	女 (N) Woman
氐 (D) Root	胃 (Wèi) Stomach	柳 (L) Willow	牛 (Níu) Ox
房 (Fáng) Room	昴 (Mo) Hairy Head	星 (Xng) Star	虚 (X) Emptiness
心 (Xn) Heart	毕 (Bì) Net	张 (Zhng) Growth	危 (Wi) Danger
尾 (Wi) Tail	觜 (Zu) Turtle Beak	翼 (Yì) Wings	室 (Shì) Room
箕 (J) Winnowing Basket	参 (Cn) Three Stars	轸 (Zhn) Deep Emotion	壁 (Bì) Wall

▲ A modern star chart with the 28 mansions indicated on the border of each hemisphere

▼ *Made in 1439, an armillary sphere at the Beijing Ancient Observatory*

Stargazing Apps & Astrotourism

With the advent of the Information and Digital Age, you no longer need to lug around a telescope or an unwieldy star chart to admire your favourite stars and constellations. Your mobile phone can serve as your window to the world of stars! Several mobile apps are available as an aid to stargazing. They help spot the twinkling trinkets in the sky and also send you an alert about upcoming stargazing events. Astrotourism is also picking up. People are seeking destinations with dark, unpolluted skies and clearly visible stars.

▶ *Mobile phone applications are well-suited for amateur astronomers and youngsters*

⭐ Identifying Celestial Objects

There are various apps for iOS and Android that are easy and simple to use. All you need to do is hold your phone up and point it at the night sky. The app will show you which stars, planets, and constellations you are looking at. If something of interest catches your eye, you can tap the screen and get additional information about those celestial objects.

⭐ Map Your Stars

Other apps show detailed maps of stars, galaxies, and planets on the screen along with information about what you are seeing when you hold up your phone or tablet. There are settings for enlarging the view and animated graphics. You can even check out what the sky will be like on a future date. There are also added companion watch apps that reveal phases of the moon and a chance to spot space stations, and other celestial objects.

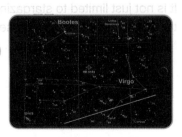

▲ *The latest apps even offer 3D animated graphics of planets and other celestial objects*

⭐ Different City Views

Another interesting feature offered by some apps is the traveller mode which allows you to see what the sky looks like from different cities.

◀ *Apps even offer fun means of learning more about space, such as informative and interesting movies*

ESO/VISTA/J. Emerson

▲ *Advancements in technology have made it possible for us to discover the marvels of space with an app*

⭐ Movies and More

Some apps allow you to view models of satellites, spacecrafts, and space missions; track their paths; and even view photos taken on these missions. There are apps with detailed 2D and 3D graphics, animations, and movies about a wide range of subjects like how a red dwarf star works, the history of our Moon, black holes, etc. They are easy to understand even for a person without much of a background in science.

⭐ Astrotourism

Astrotourism has picked up in several countries including USA, Canada, Australia, and others. It involves visits to places of astronomical interest and importance, such as planetariums and observatories. Astrotourists seek out places where stars can be seen easily in unpolluted, dark skies. It is not just limited to stargazing and also involves taking trips to watch an eclipse, a meteor shower, the Northern Lights, a rocket launch, or space-related experience. The International Dark-Sky Association in the US has listed over 60 such International Dark Sky Parks which people can visit. Most of these parks are generally near ski resorts, mountains, or state and national parks. Stargazing events, parties, and safaris are also gaining popularity now.

Our phones often distract us and keep us away from many wonderful things—stars and constellations for example. Like poet W. H. Davies said, "What is this life if, full of care, we have no time to stand and stare."

▲ *The Belgrade Planetarium in Serbia is an ideal place to visit for astrotourism.*

👁️ In Real Life

In June 2018, National Geographic along with Au Diable Vert Mountain Station, launched ObservEtoiles which is the world's first open-air **augmented reality** planetarium in Glen Sutton, Quebec, Canada.

Official Naming of Constellations

In 1919, the International Astronomical Union (IAU) was set up to promote and safeguard astronomy. This included research, education and development, communications, etc. IAU is recognised worldwide, and it is the only 'official' organisation allowed to name celestial bodies in the sky. More than 107 countries are members of the IAU.

⭐ IAU and the Constellations

Constellations were earlier informally described using the approximate shapes formed by the stars located in them. With an increase in the number of space-related discoveries in the 20th century, there arose a need to define them by specific boundaries. This was important while naming variable stars, for instance. Variable stars keep changing, becoming brighter or fading, instead of shining steadily like regular stars. Such stars are easier to spot by the constellations in which they are located. Hence, it was important to have a universally approved boundary for each constellation.

⭐ Setting Boundaries

In 1922, the IAU officially adopted the list of 88 constellations that we use today. Definitive boundaries between constellations, which extend out beyond the star figures, were set in 1930, so that every star, nebula, and galaxy, now lies within the limits of one constellation. For today's astronomers, constellations refer not so much to the patterns of stars, but to precisely defined areas of the sky. The IAU established three-letter abbreviations for each constellation. For example, Andromeda's abbreviation is 'And' and Draco's is 'Dra'.

👤✓ In Real Life

One of the best places to stargaze is Hanle, in Ladakh, India. The Indian Astronomical Observatory (IAO) here has one of the highest optical telescopes in the world. It is a remote region with very little rainfall, hardly any snow, and minimal cloud cover. So, these conditions make it the ideal location for astronomical observations. Moreover, being 4 kilometres above sea level is an added advantage as scientists are able to collect a wider range of data compared to a location at a lower level. The IAO also has an area for gamma-ray telescopes.

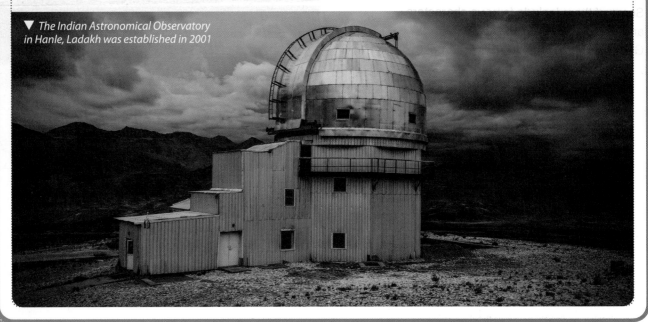

▼ *The Indian Astronomical Observatory in Hanle, Ladakh was established in 2001*

NASA's New Constellations

Spotting the Great Bear, or the Orion constellation may now be a piece of cake for you. But can you spot the Hulk or Albert Einstein constellations? You may try hard, but you will need more than just your eyes to see them. You will need an extremely powerful and special telescope to view NASA's 21 new unofficial constellations.

▲ *The Fermi Gamma-ray Space Telescope as illustrated by an artist*

★ High-energy Sky Constellations

NASA scientists came up with some new constellations in October 2018 to celebrate the completion of a decade of its Fermi Gamma-ray Space Telescope Mission. In fact, it is Fermi which was responsible for spotting these constellations that have been developed from sources of **gamma rays** in the sky. Gamma rays are a type of **electromagnetic radiation** which have the shortest **wavelength**.

Human beings can only see visible light when they look up into the sky; other sources of light like gamma rays are invisible. Since 2008, NASA's Fermi Gamma-ray Space Telescope has been scanning the heavens and observing different sources of gamma rays, the highest-energy light in the universe. Gamma-ray emissions come from various cosmic phenomena. Since Fermi began operations, it has managed to map and measure more than 3,000 different sources of gamma rays.

★ Hall of Fame

These gamma-ray constellations have been named after modern characters, scientists, and famous landmarks. Others are related to some scientific ideas or tools.

Some of them include famous characters and objects such as the Little Prince; Godzilla; the spaceship USS Enterprise from Star Trek; Sweden's recovered warship; Vasa; the Washington Monument; Mount Fuji of Japan; Schrodinger's Cat; Radio Telescope; the Eiffel Tower; the Golden Gate and the Black Widow Spider.

▲ *View NASA's fun but unofficial constellations.*

★ A Collaborative Effort

NASA was able to develop the Fermi Gamma-ray Space Telescope in collaboration with the US Department of Energy. It has also partnered with several academic institutions and other partners in Italy, Japan, France, Germany, Sweden, and America for this mission.

ASTRONOMY

AMAZING **ASTRONOMY**

*"Man must rise above Earth—to the top of the atmosphere and beyond—
for only thus will he fully understand the world in which he lives."*

—**Socrates**

Astronomy is one of the oldest sciences in the world. It includes the study of all objects and phenomena that are outside Earth's atmosphere (extra-terrestrial). These objects have been studied for thousands of years by scientists called astronomers. This ancient science dates back to the Babylonians and other early recorded civilisations, who, even at that time, recognised some of the constellations we see today. With the observance of regular astronomical events, charts and calendars were created, for the purpose of **astrology**, to predict seasons and keep track of the passage of time. New ideas were introduced by Greek philosophers like Pythagoras about the shape of Earth and the motion of objects in the universe. Greek astronomers like Ptolemy supported the theory of Earth being at the centre of the universe (a geocentric universe). The 17th century was when the telescope was invented, and the laws of motion and gravity were discovered.

Although astrology was earlier associated with astronomy, the two are no longer connected, since the former lacks a scientific basis.

Over the centuries, astronomy has been used for the purpose of navigation. Today, with advances in science and technology, the scope of the observational science of astronomy has expanded considerably and includes not only the study of the solar system but also objects and events from way, way beyond.

▼ *An astronaut's window to the marvels of the universe*

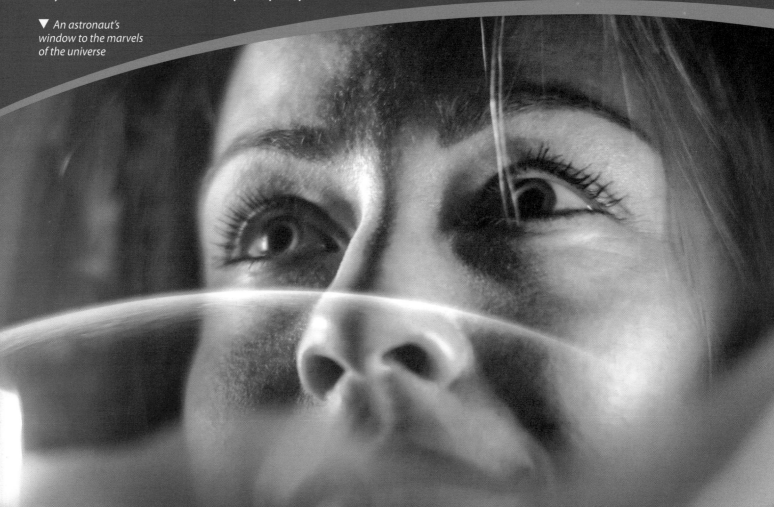

A Brief History

Astronomy was one of the first few natural sciences to develop. However, unlike other such sciences, it had reached a high level of refinement and achievement by the second half of the first millennium BCE. It has been one of the most enduring traditions across the world for almost 4,000 years.

⭐ Astronomy in Ancient Times

The Nebra Sky Disc is the oldest known representation of the cosmos. It is the earliest record of astronomical observations depicting the Sun, a lunar crescent and stars. In the Bronze Age, this was a kind of astronomical clock or tool used in agriculture for finding out the correct time for sowing and harvesting. The 1600 BCE bronze tool has a diameter of about 30 centimetres and weighs approximately 2 kg.

Early recordings of astronomical phenomena are also found in the ancient Babylonian, Chinese, Central American, and North European cultures. These ancient cultures tried to measure time; trace the movements of the Sun, the Moon, and the stars; track the regularity in the occurrence of sunrises, sunsets, and other celestial events through structures they built. The rock formation of Stonehenge in the UK is evidence of this. Native Americans also left behind rock drawings (petroglyphs) of astronomical phenomena.

▲ *The Nebra Sky Disc was discovered in 1999 in Germany, by treasure hunters using a metal detector. It depicts the Sun or a full Moon, stars, and a crescent Moon*

▲ *Stonehenge*

⭐ Timeline of Astronomy

The history of astronomy is long, and spread across many nations. Many cultures learned from each other to make advances in this field.

Ancient Mayans note the 18.6 year cycle of Earth's Moon rising and setting. They prepare a calendar charting the movements of the planets, the Moon and the Sun.

3114 BCE

▶ *A Mayan astronomer is depicted within the pages of the Madrid Codex, a Mayan book about almanacs and horoscopes*

585-470 BCE

Ancient Greeks build on the knowledge of the Mayans to predict eclipses. Specifically, Thales uses this knowledge and predicts a solar eclipse. A Greek philosopher named Anaxagoras provides an accurate explanation of eclipses. He describes the Sun and how the Moon reflects light from the Sun.

▶ *Anaxagoras also tried to explain the occurrence of meteors and rainbows. He described the Sun as a large, fiery mass*

400 BCE

The ancient Babylonians learn to record the position of celestial bodies by dividing the heavens into twelve 30-degree segments under the Zodiac system.

387 BCE

A famous Greek philosopher Plato starts a school called the Academy. Plato proposes that planets follow perfectly circular orbits and that all celestial bodies move around Earth.

▶ A part of a much larger fresco depicting the School of Athens; Plato and Aristotle are depicted here

350 BCE

Aristotle, another well-known Greek philosopher and scientist, plays a key role in the development of Western thought. He publishes *On the Heavens*, which is the oldest existing source clearly mentioning that Earth is a sphere and gives valid reasons to support his claim. He arrives at this conclusion by observing Earth's circular shadow on the Moon during a lunar eclipse.

◀ Aristotle's theories were groundbreaking at the time, and were used until around the 1500s CE

270 BCE

Greek astronomer Aristarchus of Samos proposes a system where the Sun is the central figure around which Earth and the other planets move. This is called the **heliocentric model** of the solar system. This leads to the geocentric versus heliocentric debate.

▲ A Greek copy of Aristarchus's notes on the relative sizes of the Sun, Earth, and the Moon

330 BCE

Heraclides, a Greek philosopher and astronomer and the first to suggest the rotation of Earth, proposes the very first model of our solar system. In this model, he puts the planets in order and places Earth at the very centre of the model. This is the obsolete **geocentric model** of the solar system.

▲ Heraclides was a pupil of Plato

240 BCE

Greek philosophers Eratosthenes (known for the oldest surviving record measuring Earth's size) and Aristarchus use simple geometry to calculate the size of Earth, the Moon, and the Sun, as well as the distances between the planets nearby. They estimate the size of the universe relative to Earth.

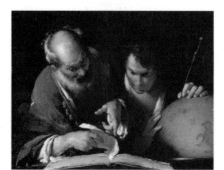

▲ The illustration depicts Eratosthenes's time as a teacher in Alexandria

130 BCE

Hipparchus, a Greek astronomer and mathematician, prepares the first star catalogue and constructs a celestial globe with the stars and constellations arranged on it.

45 BCE

Julius Caesar introduces the Julian calendar, similar to the one we use today, to the Roman Empire. It is a purely solar calendar and includes leap years.

▲ Caesar took the help of Greek mathematicians and astronomers for the calendar

⊛ Incredible Individuals

While working on the Julian calendar, the Alexandrian astronomer Sosigenes miscalculated the length of the year by 11 minutes and 14 seconds. Over the centuries, this seemingly minor mistake had led to a 10-day deviation. So, as a reformative step, Pope Gregory XIII introduced the Gregorian calendar (which we use till date) in 1582.

Renaissance & Astronomy

The Renaissance period (14th–16th century) saw a rebirth of European culture, art, politics, economics, and science. This era was also characterised by a heightened interest in the study of everything related to ancient Greece and Rome, and the discovery of new territories and continents. Astronomy too played a key role as important advances in science were made and new theories about the universe were put forth by astronomers. Great artists, scientists, thinkers, authors, and statesmen flourished during this time.

⭐ Nicolaus Copernicus (1473–1543)

Although Copernicus, the father of modern astronomy, wasn't the first to challenge Ptolemy's geocentric theory, he reinvented the heliocentric model. He was the first person to publish his claim, thereby challenging the doctrine of the Church.

Copernicus concluded that Earth and all the planets in the solar system revolve around the Sun. He also proposed that Earth rotates daily on its axis, and what human beings see in the night skies depends on Earth's motion. Copernicus did not have the equipment to validate his theories, and he was proved correct much later in the 1600s by astronomers like Galileo Galilei.

▲ An oil painting by Jan Matejko depicts Nicolaus Copernicus looking at the skies from the balcony of a cathedral. It is titled 'Conversations with God'

💡 Isn't It Amazing!

It is indeed amazing that Copernicus made many of his astronomical observations with the naked eye! He passed away more than 50 years before Galileo Galilei first observed the skies using a telescope he had made.

▲ Tycho Brahe's wealth totaled to 1% of Denmark's wealth

⭐ Tycho Brahe (1546–1601)

Danish astronomer Tycho Brahe was the first 'true' observer of the skies—he built the Danish Observatory using **sextants** instead of a telescope (which had not yet been invented). A sextant is an instrument used to determine the angle between the horizon and a celestial object like a star, the Sun, or the Moon. He showed that the Sun was much farther than the Moon from Earth by using **trigonometry**, a branch of mathematics concerned with functions of angles and their application to calculations.

⭐ Johannes Kepler (1571–1630)

A German astronomer named Johannes Kepler supported Copernicus's heliocentric model in his book, *The Cosmographic Mystery*. He became one of the first figures in the field of astronomy to offer public support to the theories proposed by Copernicus.

Kepler was a student of Tycho Brahe. The two worked together briefly before Brahe's death in 1601. Brahe's database and his observation of an exploding star (a supernova) made Kepler realise that planets and other bodies moved in ellipses. This became his first law of planetary motion out of the three. Till his discovery, it was believed that planets travelled in a circular path instead of an oval path.

▶ Johannes Kepler was a mathematician as well as an optician

Galileo Galilei (1564–1642)

Italian scientist Galileo Galilei was the pioneer of modern 'observational' astronomy. In the early 1600s, he made path-breaking discoveries using extremely powerful telescopes made by him, which were based on a model invented in the Netherlands around the time. Based on his observations of Venus, he accepted and explained the heliocentric model of the universe. This went against the prevalent theory of the geocentric system.

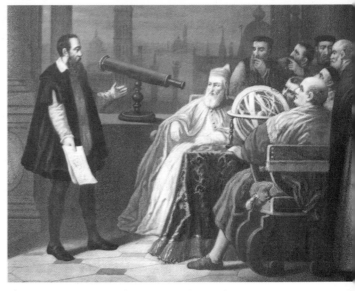

▲ *Galilei shows the chief magistrate of Venice how to use a telescope*

Galilei made revolutionary astronomical discoveries that went against the assumptions made by people before him. For example, while many believed that the Moon's surface is smooth, he rightly claimed it to be uneven. Galilei also made observations about the puzzling appearance of Saturn and its atmosphere, which later turned out to be its rings, and also explained the nature of sunspots. He claimed that Venus goes through phases like Earth's Moon and was also responsible for the discovery of four of Jupiter's moons.

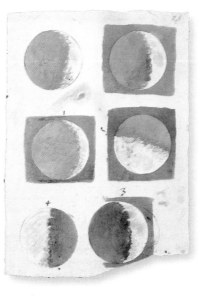

▲ *Galilei drew the Moon's phases and discovered that it had an uneven surface using a powerful telescope magnified up to 20 times*

The latter two observations implied that there existed more than one centres of motion in the cosmos and that the planets revolved around the Sun. It was a decisive moment in the world of science and astronomy.

These discoveries went against the belief of the Roman Catholic Church, which believed that Earth was the central body in the solar system. So Galilei was sentenced to life imprisonment. He died due to an illness while under house arrest.

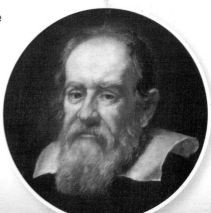

▲ *The Vatican did not admit that Galileo was right until 1992*

▼ *Galilei facing the Roman Catholic Church during an inquisition*

Modern Astronomy

The period between the 18th and 20th centuries was marked by the discovery of the outer planets of the solar system as well as discoveries in stellar and galactic areas. From the late 19th century onwards, astronomy also included **astrophysics**. While astronomy is the science that measures the positions and characteristics of heavenly bodies, the application of the laws and theories of physics to understand astronomy is called astrophysics. Scientists also research gases and dust particles found close to and in between the stars, and nuclear reactions that provide the energy radiated by stars. Cosmology—the study of the origins of the universe—was another area of interest and focus in this period.

▲ The Hubble Space Telescope was launched in 1990. It is still in operation today

▲ Cassini is credited with introducing Indian Astronomy to Europe

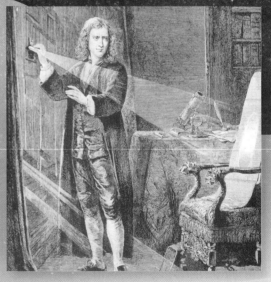

▲ Newton was knighted by Queen Anne of England in 1705, becoming Sir Isaac Newton

⭐ Gian Domenico Cassini (1625–1712)

Italian-born French astronomer, Gian Domenico Cassini, amongst others, discovered a dark gap—the Cassini Division—between the A and B rings of Saturn, in 1675. He also discovered four moons of Saturn—Lapetus, Rhea, Tethys, and Dione. His primary focus was the Sun, but later with the use of powerful telescopes, he also studied the planets. He was the first to notice the shadows cast by Jupiter's moons as they travelled between Jupiter and the Sun. He measured the planet's rotational period after observing the spots on its surface and discovered the flattened poles. Cassini was also the first to record observations of the zodiacal light. Although he did not accept new ideas and theories easily, he is still remembered as one of the important astronomers of the 17th and 18th centuries.

⭐ Sir Isaac Newton (1643–1727)

English physicist and mathematician, Sir Isaac Newton is one of the greatest scientists in history. Newton developed the three laws of motion (which became the foundation for physics), the theory of gravity, and a new branch of mathematics called calculus. He also advanced the science of optics, contributing significantly towards reflecting telescopes; worked on **diffraction**; and came up with the theory of light.

🧑‍🦱 In Real Life

Despite astronomy having developed into an advanced science, one of its major pitfalls is that it is an 'observational' science rather than one based on scientific experiments. A majority of the measurements have to be undertaken at great distances from the objects being studied, without any control over their temperature, pressure, or chemical composition. The only exceptions being meteorites (pieces of asteroids which land on Earth); lunar surface soil and rock samples; comet and asteroid dust samples brought back by robotic spacecrafts; and interplanetary dust particles in and above the stratosphere—which can be tested in a laboratory environment.

▲ In 1720, Halley succeeded John Flamsteed as Astronomer Royal

▲ Laplace is sometimes referred to as French Newton

▲ Lagrange played a major role in the development of the metric system of weights and measures

⭐ Edmond Halley (1656–1742)

An English mathematician and astronomer, Edmond Halley was the first to calculate the orbit of a comet, that was later named after him. He also played a key role in the publication of Newton's *Mathematical Principles of Natural Philosophy*.

In 1678, he published a star catalogue comprising locations of southern stars determined using a telescope. The first work of its type to be published, it helped establish him as a reputed astronomer.

⭐ Pierre-Simon, marquis de Laplace (1749–1827)

French mathematician, astronomer, and physicist, Laplace was known for his contributions in exploring the stability of the solar system. Some observed that there are disturbances in the solar system which are caused by the fact that all planets are attracted by the Sun. However, they are also attracted—though by a smaller degree—by all the other planets. New mathematical methodology was developed in the 18th century to provide a more efficient rationale for such disturbances. Laplace and Joseph-Louis Lagrange (1736–1813) played an important role in showing that the solar system was actually quite stable.

Rockets: Raring to Rise!

What is a rocket? It is a **propulsion** device which carries solid or liquid **propellants** and provides both the fuel and the **oxidiser** needed for combustion, independent of the atmosphere. Rockets are an integral part of space exploration today; they help carry spacecrafts to other planets, satellites into space, and supplies to the International Space Station. Let us find out how rockets originated.

⭐ Early 'Rockets'

One of the first objects to be successfully flown using rocket flight principles was a wooden bird. It might have been shaped like a pigeon. It was flown by a Greek named Archytas in 400 BCE. The bird was suspended on wires and pushed upwards by escaping steam. Archytas used the action-reaction principle to fly his wooden bird. This principle was recognised as a scientific law only in the 17th century.

300 years later, Hero, another Greek from Alexandria, developed a device called an aeolipile, which used rocket propulsion principles. It was shaped like a sphere and had L-shaped tubes on two sides. It was kept above a kettle of boiling water. When the water turned into steam, it moved upwards and entered the two tubes, causing the sphere to rotate.

▲ *The crater Archytas on the Moon is named in the Greek philosopher's honour*

▲ *The aeolipile described by Hero is considered to be the first steam engine*

⭐ Rocket-like Inventions

Exactly when the first real rockets were built is unclear. The Chinese experimented with tubes filled with gunpowder and discovered that the tubes could be launched by escaping gas. In 1232, they used 'arrows of flying fire'—a simple form of a solid-propellant rocket—to scare Mongol invaders. After the war, even the Mongols began making rockets, and this technique may possibly have spread to Europe.

Johann Schmidlap, a 16th century German firecracker manufacturer, invented a multistaged vehicle to propel fireworks to greater heights. A large skyrocket carried a smaller skyrocket. Once the larger rocket burned up, the smaller one carried on going higher until it burned up too. This is the fundamental principle behind current space rockets.

▶ *Soyuz rockets designed by Russia have been launched for over 40 years*

⭐ The Science of Developing Rockets

In the late 17th century, Sir Isaac Newton laid the foundations of modern scientific rocketry through his three laws of motion. His laws explain the how and why of rocketry and outline the reasons why rockets work in the vacuum of outer space. The French and the Dutch were both using rockets for military operations and by 1668, military rockets grew in terms of size and performance. In the same year, a German colonel designed a 60 kilogram rocket. However, the use of rockets in military campaigns declined over the next 100 years.

▲ The missiles in the Anglo-Mysore War were fitted with swords and could hit the enemy hundreds of meters away

Then, in the late 18th century, Hyder Ali, prince of Mysore, improved rockets by using metal cylinders instead of paper to contain the burning powder. This was an important development. The range of such rockets was more than a kilometre and they were particularly effective against cavalry. Hyder Ali's son, Tipu Sultan continued to effectively increase the use of rockets against the British in the battles that took place in 1792 and 1799. This inspired Colonel William Congreve to develop extremely successful rocket weapons for the British military. However, improved artillery lead to a decline in the use of rockets in war.

The three pioneers of modern rocketry and space exploration were Russian scientist Konstantin Tsiolkovsky (1857–1935), American professor and inventor Dr. Robert Goddard (1882–1945), and German scientist Hermann Oberth (1894–1989).

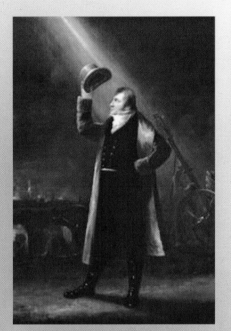

▲ Colonel William Congreve developed the Congreve rocket, which was first used in 1806

◀ Konstantin Tsiolkovsky was among the first to solve the problem of rocket travel in space

▶ German scientist Hermann Oberth is one of the founders of modern astronautics

⭐ Working Principle

Rockets use liquid or solid fuels. According to Newton's third law of motion, for every action or force, there is an equal and opposite reaction. As per this law, a rocket engine produces a driving force through action and reaction. The engine burns fuel, producing hot gases which flow in one direction and propel the rocket with force in the opposite direction.

🎖 Incredible Individuals

American professor and inventor, Dr. Robert Goddard earned his doctorate from Clark University in Worcester, where he also taught physics and carried out rocket experiments. Amongst other things, he was the first to develop a rocket motor using liquid fuels, which was used in German V-2 rocket weapons nearly 15 years later. His well-known work, A *Method of Reaching Extreme Altitudes* was published in 1919.

◀ Robert Goddard is considered the father of modern rocket propulsion

▶ Goddard successfully launched the first liquid-fueled rocket in 1926

A Brief History of Telescopes

The telescope was an important invention of the 17th century. It helped astronomers get a closer look at the heavenly bodies. It also helped in getting the scientific and religious communities to accept the heliocentric model of the solar system, which placed the Sun at the centre. The invention of the telescope revolutionised space exploration like never before.

⭐ The First Telescope

Hans Lipperhey from the Netherlands made a patent application in October 1608, for a device which made distant objects appear as if they were close by—the earliest known record of a telescope. The instrument had a positive and negative lens at opposing ends of a thin tube. Galileo Galilei heard about this invention and went ahead and made his own.

▶ Hans Lipperhey applied for a patent for his invention but was refused

⭐ Using Telescopes

In 1609, Galilei became the first person to use the telescope to view celestial bodies. However, some others have claimed to use a telescope for this purpose before him. Despite the fact that the early telescopes were small and not as powerful as the modern ones, Galilei managed to observe that Earth's Moon had mountains and craters, spotted a ribbon-like pattern of scattered light across the sky (Milky Way galaxy), and discovered four of Jupiter's moons.

⭐ Development of the Telescope

Astronomy thrived after bigger and more powerful telescopes were made. Astronomers were able to view many more features of outer space, including faint faraway stars, and could also calculate their stellar distances.

Another instrument, the **spectroscope**, helped gain information about the chemical composition and movement of heavenly bodies in the 19th century. In the 20th century, better telescopes enabled viewing objects in the depths of space. However, due to the interference of the atmosphere, the view did not improve any further.

▲ Seen here is one of Galilei's early telescopes, now kept in a museum in Florence

▼ The European Southern Observatory's Very Large Telescope (VLT) sits on top of a remote mountain in the Atacama Desert in Chile. Seen here in the photograph are two of the four unit telescopes that comprise the VLT, an extremely advanced telescope made using cutting-edge technology.

✪ How do Telescopes Work?

The early telescopes used 'lenses'—curved pieces of clear glass—to focus light. Today, curved mirrors are used in telescopes. Mirrors are lighter and easier to use than lenses, so they can be made perfectly smooth. With mirrors, the image appears upside down, this is easily resolved by using another mirror to flip the image back.

Mirrors or lenses used in the telescope are referred to as 'optics'. These optics need to be really big in a large and powerful telescope, in order to get a better view of faint far-off objects. The telescope is able to concentrate more light with bigger mirrors or lenses—it is this light that we see when we peer into a telescope. Telescopes made using lenses and mirrors are known as refracting and reflecting telescopes respectively.

▲ The deck of the Eiffel Tower has telescopes so that visitors can see the city in more detail

✪ Limitations of a Ground Telescope

When celestial bodies are viewed from a ground telescope, irrespective of how powerful the telescope might be, the vision is distorted due to shifting air pockets in Earth's atmosphere. Such atmospheric distortion makes it look like the stars are twinkling. Also, some wavelengths of radiation (ultraviolet, gamma, and X-rays) are partially blocked or absorbed by the atmosphere. For scientists, this is a problem since it is best for them to examine a body like a star by studying all the types of emitted wavelengths. The most effective way to circumvent this problem is to position the telescope beyond the atmosphere, in observatories in space like Fermi, Chandra, Kepler, Spitzer, and Planck telescopes, to name a few.

▲ A modern-day ground telescope

ⓧ Incredible Individuals

American astrophysicist Lyman Spitzer (1914–1997) was interested in the physical processes occurring in interstellar space. In 1946, he first proposed the idea of an orbiting space telescope unhindered by Earth's atmosphere. This finally resulted in the building and launch of the Hubble Space Telescope, in 1990, and other such astronomical observatories. In 2003, an orbiting infrared observatory called the Spitzer Space Telescope was named after him.

▲ Lyman Spitzer

Analysing Data from Telescopes

There is no single telescope that can look at all elements of space at once.
Today, there are different types of telescopes that are used to observe celestial bodies in outer space and collect varying types of data from them because space is dynamic. It becomes difficult to get the same image twice or recreate an image taken from a telescope at a later time. Scientists require different telescopes to point to the same object in space to get a full understanding of it.

▲ *An artist's interpretation of a bright gamma-ray burst*

⭐ Types of Telescopes

The earliest telescopes were optical telescopes. These can be of two basic types, refractors and reflectors. While a refractor makes use of convex lenses to gather light, reflectors use concave mirrors. Galilei used a refractive telescope to make his discoveries. Sir Isaac Newton invented the first reflecting telescope in 1671.

The 'objective' lens/objective mirror is the part of a telescope that collects light and determines if the telescope is refractive or reflective. Similarly, radio telescopes collect weak radio light waves and focus and amplify them for further analysis.

Telescopes are also built to serve many different purposes. They are classified into different types accordingly. For example, a solar telescope is made to specifically look at the Sun and gather data from it. A telescope that is sent to outer space is called a space telescope. An astronomer might make use of one or more types of telescopes to study space. However, the data collected from them is not synchronised.

▶ *Some novices and non-professionals buy amateur telescopes to make their observations. The pictured telescope is an amateur solar telescope*

⭐ Reading a Telescope

All telescopes work according to some basic principles—one being that the telescope relies on the interaction between energy and matter. The atomic matter or material used to make a telescope is carefully chosen so that it can read the energy emitted from a celestial object. This energy is in the form of electromagnetic waves.

The problem is that most objects emit different frequencies of energy at the same time, which is also true for the energy emitted from your body. So different wavelengths give the observer different data. This is why different telescopes are required to observe different data. Scientists build their telescopes according to the type of data they want to collect.

▶ *Radio telescopes need to be much larger than other telescopes so that they can accurately collect astronomical radio signals, and not lose them due to the noise produced on Earth*

◀ *A reflecting telescope at the McDonald Observatory in Texas*

The Hubble Space Telescope

Hubble Space Telescope is named after the foremost observational cosmologist of the 20th century, Edwin Hubble. This telescope was designed and built by the European Space Agency and National Aeronautics and Space Administration. It was deployed on 25 April 1990.

▲ *A replica of the Hubble Space Telescope is displayed in Edwin Hubble's hometown in Missouri*

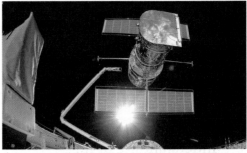

▲ *The Hubble Space Telescope was deployed from the cargo bay of the space shuttle Discovery*

⭐ The Hubble Telescope's Activities

The Hubble Space Telescope has played an important role in:

- Helping estimate the age of the universe, which is believed to be almost 14 billion years old
- Detecting black holes
- Revealing faraway galaxies
- Discovering dark energy—a force causing the universe to expand at a galloping rate
- Capturing strong explosions of energy during the collapse of gigantic stars
- Studying the atmosphere of planets outside the solar system, which revolve around stars.

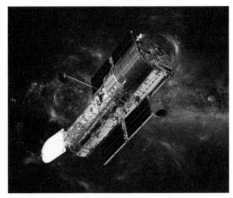

▲ *More than 1.3 million observations have been made by the Hubble Space Telescope*

⭐ Instruments and Equipment on Hubble

Hubble uses cutting-edge technology and very specialised equipment. For example, its Fine Guidance Sensors—which lock onto stars as Hubble orbits Earth—are part of its Pointing Control System and help the telescope aim precisely in the correct direction. In fact, the Hubble telescope has the ability to lock on to a target object located about 1.6 km away by moving no more than the width of a human hair!

Hubble's mirrors collect 40,000 times more light than the human eye. It uses five main scientific instruments including the Wide Field Camera 3 and spectrographs (which split light into its individual wavelengths). The Wide Field Camera 3 can see three types of light—near-ultraviolet, visible, and near-infrared. The first and the third types cannot be seen by people.

⭐ Incredible Individuals

German-born British astronomer, Sir William Herschel (1738–1822) started off as a musician. A book on telescope construction got him interested in astronomy. He wanted to observe distant celestial objects, for which he required powerful telescopes with large mirrors to collect sufficient light. He was compelled to make his own mirrors. His contribution to developing the telescope in the 18th century was crucial.

▶ *British astronomer William Herschel was the one to discover the planet Uranus*

💡 Isn't It Amazing!

Hubble does not travel to the stars, planets, or galaxies, instead it takes pictures of them as it whirls around Earth at about 27,300 kmph.

More than 15,000 scientific papers have been published using Hubble's data, making it one of the most productive scientific instruments ever built.

The International Space Station

The International Space Station (ISS) is the largest space laboratory in low Earth orbit. It was launched by the USA and Russia along with the help of experts from Europe, Japan, and Canada. Brazil and 11 members of the ESA helped in its construction.

⭐ The Origins of ISS

President Ronald Reagan had given NASA the go-ahead for this initiative in the 1980s. In the 1990s, it was redesigned to reduce costs. In 1993, USA and Russia decided to combine their individual space station plans and amalgamate their technologies, expertise, and modules with contributions from the ESA and Japan.

The construction of the ISS started in November 1998, with the launch of the Russian control module Zarya and the US-built Unity connecting node. They were linked in orbit by American space shuttle astronauts. Thereafter, constant additions were made, including a control centre, complex laboratories, equipment, and habitats. The ISS was completely functional by May 2009.

▶ *A photograph of the International Space Station seen from Atlantis STS-135, after undocking in May 2010*

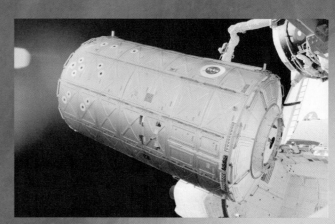
▲ *243 individuals and 19 countries have visited the ISS*

💡 Isn't It Amazing!

Here are some interesting facts about the ISS:
- The crew lives and works on the ISS while travelling at about 8 kmps.
- In 24 hours, ISS orbits Earth 16 times; it witnesses 16 sunrises and sunsets.
- The living and working space of the ISS—which is larger than a six-bedroom house—consists of six sleeping quarters, two bathrooms, and even a gym.
- The ISS measures approximately 108 metres end to end, just 91 centimetres less than a full-length American football field.
- More than 50 computers on-board control the systems.

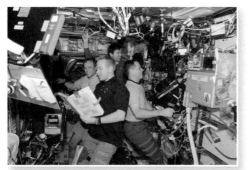

▲ *Destiny Lab module is the primary research module on ISS*

⭐ Assembling the ISS

The ISS is one of the greatest multinational collaborations ever attempted. The Russian-built Zvezda, a habitat and control centre, was added to the ISS in mid-2000. Destiny, a microgravity lab designed by NASA was added to conduct experiments. The Columbus lab, Europe's first long-duration crewed space laboratory was added to conduct experiments in life sciences and other areas, as was the Japanese-made Kibo Laboratory.

Besides the Russian modules, other elements were added over the years. Some were brought to the ISS by space shuttles and assembled by astronauts during a spacewalk, also known as an Extravehicular Activity (EVA), in orbit. Space shuttles and the Soyuz spacecraft served to transport astronauts back and forth. A Soyuz remained there at all times as a rescue vehicle. In 2006, a pair of solar wings and a thermal radiator were added.

The ISS has a 16-metre-long, Canadian-built Canadarm2, which is a large robotic arm that serves as a crane and is used for a variety of tasks. The ISS has six docking ports that allow six spacecrafts to visit the station simultaneously. In November 2000, the ISS welcomed its first resident crew, American astronaut William Shepherd and Russian cosmonauts Sergey Krikalyov and Yuri Gidzenko. Since then, the ISS has been constantly occupied and has had over 200 astronauts from 20 countries visit it.

▲ A part at the end of the robotic arm Canadarm2 used to grip objects and latch onto the station

⭐ Incredible Individuals

American biochemist and astronaut, Peggy Whitson was the first woman commander of the ISS and holds the record for spending the maximum time in space amongst American astronauts. She spent 665 days in space!

◀ NASA's Peggy Whitson conducted four spacewalks as a member of Expeditions 50, 51, and 52 on the ISS and contributed to hundreds of experiments

After 2009, the ISS was able to accommodate six crew members (generally three Russians, two Americans, and one member from ESA, Japan, or Canada). Two Soyuz 'lifeboats' had to be stationed there at all times. In 2011, after the termination of the space shuttle programme, the ISS was serviced by Russia's Progress, Europe's ATV, Japan's H-II Transfer Vehicle, and two commercially-run cargo vehicles by SpaceX and Orbital Sciences Corporation. While there is no end date for the ISS mission, in 2014, former President Barack Obama's administration indicated that it would receive support till 'at least 2024'.

▲ Crew Return Vehicle (CRV) is an escape vehicle for the ISS

The Space Shuttle

A space shuttle is a partially reusable rocket-launched vehicle. It was designed by NASA to carry astronauts and cargo to and from spacecrafts in Earth's orbit. It served for 30 years, till July 2011.

⭐ Uses of the Space Shuttle

The space shuttle could carry seven astronauts. During its lifetime, it ferried nearly 355 people to space, launched satellites, and functioned as an orbiting science laboratory. The shuttle's crew often repaired other spacecrafts and equipment; the Hubble Space Telescope is an example of this. It went on a few military missions and in later years, was often used for ISS work. Its main parts can be seen in the picture given below.

▼ *Seen here is the Discovery space shuttle before the launch of the STS-114 mission*

NASA had five orbiters, of which Columbia and Challenger were lost due to accidents. Discovery, Atlantis, and Endeavour are now in different museums across the USA. The Enterprise orbiter never went to space, but was used for testing.

— A large external fuel tank

— A pair of long and thin solid rocket boosters to provide thrust to lift off the shuttle on launch

— The large white space plane was the orbiter, which went into orbit and was where the crew lived and worked. It comprised a payload bay for transporting cargo

▲ *Seen here is Atlantis—one of the five orbiters of the space shuttle—after it undocked from the International Space Station in September 2006*

⭐ Launching and Landing

Just like a rocket, the space shuttle took off with the help of rocket boosters. These burned for approximately two minutes, were dropped into the ocean, retrieved, and reused. The main engines fired for another six minutes. Then the external fuel tank detached and burned up. By this time, the shuttle and crew were in orbit.

On its return, the engines were fired to slow down the craft, and glide it on to a runway for landing. Upon touchdown, a parachute helped lower its speed.

☀ Isn't It Amazing!

The space shuttle's orbiters are humungous and would equal the length of nearly three and a half school buses (each being about 12 metres long)!

▶ *The Space Shuttle Orbiter Pathfinder*

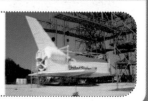

Satellites

An object that moves around a larger object is known as a satellite. There could be a natural satellite like the Moon that moves around Earth, or an artificial satellite such as a man-made machine. Both types of satellites orbit a larger astronomical body. Generally, natural satellites orbit a planet. Sir Isaac Newton was the first to suggest the idea of an artificial satellite in orbital flight, in 1687. Let us take a look at artificial satellites in Earth's orbit.

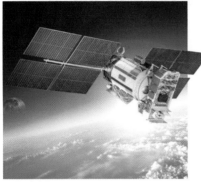
▲ A satellite can travel the entire circumference of Earth about 14 times in a day

▶ Moon is the largest natural satellite in the Solar System relative to the size of its planet

⭐ Where Do Satellites Orbit?

Artificial satellites like space stations, space shuttle orbiters, etc., can be crewed, or unmanned and controlled by robotics. Since the launch of the first artificial satellite, Sputnik 1, over 8,900 satellites have been launched into Earth's orbit by more than 40 different countries. Currently, there are over 2,787 satellites orbiting Earth, while the rest have exceeded their useful lives and become space debris. Other satellites have also sent into orbit around Venus, Mars, Jupiter, Saturn, Earth's Moon, and also the asteroid Eros.

👤 In Real Life

Global environmental changes are a matter of grave concern in the 21st century. These include the effects of global warming, ozone depletion, and widespread changes in land cover due to human activities such as **biomass burning**. Satellites have proved to be very useful in monitoring these activities on Earth. Satellite pictures enable scientists to 'view' Earth and understand the actual extent and impact of such activities on our planet. Data from satellites helps differentiate between environmental changes caused by human beings versus those caused by nature. NASA's Mission to Planet Earth programme is one such study of Earth from space.

▲ Deforestation has caused the depletion of rainforests in Brazil

⭐ Why are Satellites Important?

Satellites vary greatly in size, design, and function. Information about Earth's surface, atmosphere, and astronomical observations are mainly collected through scientific satellites. Weather satellites broadcast photographs and information related to cloud patterns and measure other meteorological conditions that help predict the weather. Relays made by communication satellites enable us to tune in to and make phone calls, receive radio and television programmes, and also access the internet from different parts of the planet. Some satellites help in navigation to determine the positions of ships and airplanes. The **Global Positioning System (GPS)** also uses navigation satellites. It is a space-based radio-navigation system that helps us find our location regardless of where we are in the world. Military satellites carry out military observation and surveillance.

▲ Many cars and phones today have GPS navigation systems that help people find their destinations

NASA's New Horizons space probe is the first to visit Pluto

💡 Isn't It Amazing!

Satellites can be small or very large. Small or 'picosatellites' weigh less than 1 kg. The ISS is an example of a large satellite which houses 6 astronauts and weighs more than 362,874 kg!

⭐ How Do Satellites Work?

Depending on the mission of a satellite, the technology on-board will vary. Computers aboard the satellite not only help receive and store data but also transmit information in the form of radio signals back to the stations on Earth. When scientists receive this information, they analyse the data and understand its implications. One method to do this is by feeding this data into computer models that use **algorithms** or mathematical formulas. The data is used by researchers to virtually recreate the processes that are happening on Earth, for example, how the atmosphere, water bodies, and land surfaces interrelate as a system. These computerised simulations enable an understanding of the correlation between Earth's systems and how its environment will change in the future. The high-resolution images of Pluto's icy surface sent back to Earth by NASA's New Horizons spacecraft is just one such example of the exemplary work done by artificial satellites.

Small Satellites

Artificial satellites vary in size and cost. They can be small enough to fit in the palm, or as large as the International Space Station. Small satellites can be further classified on the basis of their weight into minisatellites, microsatellites, nanosatellites, picosatellites, and femtosatellites. These are used in many space applications.

▲ *An astronomer holds up a KickSat, a femtosatellite*

Generic Name	Launch Weight
Minisatellite	100–500 kg
Microsatellite	10–100 kg
Nanosatellite	1–10 kg
Picosatellite	0.01–1 kg
Femtosatellite	<0.1 kg

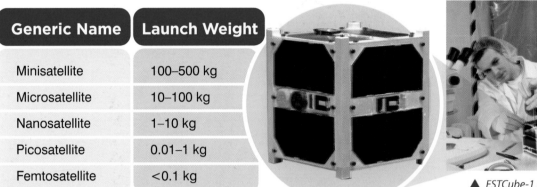

▲ *ESTCube-1 is an example of a CubeSat (a type of miniaturized satellite for space research)*

⭐ Challenges to Small Satellites

There is uncertainty in the sustainability of the business of small satellite manufacturers. They use multiple small satellites to deliver global high-resolution photos of Earth, daily. These are used for a wide range of important services such as gauging agricultural yield; oil and natural gas exploration and production; deforestation; mapping and geospatial services; tracking of ships in seas; emergency response; national security; mobile device support; and so on.

There is limited availability of adequate radio spectrum for satellites. Frequencies for CubeSats (a class of nanosatellites) are in the VFH and UFH bands, i.e., 144-146 MHz and 435-438 MHz. They are governed by the International Amateur Radio Union (IARU). These bandwidths are small and can transmit only limited data. Higher frequency bands yield wider bandwidths but need a special license.

▲ *Three microsatellites placed together*

Small satellite companies must also behave responsibly and pay great attention to the challenge of clean-up and removal of orbital debris (also known as space debris or space junk), which refers to stray man-made objects floating in space. These objects can travel at speeds of up to eight kilometres per second. At such high speeds, even a fleck of paint can damage spacecrafts. Unfortunately, there are hundreds of thousands of such pieces floating in space. Small satellite makers will need to design new ways to deorbit after completing their missions, as the debris poses extreme danger to human life and property (such as the ISS) in space.

⭐ ISRO Nano Satellites

▲ *MAYA-1, a nanosatellite built in the Philippines*

ISRO (Indian Space Research Organisation) Nano Satellites (INS) is a nanosatellite bus system to carry experimental payloads (cargoes) up to 3 kilograms. The INS system accompanies bigger satellites on Polar Satellite Launch Vehicles (PLSV). The main goals are to conceptualise and make low-cost modular nanosatellites; carry ISRO technology payloads; provide a standard vehicle for on-demand services; and carry materials for universities; and research and development laboratories.

PSLV-C37, launched on 15 February 2017, carried two ISRO Nano Satellites—INS-1A and INS-1B as co-passenger satellites. INS-1C was launched by PSLV-C40 on 12 January 2018. Small satellites are continuously being made cheaper, faster, and with less wastage by leveraging 3D printing technology.

Demystifying and Calculating Distances in Space

How do scientists measure astronomical distances of celestial objects and find out how far they are? On Earth, we measure 'distance' in kilometres or miles. Similarly, distances of objects in space have specific measurements and units.

⭐ Light year and Astronomical Unit

In astronomy, vast distances in space are calculated using the unit of **light year**, which is the distance travelled by light (moving in a vacuum) in one year, at 299,792,458 miles per second. An **Astronomical Unit (AU)** is a unit of measurement equal to 149.6 million kilometres, which is the mean distance between the centres of Earth and the Sun. So, one light year is equal to about 9.46 trillion kilometres or 63,241 AU.

Proxima Centauri is the star closest to Earth. It is 4.24 light years away from Earth and is a dwarf star. Even though it is the closest star, walking to Proxima Centauri would take 215 million years and travelling to it on the Apollo 11 spacecraft would still take 43,000 years! That is how far objects in space are. So, it is much easier to talk about their distances in light years, rather than referring to them in millions, billions, or even trillions of kilometres or miles.

⭐ Measuring Distances

In astronomy, geometry is used to measure distances between celestial bodies such as a planet and a star, or between two stars. One of the most accurate methods used to measure distances to stars is called '**parallax**', and its unit is an **arcsecond**. But what exactly is this method?

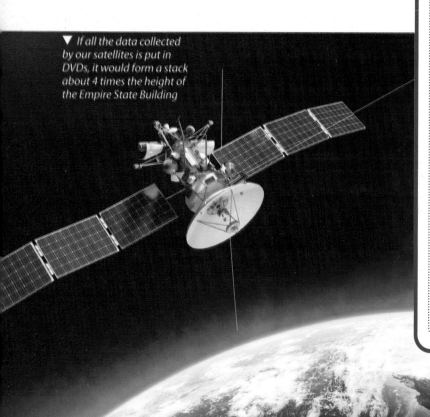

▼ *If all the data collected by our satellites is put in DVDs, it would form a stack about 4 times the height of the Empire State Building*

⊛ Incredible Individuals

One of the most important American astronomers in the first half of the 20th century was Henry Norris Russell (1877–1957). He played a key role in laying the foundations of modern theoretical astrophysics by making physics the central subject in astrophysical practice.

▲ *American astronomer Henry Norris Russell spent most of his professional life at Princeton University as a student, instructor, and professor and later as director of the observatory*

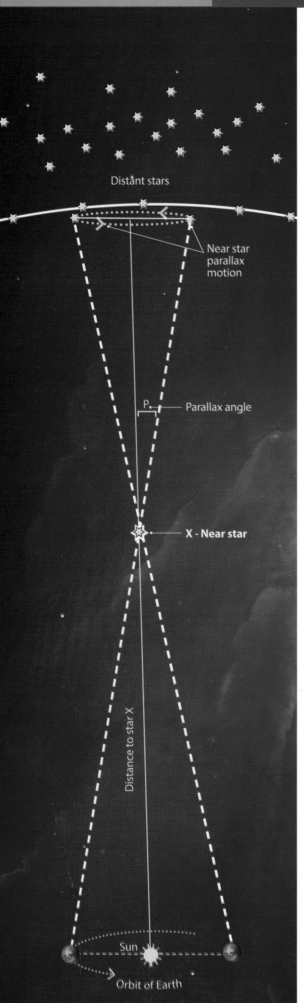

Distant stars

Near star parallax motion

P. — Parallax angle

X - Near star

Distance to star X

Sun

Orbit of Earth

⭐ Understanding Parallax

A parallax is the difference in the direction of a celestial object, as seen by an observer from two widely separated points. Try this experiment to understand what a parallax is:

- raise a finger in front of your face at an arm's distance. Keep still and be careful not to move your finger.

- close one eye and observe the position of your finger with the other eye.

- now, close that eye and open the other. Observe the position of your finger again. What did you notice?

It would appear that the position of your finger has 'shifted' a small distance in relation to the more distant objects behind it. Your finger and your two eyes are three points on a plane that form a long triangle. The shift that you notice is caused due to your eyes being separated from each other by a few inches. So each eye sees the finger in front of you from a slightly different angle. That small angle by which your finger appears to move is known as the parallax.

Now, instead of your two eyes, take the base of the triangle as the two points on Earth (six months apart), on opposite sides of the Sun. The star marked as X in the diagram is like your finger. The line shown going up from the Sun to star X (seen in the middle of the diagram) is the distance between the Sun and star X. If you click a photograph of a star, it will seemingly move relative to the background stars, just like your hand seemingly shifted relative to your surroundings. Knowing the parallax angle that the star moved and the size of Earth's orbit, one can calculate the distance to the star.

◀ *The first successful measurements of stellar parallax were made by Friedrich Bessel in 1838*

⭐ Arcseconds and Parsecs

Since the parallax angle by which even the nearest stars appear to have moved is so small, it is difficult to measure this distance. Parallax is measured using a unit called an arcsecond. A circle has 360 degrees. Each degree is the same as 60 arcminutes. 1 arcminute is the same as 60 arcseconds. So, 1 arcsecond is $1/3,600^{th}$ of a degree. Usually, a unit called **parsec** is used to measure interstellar distances. A parsec is the distance at which a star has a parallax of 1 arcsecond. 1 parsec is the same as 3.26 light years or 206,265 AU. Parsec is used to measure larger distances, while parallax or arcsecond is used to measure smaller distances.

The Future of Space Exploration

Over the years, humans have made incredible progress in space exploration. The 21st century is also called the Age of Information and Technology. The study of space has become even more exciting in this century, thanks to innovations in space travel and exploration.

⭐ Recent Developments

NASA recently launched its new-generation Orion spacecraft and will soon complete building the massive tennis court-sized James Webb Space Telescope. ESA successfully landed a space probe called Rosetta on a comet, 510 million kilometres away. China has begun developing its next space station. India is preparing for its first manned mission to space to be carried out by 2022!

There are many other new developments in the field of space exploration. Low-cost recyclable rockets could be a possibility in the future. People might be able to take short space vacations of 7-10 minutes. Some astronomers even believe that human beings could form a colony on planet Mars, though this might only be possible in the distant future.

▲ NASA's James Webb Space Telescope is a marvellous engineering accomplishment and is the most advanced space observatory in the world

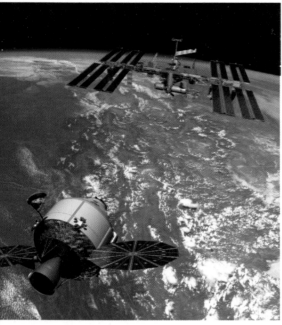

▲ The Orion space capsule and the ISS photographed in September 2006

⭐ Private Spaceflights

Private companies have played a part in spaceflights since 1962, when NASA launched its first privately-made satellite. Today, companies like SpaceX and Boeing have started competing for big government contracts.

On February 6, 2018, SpaceX successfully launched an operational rocket named Falcon Heavy into space. It carried a Tesla Roadster, which is an electric sports car. Starman, a mannequin dressed in a spacesuit, sat in the driver's seat of the car. Falcon Heavy became the most powerful operational launch vehicle in the world.

Blue Origin and Virgin Galactic are some other examples of private companies that have ventured into space tourism. Blue Origin's upgraded New Shepard spacecraft shows amazing views of Earth. It went on its tenth test flight in January 2019. This marks another step towards sending paying tourists into suborbital space.

◀ Launched by SpaceX, Falcon Heavy's side boosters land on Landing Zone 1 (LZ1) and Landing Zone 2 (LZ2) during a demo mission

★ Headed to the Moon

Moon missions are essential to explore the distant world. Long-duration visits to Earth's satellite help build the experience and expertise required for similar long-term space expeditions to other planets. The Moon can also be used as an operational base where astronauts can restock supplies (including rocket fuel and oxygen) by making them from local materials. Even though people have been to the Moon before, there are still many things left to be explored. For example, astronomers and scientists need to visit the Moon's poles to investigate if water, in the form of ice, exists there. Future missions to the Moon are certainly on the cards.

▲ *Twelve people have walked on the moon till today*

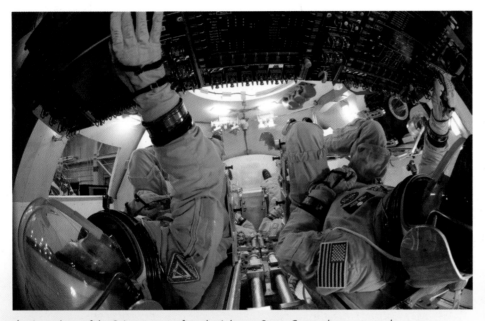

▲ *A mock-up of the Orion spacecraft at the Johnson Space Center demonstrates how crew members would be seated during a launch*

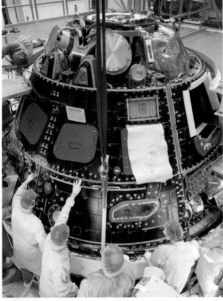

▲ *Technicians carrying out some work on the Orion crew module at NASA's John F Kennedy Space Center in Florida*

👤✓ In Real Life

The Falcon Heavy launch generated excitement amongst the general public and space industry. Along with broadcasts of Starman, the launch was viewed 40 million times on SpaceX's YouTube channel. The company has since then bagged its first competitive contract from the US Air Force.

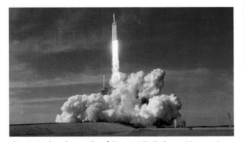

▲ *Maiden launch of SpaceX's Falcon Heavy in February 2018*

★ State-of-the-art Spacecrafts

The new NASA missions are getting more advanced with state-of-the-art technologies. For example, the design of NASA's Orion crew exploration vehicle is along the lines of the earlier Apollo missions, but with upgraded systems that use modern technology. The new capsules will be large enough to accommodate four crew members and have three times the volume capacity. The Orion capsules are supposed to be safer and more reliable than the space shuttle.

An added innovation is that they are built to be reused up to ten times and will use the same method of parachuting back to Earth, but will land on dry land, instead of an ocean splashdown. Having launched Orion in an unmanned test flight in December 2014, NASA aims to send a crewed mission on it in 2021. Such new-age space vehicles herald a new period in space exploration—one which will take human beings farther than they have ever been before, including in close proximity to the Moon and Mars!

Space Tourism

Recreational space travel is known as space tourism. Today, space tourists can visit celestial bodies on government-owned spacecrafts like the Soyuz and the ISS. While it will not be very common, people might also be able to travel to space on vehicles operated by private companies.

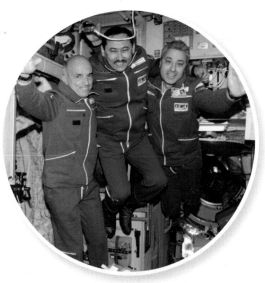

▲ *Dennis Tito (extreme left)— the first American space-flight participant—along with a Soyuz commander and flight engineer. The trio took off from the Baikonur Cosmodrome in Kazakhstan*

⭐ Orbital versus Suborbital Flights

Would you like to zoom off into space and go where no private citizen could have gone prior to 2001? Now you can! In fact, you can choose between an orbital space flight and a suborbital flight. There is an astronomical difference in the cost that may help you make your decision.

The difference between an orbital and suborbital flight is in its trajectory. A trajectory is the path that a rocket or spacecraft takes. An orbital flight continuously goes around Earth, moving very fast, while a suborbital flight entails lift-off, making a great arc and falling back to reach Earth. Going into space is expensive. An orbital space tourism flight would be more expensive, since the spacecraft has to reach a speed of almost 12,874 kmps to get into orbit. However, going into space and falling back to Earth would use less energy and is therefore less expensive.

Orbital space tourism flights began with an American businessman named Dennis Tito in April 2001. He paid $20 million for a flight aboard the Soyuz TM-32, which took him to the ISS. He spent seven days at the ISS. Several other individuals from different countries went on space tourism flights thereafter. A company called Space Adventures even offered a spaceflight around the Moon on a Soyuz craft for an amount of $100 million!

💡 Isn't It Amazing!

XCOR's EZ-Rocket, a ground-launched, rocket-powered aircraft piloted by Dick Rutan created history, in 2005, with its record-setting point-to-point flight from the Mojave California Spaceport.

▶ *XCOR Aerospace's EZ-Rocket landing in California city*

▼ *Virgin Galactica- a private company that designs commercial spacecrafts and aims to offer sub-orbital spaceflights*

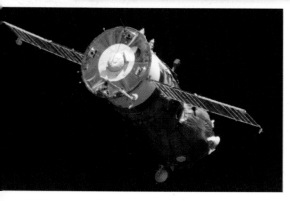

▲ *The Soyuz TM-32 after leaving from the ISS*

Several private companies now make spacecrafts to ferry human beings on suborbital flights. Amongst them are Virgin Galactic, Astrium, XCOR Aerospace, and Blue Origin. The industry is now opening up a space that was so far only the domain of trained astronauts and scientists.

▲ Seen here are Virgin Galactic's White Knight Two and SpaceShip Two during a fly-by at the Spaceport America launch complex in New Mexico

⭐ Why is Space Tourism Significant?

Notwithstanding the prohibitive costs there are benefits of space tourism which some people feel will eventually help the entire human race.

The space tourism industry now has private players, so space ambitions and missions will no longer be dependent on government funding. Commercial spaceflight companies are already researching capsules to take tourists around the Moon and even land on Mars. This will create and motivate a new generation of engineers who will get an opportunity to be at the forefront of space exploration.

With increased competition, the cost of reaching space is likely to reduce. Currently, private space companies are in the early stages of developing first-generation rocket planes. Eventually, suborbital, point-to-point flights may become a reality and transport people at a fraction of the time it currently takes. Suborbital flights will cater not only to space tourism but also to scientific research. This could also have environmental benefits.

When astronauts first viewed Earth from space as a tiny round blue speck against the vastness of the universe, it changed their view of our planet. That's another reason why space tourism is significant. Space travel will change our perspective and world view for the better and help us strive harder to solve some of Earth's biggest problems like climate change, pollution, etc.

▲ A view of the mock-up interior of the European Aeronautic Defence and Space Company Astrium Space Tourism Project

Robotics

The design, construction, and use of machines (robots) to do tasks which were conventionally done by human beings is termed robotics. Robots are often used in automobile manufacturing and in industries with hazardous environments. They are used to invent diagnostic and surgical techniques in the field of medicine. Some robots are equipped with **artificial intelligence (AI)**, which allows them to function in a way similar to humans. They might have vision, touch, temperature-sensing mechanisms, and simple decision-making features. Some robots are even shaped like human beings. They are called androids. Today's robots have come a long way from the first one installed in 1961 in a factory by General Motors, which was used to move hot metal pieces.

▲ *Kismet is a robot that was programmed with some social skills. Replicating social skills has been a challenging task in robotics*

⭐ What do Robots do in Space?

One big advantage of sending robots into space is that we need not worry too much about their safety, unlike in the case of human astronauts. Scientists certainly need these well-crafted robots to last for a long time to investigate, conduct experiments, and send back data and information about their destinations. But sending robots helps save human lives, in case there is a mishap or the mission fails.

It is also less expensive to send a robot to space. Robots do not eat, sleep, or go to the washroom. They can survive in outer space for many years. Some are even left there with no need for a return journey.

▶ *An artist's portrayal of NASA's Mars Exploration Rover as seen on the surface of Mars. The first two rovers were launched within weeks of each other. They were the rovers Opportunity and Spirit*

Another advantage of doing so is that robots can undertake risky tasks that humans cannot. They can bear harsh conditions in space, such as very low or high temperatures and increased levels of radiation. Therefore, advances in robotics have also expanded the scope of space exploration.

★ NASA's Robots

Curiosity, Spirit, and Opportunity are among the most well-known and popular rovers built by NASA to investigate Mars.

NASA's more recent robots are Puffer (Pop-Up Flat Folding Explorer Rover) and BRUIE (the Buoyant Rover for Under-Ice Exploration). Origami designs have been the inspiration behind Puffer, which is a very lightweight, two-wheeled robot that can make itself flat and crouch down to explore tight spots.

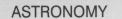

▶ A computer-aided-design drawing of NASA's 2020 Mars rover

BRUIE is unique as it can float on water, take photographs, collect data, and travel with ease on the bottom of an icy surface using wheels.

Sometime in the future, it may be possible for robots like these to look for signs of life on icy bodies in the solar system.

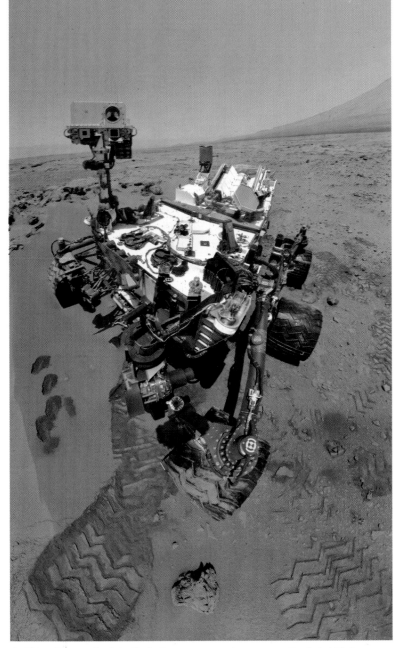

▲ This self-portrait of the Curiosity rover was taken at one of its first drill sites

★ Other Types of Robots

Not all robots are rovers, some take on other curious shapes, like the Hedgehog, which is a spiky, cube-shaped robot being built by NASA along with Stanford University and Massachusetts Institute of Technology (MIT), USA. The Hedgehog robot is mainly being designed to explore asteroids or comets which are smaller celestial bodies that have very little gravity and an uneven terrain. So, instead of rolling on four wheels like a rover, this one hops and tumbles and can operate on any one of its sides.

R5 or Valkyrie developed by NASA's Johnson Space Center is a humanoid robot. These robots are made because there are some situations where it is best for a robot to have human-like movements to carry out particular tasks. For example, similar robots could be useful in helping human beings settle on Mars in the future. Irrespective of their shape, size, and function, robots are an important invention for space exploration.

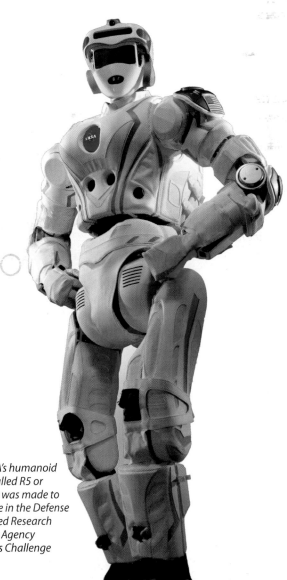

▶ NASA's humanoid robot called R5 or Valkyrie was made to compete in the Defense Advanced Research Projects Agency Robotics Challenge

Future Space Missions

"To confine our attention to terrestrial matters would be to limit the human spirit."
— **Stephen Hawking**

The human spirit has always sought a challenge. Space exploration is one such challenging area. As long as the universe exists, scientists will continue to seek answers about its origins by employing advanced technology, instruments, satellites and space probes. Scientific inquiry; rivalry and competition amongst nations; commercial gains; and the search for 'other habitable' planets are some other motivations that have led to advancements in space exploration.

★ Future Space Missions

The 2020 Mars Rover

Camera technology has greatly advanced since NASA's Mars Pathfinder, with five cameras, landed in 1997. The 2020 rover Perseverance will have 23 cameras. It will explore a region of the planet believed to have supported microbial life many years ago. The rover will also perform an experiment to extract oxygen from the Martian atmosphere, provide landscape photographs, reveal obstacles and study the atmosphere.

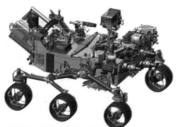

▲ *A computer-assisted-design work of NASA's 2020 Mars rover Perseverance*

Lunar Flashlight

◄ *The Lunar Flashlight, a secondary payload on NASA's first Space Launch System flight, will investigate the lunar surface for ice deposits*

NASA's Lunar Flashlight (planned launch in November 2021) on the Space Launch System's Exploration Mission-1 (EM-1) flight will map the Moon's south pole for volatiles (components that are gases at room temperature) and will be the first CubeSat to reach the Moon, use green propulsion, and look for water ice using lasers.

Mid-Infrared Instrument (MIRI)

MIRI will play a crucial role in NASA's James Webb Space Telescope and will click images of stars and galaxies in infrared light. The data generated will throw light on the evolution of the universe and the search for the very first star formation episode. The instrument is working toward a 2021 launch date.

▲ *(L-R): Pictures of the Mid-Infrared Instrument (MIRI) and a NASA engineer inspecting copper test wires inside the thermal shield of MIRI which will travel aboard the James Webb Space Telescope*

▲ An artist's rendering of the Europa Clipper spacecraft, as per NASA's Jet Propulsion Lab

NASA's Mission to Europa

NASA's Europa Clipper, a radiation-tolerant spacecraft with nine scientific instruments on-board, will study Europa (one of Jupiter's largest moons) to search for conditions that may support life. There has been some proof that an ocean of liquid water exists below the icy moon's crust. It will do a long, looping orbit around Jupiter with a series of close fly-bys of Europa.

▲ Developed by NASA, the DSAC, a miniature mercury-ion atomic clock is expected to improve the precision of navigation in deep space

NASA's Deep Space Atomic Clock (DSAC)

DSAC is 50 times more accurate than the best navigation clocks today. It is a small, ultra-precise mercury-ion atomic clock to be used for radio navigation, i.e. using radio frequencies to accurately determine the position of something. Radio navigation is vital for deep-space exploration missions. The DSAC will improve navigation of spacecrafts to reach far-off places, enable gathering of more data with enhanced precision, and help in radio science and GPS.

INSPIRE

NASA's Interplanetary NanoSpacecraft Pathfinder In Relevant Environment (INSPIRE) mission plans to show the groundbreaking capability of deep-space CubeSats by putting a nano spacecraft in Earth-escape orbit.

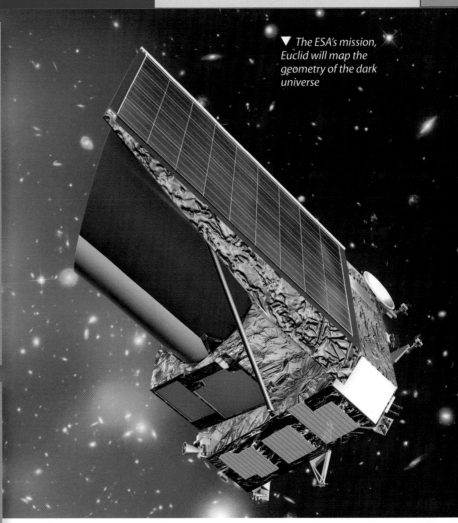

▼ The ESA's mission, Euclid will map the geometry of the dark universe

⭐ The Euclid Mission

Euclid is a planned mission of the ESA with significant inputs from NASA. These inputs include infrared detectors for one instrument and science and data analysis. The mission plans to investigate and provide information on dark matter and dark energy. The scheduled launch is in 2020.

⭐ Gaganyaan

One of India's most ambitious space projects is Gaganyaan. ISRO's Human Space Flight Centre is responsible for its implementation. It will be India's first manned mission and will take three Indian astronauts into space for seven days in low-Earth orbit. The mission will make India only the fourth country in the world after the USA, Russia, and China to send human beings to space!

▶ An info-graphic displayed at the Bangalore Space Expo (September 2018), shows ISRO's Gaganyaan orbital vehicle's Crew and Service Module

MISSION EXPLORATION

EXPLORING **SPACE**

The human race has been curious about outer space and celestial bodies for a long, long time. This interest in the unknown and the curiosity to explore new worlds and frontiers has been an enduring one. It has encouraged human beings to push the boundaries of science and technology, and has challenged us beyond imagination. More than 400 years ago, astronomers had to rely only on their eyes to observe the skies, but with the advent of the telescope and, much later, rockets and spacecrafts, they were able to delve deeper into the mysteries of outer space. Space exploration has thus, reaped multiple benefits for humanity for decades, including a deeper understanding of our universe, and particularly, the solar system. It has unravelled answers to basic questions like the place of humans and Earth in the vast cosmos, and the history of our planetary system.

▼ *A rocket can carry over 6,000 pounds of weight at speeds of up to 22,000 miles per hour*

A Brief History

By the early 20ᵗʰ century, rocket technology had progressed to a point where it was possible to send objects with sufficient speeds to orbit Earth and perhaps even escape Earth's gravity to go further. The idea of human space exploration gained popularity amongst the public, and even scientific and military planners started to initiate space projects and develop launch vehicles.

⭐ Early Rocket Pioneers in the 1900s

A Russian school teacher and mathematician, Konstantin Tsiolkovsky (1857–1935) was one of the first persons to study the use of rockets for spaceflight in the 1900s. His article, *Exploration of Cosmic Space by Means of Reaction Devices,* in 1903, mentioned several principles of spaceflight. His work influenced rocket research in the Soviet Union and Europe.

▲ *A theoretical scientist and a practical engineer, Dr Robert H. Goddard is acknowledged as the father of American rocketry*

In the United States of America, Robert Goddard (1882–1945) was inspired by space exploration after reading H.G. Wells's book, *The War of the Worlds*. He was awarded his first two patents for rocket technology in 1914. When Goddard claimed that rockets could be used to send objects to the Moon, he was ridiculed, after which he did most of his work in secrecy. As a physics professor, Goddard experimented with liquid-fuelled rockets and built engines and more advanced rockets.

Hermann Oberth's (1894–1989) books and work explained the mathematics behind the theory of rocketry, rocket design, the idea of constructing space stations, and outer space journeys to other planets. *Ways to Spaceflight* was his second significant book. Inspired by his work, rocket clubs and associations—including the Verein für Raumschiffahrt (VfR: Society for Spaceship Travel)—were set up in Germany. These groups attempted to put Oberth's ideas into practice.

⭐ Other Pioneers

Frenchman Robert Esnault-Pelterie (1881–1957) wrote about the theoretical features of spaceflight in 1907, and Austrian Eugen Sänger (1905–1964) suggested developing a 'rocket plane' that would reach speeds of 10,000 km per hour and achieve a height of 65 km.

⊙ Incredible Individuals

At 20, German-born Wernher von Braun (1912–1977) became the chief engineer of a rocket-development team for the German army. In 1933 Nazi Germany, Braun was titled the civilian head of that team. He played a significant role in all areas of rocket science and space exploration, first in Germany, and after World War II, in the USA. Through his talks and writings, Braun helped popularise the concept of human space travel and created an open environment for government space activities.

▶ *A key figure in America's space programme, Wernher von Braun standing near the F-1 engines of the Saturn V Dynamic Test Vehicle, at the US Space and Rocket Center in Alabama*

⭐ Rockets: Early Development

Germany

Influenced by the rocket-building activity of the VfR in the 1930s, the German military started making rockets at a centre close to the Baltic Sea. The V-2 ballistic missile was developed and launched there in 1942. Initially used as a military weapon, it later served as a prototype in the American and Russian space programmes. After World War II, some of the Germans surrendered to the USA and went there along with the engineering plans and parts required to build V-2s. Amongst them was Wernher von Braun, who played a crucial role in early rocket development in both Germany and America.

▲ *Wernher von Braun (seen in the picture in a black suit) is often known as the "Father of Rocket Science"*

United States

In the 1930s, young American engineers under the leadership of Frank Malina (1912–1981) worked on rocket science. Aerodynamicist Theodore von Kármán (1881–1963) and Chinese engineer Qian Xuesen (1911–2009) supported them. Xuesen went back to China in the 1950s and pioneered rocketry. In 1943, Malina and his colleagues developed weapons which were modified for use in early space experiments in the USA. From 1946 till 1951, several experiments were conducted by US scientists on captured V-2 rockets. The Upper Atmosphere Research Panel headed by Physicist James Van Allen worked on the scientific uses of rocket launches.

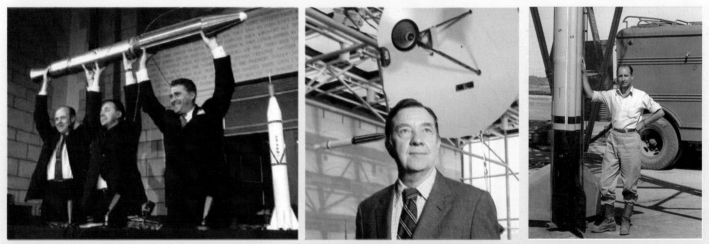

▲ *(From L-R): William Pickering, James Van Allen and Wernher von Braun—the brains behind Explorer 1 (1958); Physicist James van Allen seen at the Smithsonian National Air and Space Museum in Washington D.C., USA; American engineer Frank Malina at the White Sands Missile Range, seen with the fifth WAC Corporal. In 1943, Malina and his colleagues called their group the Jet Propulsion Laboratory, which became a centre for missile research and development in USA*

Soviet Union

In 1921, the Russian government built a military centre focused on rocket research. In the 1930s, Valentin Glushko did groundbreaking work on rocket engines. In 1933, members of GIRD (Group for the Study of Reactive Motion) were responsible for launching the first Soviet rocket that worked on liquid fuel.

▶ *A stamp commemorating Valentin Glushko*

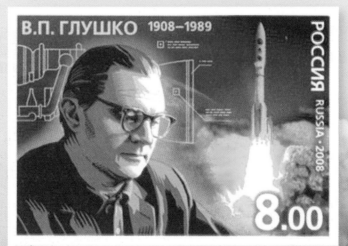

The Cold War and Space Race

Both the Cold War and the Space Race were important and exciting events in the history of space exploration. Read on to find out more.

⭐ The Cold War

After World War II, from 1947 to 1991, the USA and the Soviet Union—the most powerful nations of the time—were embroiled in a 'Cold War' i.e., a war in which there was no direct battle, minimal use of weapons, and the two parties were not officially in a state of war. Both countries had different political ideologies; while USA was a capitalist democracy, the Soviet Union was a Communist totalitarian regime. The countries were motivated by both ideological and geopolitical factors. While both had acquired atomic bombs, it would have been disastrous for them to engage in a real war. So, they competed on other fronts in a race for supremacy. Space was one such front.

⭐ What was the Space Race?

Both the USA and the Soviet Union tried their best to gain expertise in space exploration, space flights, and rocket technology. This resulted in the Space Race. The rivalry between the two nations was so great that both had secret satellites which they used to spy over each other's activities. Military usage to locate an enemy was one of the main aims of spaceflight.

▲ *The Space Race ultimately became a race to reach the Moon first*

⭐ Publicity Versus Secrecy

The Space Race also showed philosophical differences between the two nations in the way they functioned. Military and civilian agencies were separate in the USA. Only military space missions were kept confidential. Civilian space activities were widely publicised, especially the race to the Moon.

On the other hand, all the space programmes in the Soviet Union were run very secretively, and as part of the military. No prior publicity was done regarding their launches, and only those missions which were successful were made public.

Since the Soviet Union was so silent and secretive about their space activities, the leaders of the USA feared a nuclear attack and wanted to know what their rival was doing. So, they took photographs of the Soviet Union from space from 1960 to 1972 as part of a military observation project named Corona.

◀ *The American Saturn V rocket aided NASA's Apollo programme in the human exploration of the Moon*

🏅 Incredible Individuals

Russian scientist Sergey Pavlovich Korolyov (1907–1966) was best known as the 'Chief Designer', having played a key role in the design, testing, and construction of the Soviet Union's guided missiles, rockets, and spacecrafts (including Vostok, Voskhod, Soyuz, and several others).

The Moscow Group for the Study of Reactive Motion was formed by Korolyov along with F.A. Tsander. In 1933, this group was responsible for launching Russia's first liquid-propellant rocket. After World War II, amongst other things, Korolyov improved the German V-2 missile, increasing its range to about 685 kilometres. His work on developing a series of ballistic missiles in 1953 resulted in Russia's first intercontinental ballistic missile (ICBM).

Korolyov was the guiding force behind the Soviet Union's space flight programme.

⭐ Race to the Moon

At the beginning of the Space Race, there were no clear goals, nor were there any defined rules. At first, the Soviet Union led with the launch of Sputnik 1, the world's first artificial satellite. Their achievements included putting the first living creature, Laika the dog in space; the first man, Yuri Gagarin in space; the first woman, Valentina Tereshkova in space; the first spacewalk, etc.

The pressure to catch up inspired the US. President John F. Kennedy's declaration in 1961, "I believe that this nation should commit itself to achieving the goal before this decade is out, of landing a man on the Moon and returning him safely to the Earth," reflected USA's resolve of landing a man on the Moon.

This marked a turning point in the Space Race—which turned into a race to be the first on the Moon.

While the Americans were open about their goal, the Soviets, for many years, were very secretive and even denied their participation in the race to the Moon.

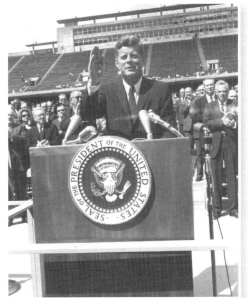

▲ US President John F. Kennedy addressing a crowd of 35,000 people at Rice University in 1962, where he said, "But I do say space can be explored and mastered without feeding the fires of war..." and also referred to America's Moon mission

◄ Artificial satellites in space have multiple uses: they help in predicting the weather, in communication, and in taking photographs of celestial objects, which help scientists gain a better understanding of our universe, including the solar system

🔆 Isn't It Amazing!

Explorer 1 was the first space satellite put into space by NASA in 1958, and was responsible for discovering the innermost regions of the Van Allen radiation belts—two regions of charged particles surrounding our planet. This made history since it was the first scientific discovery to be made by a man-made (artificial) satellite.

▶ The Explorer 1 space satellite just before its launch at NASA's Jet Propulsion Lab

The First Space Explorers

The Soviet Union initially led the Space Race by sending the first living creature and the first man into space. However, the USA won by becoming the first country to send a human being to the Moon. Let us see who these first and early space explorers were.

★ Soviet Union: Racing Ahead

The world's first artificial satellite, Sputnik 1, launched by the Soviet Union on 4 October 1957, marked the beginning of the Space Age. It weighed 83.6 kilograms, and circled Earth every 96 minutes until early 1958, after which it fell back and burned up in Earth's atmosphere.

One month later, Sputnik 2 carried Laika, a dog, went into space. Similar experiments were carried out on different animals via eight other Sputnik missions to test the spacecrafts' life-support systems and re-entry procedures. These helped collect vital information about the temperatures, pressure, particles, radiation, and magnetic fields in space.

In hot pursuit, USA launched their satellite Explorer I in January 1958.

▲ *A model of Sputnik 1*

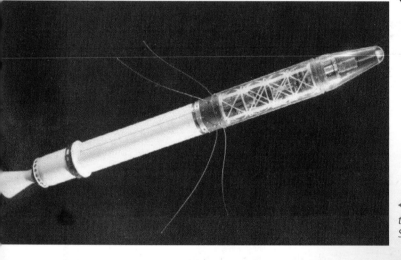

◀ *America's answer to the Soviet Union's Sputnik—Explorer 1*

★ Soviet Cosmonauts

While 'astronaut' refers to a person from the USA, Europe, Canada, or Japan, who is certified and trained to travel in space, 'cosmonaut' is a term used in Russia and the former Soviet Union for a person certified by the Russian Space Agency to work in space. On 12 April 1961, the Soviet Union sent the first cosmonaut, Yuri Gagarin into space aboard the Vostok I. Over the next two years, there were six Vostok space missions. Except for the first two, all the other Vostok spacecrafts went up in pairs. Each of them bettered the time in orbit and distance covered. In June 1963, Vostok 6 transported the first female cosmonaut, Valentina Tereshkova into space. The Vostok spacecrafts travelled extremely close together (sometimes as close as 4.8 km). This paved the way for future space dockings between orbiting vehicles.

American Astronauts

A few weeks after the Vostok 1 launch, the United States began the Mercury mission—a series of manned spaceflights. Alan B. Shepard Jr. was the first American in space and undertook a 15-minute flight aboard Freedom 7. One year later, astronaut John H. Glenn became the first American to orbit Earth. In May 1963, Faith 7 was the final flight in the Mercury series, and the first US spaceflight that lasted more than a day, orbiting Earth 22 times.

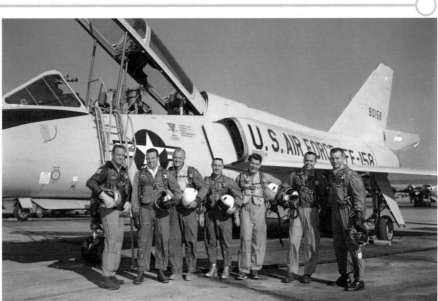

▶ *The Mercury Seven astronauts posing in front of an F-106 Delta Dart*

The US Moon Mission

Apollo 11 was the historic mission that took the first human beings to the Moon. It was launched on 20 July 1969 and successfully returned to Earth on 24 July. The astronauts aboard, Neil Armstrong, Buzz Aldrin (real name Edwin Eugene Aldrin Jr.), and Michael Collins undertook various tasks to collect important information after arriving on the lunar surface, including measuring the composition of the solar wind reaching the Moon, setting up devices to figure out the precise distance between Earth and the Moon, and measuring **moonquakes** and the impact of meteors. They also collected rock and soil samples from the Moon's surface.

▼ *Vostok 1—the Soviet spacecraft that took the first human to space*

⊛ Incredible Individuals

Katherine Johnson (1918-2020), an American mathematician, was a genius. She was amongst the first three African Americans who got selected for a graduate programme at West Virginia University. Johnson was responsible for calculating and analysing the flight paths of several spacecrafts, including the path for Freedom 7. She played a key role in most of the important NASA space programmes for more than 30 years. She was a key team member of the Apollo 11 mission.

▲ *Katherine Johnson after receiving the Presidential Medal of Freedom in November 2015*

The American Space Programme

One of the main reasons why the US space programme started was to invent larger rockets for military warfare and national defence. Since then, it has grown by leaps and bounds and has accomplished things that make not just Americans, but all of humanity, proud.

The Beginning

The American space programme emerged as a result of the intermediate range and intercontinental ballistic missile programmes (IRBM and ICBM). These were started after World War II by the US military in order to launch larger warheads into space with the help of rockets.

In the 1950s, the US government's priority was to develop the Utility-2 (U-2) aircraft to conduct military observations of the Soviet Union. In 1960, when a U-2 was shot down, Americans realised that the only way to 'observe' the Soviet Union was through satellites and space exploration.

While the US was capable of sending a satellite into Earth's orbit by the mid-1950s, they believed a 'space race' was unnecessary. The Soviet Union beat them to it when they launched Sputnik in 1957. After several failed attempts, it took America another year and a half before they could successfully launch Explorer 1 and later, Vanguard.

The Birth of NASA

The National Aeronautics and Space Administration (NASA) was established in 1958 in response to the Soviet launching of Sputnik. NASA's mission was to conduct research, develop vehicles, and undertake space exploration activities within and outside Earth's atmosphere.

The following four directorates help NASA carry out its many functions:

- **Aeronautics** (the science of designing, building, and operating an aircraft) Research for developing cutting-edge aviation technologies;

- **Science:** programmes to understand the origin, structure, and evolution of the universe, the solar system, and Earth;

- **Space Technology:** Expansion of space science and exploration technologies;

- **Human Exploration and Operations:** Managing manned space missions, operations for launch services, and space transportation and communications for manned and robotic space exploration programmes.

The Congress had established the National Advisory Committee for Aeronautics (NACA) in 1915. NASA was an off-shoot of the same.

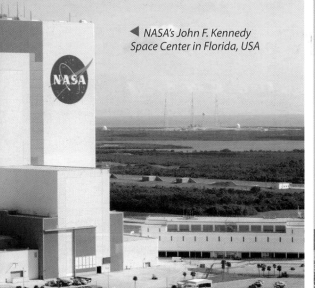

NASA's John F. Kennedy Space Center in Florida, USA

⭐ Major Achievements

By the early years of President Kennedy's administration, NASA was fairly well-established and gained momentum when he committed to send an American to the Moon. Thus began NASA's legendary Apollo missions which enabled Armstrong to be the first man to land on the Moon in 1969. NASA undertook several other unmanned missions to explore the solar system, including Viking, Mariner, Voyager, and Galileo.

NASA also launched several satellites, including the Landsat satellite series to collect data on Earth's features and natural resources, and other weather and communications satellites.

The **space shuttle**, the world's first reusable spacecraft designed by NASA took off on its first flight in April 1981 and went on 135 flights before its mission ended in 2011. A space shuttle is a partially reusable rocket-launched vehicle, which transports astronauts and cargo to and from spacecrafts that are orbiting in space, and one that is capable of landing on a runway when it comes back to Earth.

The NASA-built space shuttle was the first spacecraft in history that had the ability to carry large satellites to and from orbit

One of the two copies of the Voyager Golden Record

💡 Isn't It Amazing!

NASA's spacecraft Voyager 1, launched in 1977, is orbiting in **interstellar space** since 2012, and it will be the first man-made object to leave the solar system once it passes the Oort Cloud, after a few hundred years. No other spacecraft in the world has travelled so far.

Voyager 1 has on-board one copy of the 'Golden Record'—a message from the human race to the universe, which comprises greetings in 55 different languages, photographs of people and places on Earth, and a wide range of music from Beethoven to Chuck Berry!

The Soviet Space Programme

The Soviet Union's space programme was divided into two parts—military and scientific. All their military missions were well-guarded secrets. Only some aspects of their space programme were publicised.

⭐ Initial Development

The launch of the first satellite took the world by storm and inspired others to make advances in space. The satellite was named Sputnik, which in Russian means 'fellow traveller'.

At first the Soviets' intent was to be seen as a leader in technical, scientific, and military power. In the 1960s, however, they expanded their goal and launched new satellites for the purpose of military and commercial use.

Satellites for **meteorology** and civil communication were publicised, but those designed for photographic and military observation through Electronic Intelligence Satellites (ELINT), radar calibration, secret communication, navigation and the study of **geodesy** and satellite interception were disguised as part of their scientific research. The actual objective was mostly military use.

⭐ Shift in Focus

In the latter half of the 1960s, the Soviet Union attempted to test bigger and more intricate **rocket boosters** and space vehicles. But they were not completely successful and were not able to develop a booster which was big enough for a human mission to the Moon. Since the USA was already ahead of them with their Apollo project, the Soviets began to focus their human space programme on space stations in orbit around Earth instead. A space station is an artificial structure placed in space and has a pressurised enclosure, power, supplies, and environmental systems to support human habitation for a long duration. This shift in focus contributed greatly to inventions in space, as space stations have come a long way since then, and now form an integral part of the space framework.

◀ *The Soviet Union's Soyuz rocket being launched*

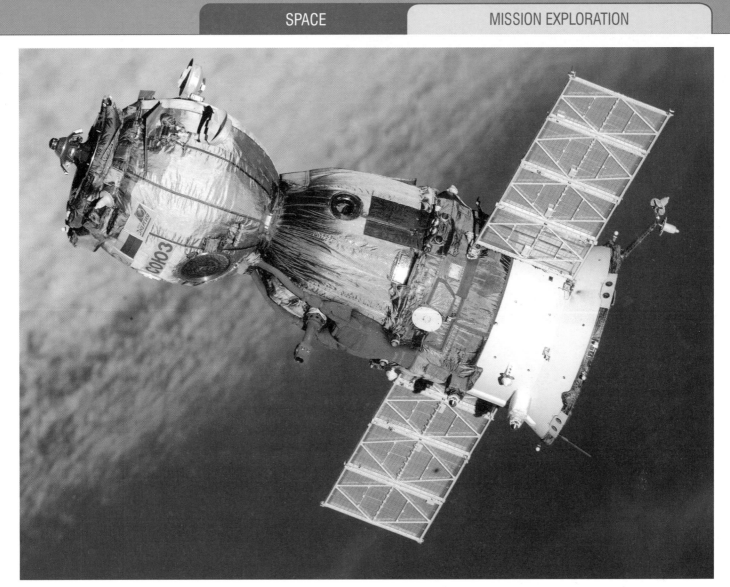

▲ *Russia's Soyuz Spacecraft*

⭐ Military Goals

In the early 1970s, they largely focused on building advanced and improved space systems for supporting the military. They also attempted to maintain their image of being experts in space exploration by advertising about the Salyut space stations. Salyut 1 was their first space station launched into orbit in 1971, with its three-person crew that spent 23 days on-board. Unfortunately, they didn't survive their journey back to Earth. Salyut 2 was also not successful and exploded after it reached orbit. Salyut 3 and 5 were military space stations, while 4, 6, and 7 were for scientific research.

The Soviet Union's space programme was largely focused on military efforts, with nearly 70 per cent of its annual launches being for this purpose. In the 1960s, the joint military-cum-civil missions had increased, but not significantly. The USA, however, had a more even distribution between military and non-military initiatives.

👤 In Real Life

Launched in 1977 and 1982 respectively, the Salyut 6 and 7 space stations were built with enhanced technology and a better design. Salyut 6 remained in orbit for four years and hosted several Soviet and international visitors. Over the four-year period, 28 astronauts visited the spacecraft and spent 2,117 manned days on it. Overall, the Salyut programme paved the way and helped develop and implement Mir, the next-generation space station.

All about Astronauts

An astronaut is a person who travels into outer space, but the term is commonly used for persons on US spacecrafts. The Chinese call them taikonauts or *yuhangyuans*, which in Chinese means 'space navigator'. Read on to know more about their brave journeys.

⭐ Who can Become an Astronaut?

People who apply to become astronauts undergo a strict selection process. Experienced test and jet aircraft pilots, and those with advanced scientific, medical, or engineering prowess are eligible. In the US, astronauts are classified into shuttle pilots and mission commanders, mission specialists, and educator mission specialists.
In Russia, they have two categories: mission commanders, who are usually pilots, and flight engineers.

⭐ How do Astronauts Prepare to Go into Space?

Astronauts undertake two to four years of rigorous physical and mental training and should be able to live in isolated and confined spaces for long periods. They undergo training in technical, safety, and survival techniques as well as handling emergencies. They are also trained in systems, robotics, spacecraft operations, space engineering activities, etc. Some of them working on the **International Space Station (ISS)** need to learn Russian to communicate with the Russian Mission Control Centre. The ISS was set up in low-Earth orbit mainly by the USA and Russia, with help and components from a multinational association.

▼ *Spacesuits protect astronauts from the hazards of being out in space.*
They are also known as Extravehicular Mobility Units

⭐ Simulations and Mock-ups

To prepare for space, astronauts often practice on life-sized models called 'mock-ups'. In the USA, the Space Vehicle Mock-up Facility serves this purpose.

At the facility, astronauts practice and learn to navigate themselves in a weightless condition called **microgravity** or zero gravity. The KC-135 (also called the Weightless Wonder or, humorously, the Vomit Comet) provides US astronauts with a zero-gravity environment for 20-25 seconds. Two other types of facilities help them practice moving large objects in space that have a tendency to float away, and practice spacewalks and rehearse on a full-sized model of a space vehicle while underwater.

⭐ What do Astronauts Eat?

Earlier, astronauts had to eat unappetising edible cubes, freeze-dried powders, and semi-liquids packaged in aluminium tubes. Freeze-dried foods were difficult to rehydrate and crumbs were dangerous since they could float off and destroy instruments on board. Since then, food eaten in space has improved considerably and astronauts today have a more appetising menu consisting of food items that can be prepared easily. Salt and pepper are only available in liquid forms since the powder form would pose a threat to both astronauts and the spacecraft.

▲ Astronauts float in space due to zero gravity, which leads to weightlessness

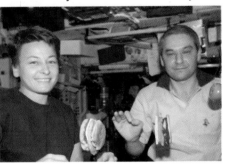

◄ A meal in space—astronauts eating floating tomatoes and hamburgers in the service module

⭐ Why do Astronauts Wear Spacesuits?

Spacesuits protect astronauts from harmful radiation and extreme temperatures experienced in space. They shield them against dangerous and fast-moving space dust particles that can injure them. The Primary Life Support Subsystem supplies oxygen for breathing and removes exhaled carbon dioxide. The visors protect the astronauts' eyes from harsh sunlight. A Liquid Cooling and Ventilation Garment keeps astronauts cool during a spacewalk.

👤 In Real Life

In space, flour tortillas are considered to be a better food choice than bread. This takes care of the problem of bread crumbs floating around. Meals and menus are planned in advance, and nutritionists ensure that the astronauts get their required daily intake of calories.

▶ A spacesuit weighs approximately 127 kg

The First Humans in Space

The Soviet Union sent the first human beings to outer space. This was a huge milestone for them and for the entire space industry. Let us take a look at some of these pioneers.

⭐ Yuri Gagarin: First Man in Space

Yuri Gagarin (1934–1968), the son of a carpenter, initially studied at a trade school near Moscow. He later took up flying and graduated from the Soviet Air Force cadet school in 1957.

Gagarin made headlines on 12 April 1961, when he blasted into space aboard the Vostok 1 spacecraft at 9:07 am, Moscow time, orbited Earth at a speed of 27,400 kilometres per hour and reached a height of 301 kilometres. He spent 108 minutes in orbit before returning to Earth. Gagarin ejected from the vehicle and landed by parachute. He became a worldwide hero and was awarded the Order of Lenin amongst other recognitions and titles.

▲ At the Paris International Air Show (1965), Yuri Gagarin greets NASA's Gemini 4 astronauts Edward White II and James McDivitt

⭐ Valentina Tereshkova: First Woman in Space

After Gagarin's success, Soviet Chief Designer Sergey Korolyov wanted to send a woman to space. Earlier, it was assumed that the best candidates were military pilots, as they were accustomed to the stress of space flight, however, they were exclusively male. Since the Vostok spaceship was mostly automated, piloting was no longer a requirement, but parachuting skills were essential since Vostok cosmonauts were required to use and manoeuvre a parachute to help them land safely on Earth when they were ejected from the capsule.

For this reason, in 1962, Valentina Tereshkova was selected from among 400 female applicants. While Tereshkova had little formal education, she was an experienced and skilled parachutist. She became the first woman in space aboard the Vostok 6 on 16 June 1963. In three days, Tereshkova orbited Earth 48 times and successfully landed back on Earth on 19 June. No other Russian woman went into space until 19 years later.

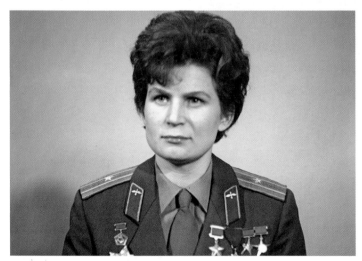

▲ Major of the Soviet Air Forces, Valentina Tereshkova was the first woman in space

⚙ Incredible Individuals

When NASA opened up its astronaut selection process to women in 1976, Sally Ride was one of the 8,000 applicants. Women were being considered and selected as Mission Specialists for the first time. In June 1983, Ride blasted off into orbit on the Challenger orbiter, becoming the first American woman to go into space.

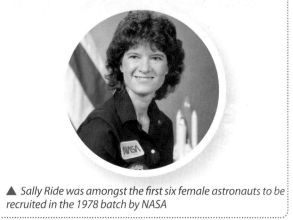

▲ Sally Ride was amongst the first six female astronauts to be recruited in the 1978 batch by NASA

The First Americans in Space

Let us now take a look at the incredible achievements of two interesting Americans—the first in space and the first to orbit Earth!

★ Alan Shepard: First American Astronaut in Space

Alan Shepard (1923–1998) was in the US Navy and had served in the Pacific in World War II. In 1951, he qualified as a test pilot and experimented, amongst other things, with high-altitude flying and in-flight fuelling systems. In 1959, he was selected as one of the original seven astronauts for NASA's Mercury mission.

Aboard the Freedom 7, Shepard became the first American to travel to space, doing a 15-minute **suborbital flight**, reaching a height of 185 kilometres. Shepard became a national hero. He also commanded the Apollo 14 flight in 1971 that landed on the Moon's Fra Mauro highlands. Amongst the many awards he received were the NASA Distinguished Service Medal and the Congressional Space Medal of Honor.

▲ Alan Shepard, is the only person to play golf on the moon

★ John Glenn: First American to Orbit Earth

John Glenn (1921–2016) had an illustrious career in the US Navy, which he first joined in 1942. Besides flying for 59 missions in the South Pacific during World War II, he flew for 90 missions in the Korean War, and in the last few days shot down three MiGs (Soviet military fighter aircrafts). He became a US Naval test pilot in 1954 and did experiments which entailed flying F-8 fighter planes. In 1962, Glenn completed the first orbital flight (Mercury-Atlas 6) in his space capsule Friendship 7. Glenn successfully did three orbits and landed back on Earth 5 hours later. It was a feat which got him much recognition (earlier, in 1961, Gagarin had completed one single orbit).

In October 1998, he undertook another space journey as a **payload** specialist. The trip lasted for nine days on-board the Discovery space shuttle, where they did research on similarities in the natural ageing process and a human being's bodily response to zero gravity or weightlessness. The Presidential Medal of Freedom was awarded to Glenn in 2012.

▲ John Glenn became the first American to orbit Earth aboard the Mercury-Atlas 6 mission in 1962

▲ On his second space flight in 1998, John Glenn, at the age of 77, became the oldest person to travel to space

The First Human Beings to Reach the Moon

On 20 July 1969, Neil Armstrong, Buzz Aldrin, and Michael Collins created history by becoming the first astronauts to reach the Moon aboard the Apollo 11. Armstrong stepped onto the lunar surface—the first person to do so—with the famous words, "That's one small step for [a] man, one giant leap for mankind." Aldrin and Armstrong spent over two hours on the Moon collecting surface samples and clicking photographs. After spending 21 hours and 36 minutes on the Moon, they returned to Earth in a splashdown in the Pacific.

⭐ Neil Armstrong

Neil Armstrong (1930–2012) qualified as a pilot at 16 and served in the Korean War. After completing his degree in aeronautical engineering in 1955, he worked with NACA as a civilian research pilot, and later worked for NASA. He tested many supersonic fighters, including the X-15 rocket plane.

In 1966, as commander pilot of the Gemini 8, along with David Scott, he managed the first manual space docking with another unstaffed rocket. A glitch made the spacecraft go into an uncontrollable spin, but Armstrong recovered control and managed an emergency landing in the Pacific Ocean.

⭐ Edwin 'Buzz' Aldrin

Buzz Aldrin graduated from the US Military Academy in New York, became an air force pilot and served 66 combat missions in the Korean war. He did his PhD in **astronautics** from MIT. In 1963, he was the first person with a doctorate to be recruited by NASA.

His work on docking and rendezvous techniques for space vehicles led to the success of the Gemini and Apollo programmes and is still being used. Aldrin started underwater training to mimic spacewalking and completed five and a half hours on three spacewalks. He wrote several memoirs and books and was awarded the Presidential Medal of Freedom and the Congressional Gold Medal.

🔎 In Real Life

All the crew members of Apollo 11 spent 21 days in isolation to prevent contamination by lunar microbes. After their successful return, the crew did a 21-nation tour and were hailed globally!

▲ *Commander of the Apollo 11 flight Neil Armstrong*

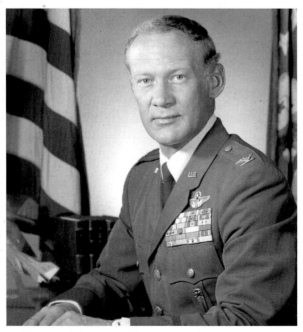

▲ *Lunar module (Eagle) pilot Buzz Aldrin*

Extravehicular Activity or Spacewalks

Astronauts can't actually 'walk' in space due to negligible or zero gravity; instead they float. What exactly is a 'spacewalk' then? Whenever an astronaut gets out of a vehicle, while still in space, it is known as a spacewalk or an EVA i.e., **extravehicular activity**. In the early days of space exploration, it was a big deal for humans to 'walk' in space. Today, however, astronauts regularly undertake spacewalks, especially outside the ISS, to complete different tasks.

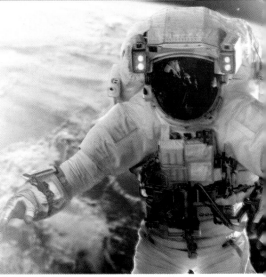

▲ *Spacewalks usually last between five and eight hours*

⭐ Challenges on a Spacewalk

Spacewalks help astronauts conduct useful science experiments, test new equipment, and repair satellites or the spacecraft. Pressurised spacesuits protect them and provide them oxygen to breathe and water to drink.

There are several risks involved when astronauts go on a spacewalk, including drowning in space—liquids don't flow due to zero gravity and a malfunction in the spacesuit, for example, can cause liquids to accumulate, which can prove dangerous for an astronaut; floating away into space; body fluids and blood boiling in case there is an accidental depressurisation of the spacesuit; and exhaustion.

⭐ Safety During Spacewalks

To ensure that astronauts and their tools don't float away in space, they usually use safety ropes or tethers attached to the spacecraft—this keeps them and their tools close to the vehicle. They also wear a **SAFER** (Simplified Aid for EVA Rescue), which has thruster jets, and can be used to return to the space station, just in case they get unstrapped from the tether.

⭐ Training for Spacewalks

Floating in space is like floating on water. On Earth, astronauts practice spacewalking underwater in a huge swimming pool. An underwater environment for training is very useful as it best simulates the weightlessness experienced during spacewalking. For every one hour of spacewalking, they train for seven hours in the pool. Another method is through **virtual reality** simulation. Virtual reality helps astronauts precisely simulate the circumstances of a spacewalk. They keep practicing and planning for months, even years, before their spacewalk.

⭐ Incredible Individuals

Russian astronaut Alexei Leonov was the first person to go on a spacewalk. He did this in March 1965 for a duration of 10 minutes. In June 1965, Ed White became the first American to do a spacewalk, during the Gemini 4 mission, and did so for 23 minutes.

▶ *L-R: Soviet cosmonaut Alexei Leonov and American astronaut Edward White*

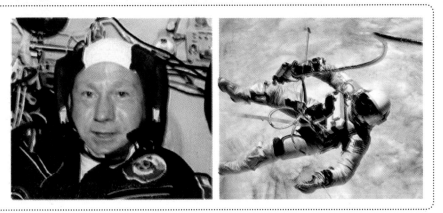

Milestones in Space Exploration

The United States of America and Soviet Union were the key players in space exploration from 1957 till the end of the Cold War in 1991. After the disintegration of USSR, Russia, and US became collaborators on space missions and projects, for instance, the ISS. Major milestones in space aviation and exploration are listed below.

▶ *The Skylab space station prior to launch*

1957
October: The Soviet Union launched the first artificial satellite, Sputnik, into space. In November of the same year they sent the first living creature, a dog, into space aboard Sputnik 2.

1958
January: First satellite launched by USA—Explorer 1.

1960
August: Soviet Union's Sputnik 5 carried two dogs (Strelka and Belka)—the first living beings to survive a journey into space.

▲ *The space capsule of Sputnik 5 in a museum*

1961
April: Yuri Gagarin, a Russian cosmonaut, became the first human in space.

May: Alan Shepard became the first American to go into space.

1962
February: John Glenn became the first American to orbit Earth.

June: Russia sent the first woman into space—Valentina Tereshkova.

1965
March: Cosmonaut Alexei Leonov undertook the first spacewalk.

June: Ed White became the first American to undertake a spacewalk.

July: NASA's Mariner 4 transmitted the first photographs of Mars.

1971
April: Salyut 1, the first-ever space station was launched by the Russians.

November: The Mariner 9 probe became the first craft to orbit another planet—Mars.

1970
September: Soviet craft Luna 16 was launched and was the first automatic spacecraft to bring back soil samples from the Moon.

1969
July: The first humans landed on the Moon—Neil Armstrong and Buzz Aldrin.

1968
December: NASA launched Apollo 8; later, its crew members became the first men to orbit the Moon.

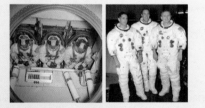

▲ *The Apollo 8 crew in training*

1966
February: Soviet Union's Luna 9 became the first spacecraft to land on the Moon.

June: Surveyor 1 became the first American spacecraft to land on the Moon.

▲ *The Luna 9 mission proved that landers would not sink into the dust on the Moon*

1973
May: Skylab, the first American space station was launched—it was the first manned research lab in space.

1975
May: USA's Apollo 18 and the Soviet Soyuz 19 launched in the Apollo-Soyuz Test Project—the first joint US-Soviet space project.

1976
September: Water frost discovered on Mars by American probe Viking 2.

1977
August and September: The USA launched interplanetary probes Voyager 2 and then Voyager 1.

1979
March and August: Voyager 1 and 2 began sending images of Jupiter and its moons.

1981
April: The first space shuttle, Columbia was launched. In February 2003, on its 28th mission into space, minutes before it was to land, it broke apart, killing all 7 astronauts on board.

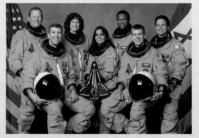

▲ *Crew members of space shuttle Columbia died when it crumbled over Texas in February 2003*

1986

January: Voyager 2 began transmitting images from Uranus.

February: The core section of the Soviet space station Mir was launched.

1990

August: NASA's Magellan, the first planetary spacecraft launched from the space shuttle, began mapping the surface of Venus using radar equipment. Also, the Hubble Space Telescope was deployed by space shuttle Discovery.

1992

May: NASA's space shuttle Endeavour began her maiden voyage.

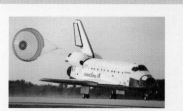

▲ *Space shuttle Endeavour flew its final mission in 2011*

2000

February: USA's Near Earth Asteroid Rendezvous (NEAR) spacecraft began transmitting images of the asteroid Eros. A year later, NEAR landed on its surface.

1998

November: The first segment of the International Space Station (ISS), built in collaboration with the space agencies of USA, Russia, Europe, Japan, and Canada, was launched.

1997

July: The Mars Pathfinder, an American robotic spacecraft, arrived on Mars and later began transmitting images.

1995

February: American astronaut Eileen Collins became the first female space shuttle pilot. In 1999 she became the space shuttle's first female commander.

▲ *Eileen Collins seated at the flight desk commander's station*

2001

April: American Dennis Tito paid the Russian space programme $20,000,000 to become the first tourist in space.

◀ *Dennis Tito (extreme left) was the first private citizen to visit the International Space Station*

2003

August: The Spitzer Telescope, the largest-diameter infrared telescope in space, was launched by NASA.

2005

July: A planned collision of a NASA spacecraft with a comet took place, to help study the building blocks of life on Earth.

Also, space shuttle Discovery (STS-114) was launched with seven astronauts aboard—it was USA's first 'Return to Flight' mission after the 2003 Columbia disaster.

2006

January: NASA's spacecraft Stardust returned to Earth with the first dust ever collected from a comet.

2007

August: NASA launched its Phoenix Mars Lander, which discovered chunks of ice on the planet.

2012

May: SpaceX launched its Dragon C2+ mission to send supplies to the International Space Station.

August: NASA's Voyager 1 probe, launched in 1977, entered interstellar space.

2010

March: NASA's MESSENGER (Mercury Surface, Space Environment, Geochemistry, and Ranging mission) became the first spacecraft to orbit Mercury.

November: Curiosity, the biggest, most advanced robot ever sent to explore another planet, was launched by NASA. It landed on Mars in August 2012. Curiosity was launched in November 2011.

2010

December: SpaceX (Space Exploration Technologies Corporation), a private American aerospace company, launched a spacecraft into orbit and returned it safely to Earth. It became the first non-governmental organisation to do so.

2009

March: NASA launched the Kepler spacecraft to look for exoplanets.

June: NASA launched the Lunar Crater Observation and Sensing Satellite (LCROSS) to confirm the presence or absence of ice on the Moon. In November they discovered a significant amount of ice near the Moon's south pole.

2013

November: The Mars Orbiter Mission or Mangalyaan was launched successfully by the Department of Space–Indian Space Research Organisation (ISRO). At a cost of ₹4.5 billion, it is one of the cheapest interplanetary space missions ever. USA, Russia, and Europe are the only others who have sent missions to Mars, and much to the credit of India, it succeeded in its first attempt.

2015

March: NASA's Dawn spacecraft became the first to orbit a dwarf planet, Ceres.

July: NASA's New Horizons, which had conducted a six-month-long study of Pluto and its moons, came closest to the planet.

2018

June: Japanese mission Hayabusa 2 arrived at the Ryugu asteroid. In September of the same year, it stationed the first rovers to operate on an asteroid. It will bring back asteroid samples to Earth in 2020.

2019

January: China's Chang'e-4 robotic spacecraft was the first to land successfully on the far side of the Moon (side facing away from Earth).

September: India's Chandrayaan-2 Moon lander, Vikram, made a hard landing on the lunar surface. It was targeted to make a soft landing on the Moon's south pole but ISRO lost communication with it moments before its landing.

The Apollo Programme (1961–1972)

The Apollo programme launched by NASA was an extensive space mission that went beyond making humans land on the Moon. In fact, it was aimed at establishing space technology, conducting scientific exploration, and creating human potential to operate in the lunar environment. It also paved the way for exploring more distant places in the future.

▼ An astronaut on a lunar landing mission. Elements of this image were furnished by NASA

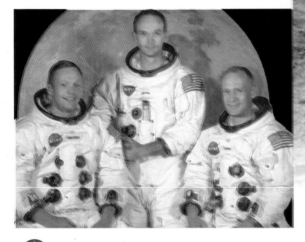

◀ Crew members of the Apollo 11 lunar landing mission. From left to right: Commander Neil A. Armstrong, Command Module Pilot Michael Collins, and Lunar Module Pilot Edwin E. Aldrin Jr.

▲ The Apollo 11 mission badge

⭐ The Challenges

Landing humans on the Moon entailed taking-off from Earth, which rotates at over 1,600 kilometres per hour and going into orbit at over 28,000 kilometres per hour. It also involved picking up speed at the precise time to over 40,000 kilometres per hour and travelling to the Moon (approximately 386,243 kilometres away), which itself travels at about 3,200 kilometres per hour relative to Earth. Then the spacecraft had to orbit the Moon and drop a special landing vehicle on its surface. After it reached the Moon, the astronauts needed to do several experiments, take measurements, collect samples, and leave instruments that would bring back important information to Earth eventually returning home.

It was a gigantic task. A single expedition was insufficient to ensure success, and NASA needed to develop an extremely dependable system for undertaking this task repeatedly.

Exactly how this was to be achieved was not clear, but NASA, the Department of Defence, American universities, and American industries had the basic scientific and technical knowledge required to say that it was possible. All these bodies with years of experience and knowledge came together from different fields, including military, civil aviation, etc. Engineering and management systems with extremely high levels of efficiency were devised to ensure dependability in complex machines.

Besides a Moon landing, Apollo expeditions aimed to develop technologies to achieve other space-related national goals—expanding the limits of technological achievements, implementing scientific studies, and building human capacity to work on the Moon.

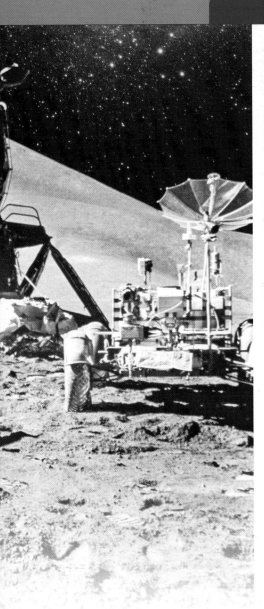

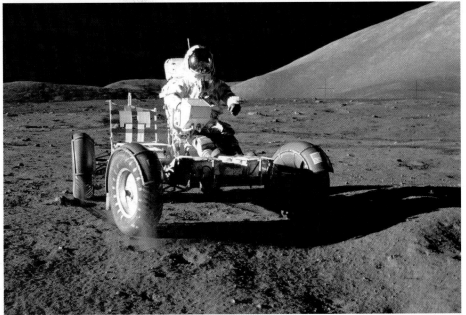

▲ *The Lunar Roving Vehicle –a battery-powered rover used on the Moon in the last three missions of the American Apollo program*

⭐ Overview

The first crewed Apollo flight was in 1967; the last was in 1972. The Apollo 11 flight of 1969 was the most famous—it landed the first humans on the Moon. The initial four Apollo flights tested the equipment for the programme, and six of the last seven flights reached the Moon—Apollos 11, 12, 14, 15, 16, and 17.

Apollos 7 and 9 orbited Earth to test the command and lunar modules, but they did not send back any Moon-related data. Missions 8 and 9 orbited the Moon to test different components and sent back photographs. Apollo 13 was unable to land on the Moon but managed to send back photographs. The six other flights which landed on the Moon sent back large amounts of scientific information and nearly 400 kilograms of Moon samples. They carried out various experiments involving oil mechanics, meteoroids, heat flow, magnetic fields, etc.

⭐ Spacecraft and Rockets Used

Apollo flights used two modules. One was a command module—a capsule with room for three astronauts—which flew them to the Moon and back to Earth. The second was the lunar module, used to land on the Moon, with a capacity of two astronauts.

The first few flights used a smaller rocket—the Saturn IB rocket, 22-storeys high, with two stages (parts). After the first section depleted its fuel, the second part would continue flying. The later flights used a more powerful rocket—the Saturn V. This had three stages, was much taller, and was responsible for sending the Apollo vehicle to the Moon.

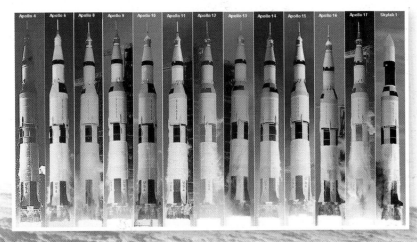

▶ *The Apollo 13 mission badge. The Latin phrase EX LUNA, SCIENTIA, means From the Moon, Knowledge*

◀ *Rockets used for Apollo missions*

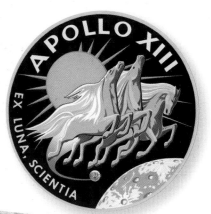

Mission Highlights of the Apollo Flights

APOLLOS 1, 4, AND 5

On 27 January 1967, the first planned manned flight, Apollo 204 (AS-204), later officially referred to as Apollo, caught fire during a pre-flight test, killing all three crew members—Virgil Grissom, Edward White, and Roger Chafee. The fire took place in the command module.

Changes were made to the Apollo command modules thereafter. There were no Apollo flights numbered 2 or 3. The first Saturn V launch of AS-204 (November 1967) became Apollo number 4, and its last launch was numbered Apollo 5.

APOLLO 6 OR AS-502

Date: 4 April 1968

This was the second launch of a Saturn V and was a success, although two of the first-stage engines broke down and the third-stage engine did not reignite after reaching orbit.

APOLLO 7: THE FIRST CREWED APOLLO SPACE MISSION

Date: 11–22 October 1968

Mission: Tested the Command Service Module (CSM) with crew performance

Crew: Schirra, Eisele, Cunningham

ⓘ Quick Facts

- Apollo 7 did the first live TV broadcast of Americans from space using a 4.5-pound video camera on-board.
- All three crew members developed a cold—an uncomfortable sensation, since it is very difficult to drain out the mucus which accumulates in the nose and head. On their return flight, the crew decided not to wear their spacesuit helmets or they would not be able to blow their noses and the pressure generated could burst their eardrums! They all took decongestant pills an hour before re-entry.

APOLLO 8: THE FIRST TO ORBIT THE MOON

Date: 21–27 December 1968

Crew: Borman, Lovell, Anders

ⓘ Quick Facts

Almost 69 hours into the flight, Apollo 8 passed behind the Moon and lost signal. The astronauts became the first humans to view the far side of the Moon!

There were six worldwide live telecasts across five continents with good audio and video quality.

On Christmas Eve, the crew read verses from the *Bible* and wished viewers a merry Christmas.

APOLLO 9: TESTED THE LUNAR MODULE

Date: 3–13 March 1969

Mission: Gained experience in rendezvous and docking; also tested the entire system, booster, and command and service modules in Earth's orbit

Crew: McDivitt, Scott, Schweickart

ⓘ Quick Facts

- The first crewed throttling of an engine in space was conducted.

APOLLO 10: TESTED THE LUNAR MODULE AROUND THE MOON

Date: 18–26 May 1969

Crew: Cernan, Young, Stafford

ⓘ Quick Facts

- A successful rehearsal of the first flight of a complete, crewed Apollo spacecraft to orbit the Moon was carried out, and except for the actual landing, it included all other aspects of a lunar landing.

APOLLO 11: FIRST HUMANS TO WALK ON THE MOON

Date: 16–24 July 1969

Crew: Armstrong, Aldrin, Collins

ⓘ Quick Facts

- Approximately 530 million people watched Armstrong on television in the first colour TV transmission from Apollo 11 to Earth, when he stepped out on to the Moon's surface.

- President Richard Nixon spoke to the astronauts via a telephone link, and a celebratory plaque signed by him and the three crew members was left behind on the Moon's surface.

- Remembrance medallions with the names of the three Apollo 1 astronauts and two cosmonauts who died in accidents were placed on the lunar surface. Goodwill messages from 73 nations compiled in a silicon disk along with the names of leaders from Congress and NASA were also left behind.

APOLLO 12: THE SECOND CREWED LUNAR LANDING

Date: 14–24 November 1969

Mission: Landed on the Moon, put in place the Apollo Lunar Surface Experiments Package (ALSEP) and recovered parts of the Surveyor III spacecraft

ⓘ Quick Facts

- Scientists were specifically interested in the salvaged TV cable of Surveyor since some biological organisms were stuck inside and they wanted to find out if they had survived.

APOLLO 13: FARTHEST FROM EARTH

Date: 11–17 April 1970

Crew: Lovell, Swigert, Haise

Mission: It was supposed to be the third Moon landing but was terminated due to a crack in the oxygen tank of the service module. The astronauts were brought back safely.

ⓘ Quick Facts

- This was one of the famous Apollo flights, about which a movie titled *Apollo 13* was also made.
- It was called a 'successful failure' due to the experience they gathered from rescuing the crew members.
- Sufficient power supply was a problem. If the battery failed there would have been insufficient power to return to Earth. The electrical supply was switched off, and it became extremely cold.
- Water and food also had to be conserved. The crew started eating lesser, became dehydrated, and lost weight.

APOLLO 14: EIGHTH CREWED FLIGHT TO THE MOON AND THE THIRD TO LAND ON IT

Date: 31 January–9 February 1971

Crew: Shepard, Mitchell, Roosa

Mission: Landed on the Moon mainly to explore the Fra Mauro region and carry out several other experiments

ⓘ Quick Facts

- Apollo 14 docked with the lunar module after six attempts.
- It was the first time that a lunar crew had spent 9 hours, 24 minutes in total on two separate spacewalks.
- Astronaut Alan Shepard established a new record of travelling the farthest distance on the Moon—approximately 2.74 kilometres.
- They collected almost 43 kilograms of rocks and soil, which were to be sent to 187 scientists in the USA and 14 other nations for studying and analysing.

APOLLO 15: FIRST USE OF LUNAR ROVER

Date: 26 July–7 August 1971

Crew: Scott, Irwin, Worden

Mission: Landed on the Moon and was the first of the Apollo 'J' missions, with a capacity to stay for a longer period on the Moon with more surface mobility. Amongst other objectives, the mission was to explore the Hadley-Apennine region; conduct lunar surface and orbital scientific experiments; and test and evaluate new equipment.

ⓘ New Records Set

- Heaviest payload in a lunar orbit (48,534 kilograms)
- Maximum distance travelled on the Moon's surface (28 kilometres)
- Most number of lunar spacewalks (3) and longest in terms of duration (18 hours, 37 minutes)
- Longest time in lunar orbit (145 hours)
- Longest manned lunar and Apollo expedition (295 hours)
- First satellite put in lunar orbit by a manned spacecraft
- First car to be driven on the Moon (crew travelled 28 kilometres in it)
- First deep-space and operational EVA

APOLLO 16: FIRST LANDING IN THE LUNAR HIGHLANDS

Date: 16–27 April 1972

Crew: Young, Duke, Mattingly

Mission: To study sample materials and surface features from a selected spot in the Descartes region; conduct surface experiments; and undertake in-flight experiments and photography from the lunar orbit

ⓘ Highlights

- The fourth ALSEP became operational after flights 12, 14, and 15.
- Small changes made to EVA equipment were tested and evaluated, e.g., longer seat belts on the Lunar Roving Vehicle, etc.

APOLLO 17: LAST HUMANS TO WALK ON THE MOON

Date: 7–19 December 1972

Crew: Cernan, Schmitt, Evans

Mission: Moon landing and study of surface features of Taurus-Littrow region, including sampling of older and younger rocks that had previously been brought back and studied on the Apollo 16 and Luna 20 missions

ⓘ Highlights

- Final mission in the J-type series—different from G and H series in terms of extended hardware capability, larger scientific payload capacity, and the use of the battery-operated Lunar Roving Vehicle (travelled 30.5 kilometres)

Jupiter and the Juno Mission

Jupiter is one of the most significant planets and is key to understanding the origins of our solar system. What is the reason for this and why did NASA launch the crucial Juno Mission?

⭐ Why Explore Jupiter?

Why explore and study Jupiter? After the Sun, Jupiter is the next most central object in the solar system and comprises hydrogen and helium—the same light gases which make up the Sun. Due to its humungous size and mass, and the fact that it was the first gas-giant planet to develop, it has played a significant role in the evolution of the other planets—including helping form their orbits—and other objects like asteroids and comets. By finding out the amount of water, and hence oxygen, on Jupiter, scientists can get a better idea of how the planet formed and how heavy elements—vital for life and the survival of rocky planets like Earth—were scattered across the system. Studying Jupiter also helps us understand the history of other giant planets that have been found.

⭐ Juno's Mission and Goals

On 5 August 2011, Juno blasted off into space from Cape Canaveral in Florida, USA. Juno was constructed by Lockheed Martin Corporation—a foremost American company whose main business is aerospace products—with some equipment sourced from across the globe. It was launched aboard the powerful Atlas V 551 rocket and entered Jupiter's orbit on 4 July 2016. It began collecting scientific data using instruments and probes below Jupiter's cloud cover. The mission had several tasks—to get more details about the origins of the planet, learn about its core or interior structure, its atmosphere, and magnetosphere. It would also study Jupiter's **auroras**.

◀ *After the Sun, Jupiter is the most dominant celestial object in the solar system*

💡 Isn't It Amazing!

Jupiter's equatorial region has a huge concentration of harmful radiation which can destroy Juno's electronic systems. However, the explorer's close polar orbit helps avoid this danger zone. Juno will be exposed to radiation equivalent to 60 million dental x-rays in one year. It is also the most distant solar-powered explorer launched by human beings.

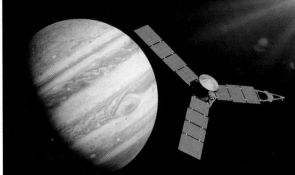

▲ *Juno is the most distant solar-powered spacecraft ever*

⭐ What did the Juno Mission Accomplish?

The initial data collected from the mission reveals Jupiter to be an intricate, gigantic, and blustery world characterised by deep storm systems which travel into the core of the planet, and a huge, uneven, and bumpy magnetic field.

Juno's colour camera, JunoCam was used to show the planet's poles to the public, and also revealed polar cyclones the size of Earth that are tightly clustered and rubbing together.

The probe tested the thermal microwave radiation from the planet's atmosphere from the top of its ammonia clouds and reached deep down within its layers. The data revealed that Jupiter's belts and zones are enigmatic—the belt close to the equator juts all the way down; the belts and zones located near the other latitudes appear to grow into other structures. Atmospheric ammonia varies—it increases at the lower depths right up to a few hundred kilometres which is as far as their instrument can see.

◄ *The Atlas V-551 launch vehicle blasting off from the Cape Canaveral Air Force Station in Florida, carrying NASA's Juno planetary probe*

► *A memorial plate with some of Galileo Galilei's writings is aboard Juno*

👤 In Real Life

Accompanying the spacecraft on this 2.7-billion-kilometre journey are three aluminium LEGO figures of—astronomer Galileo, known for discovering Jupiter's four large moons; Juno, the Goddess after whom the mission is named; and her husband Jupiter, the Roman God.

► *The three mini LEGO statues flying in the Juno spacecraft—Galilei, Juno, and Jupiter—are part of a joint educational programme of NASA and the LEGO Group to encourage children to discover science, technology, engineering, and mathematics*

Exploring the Red Planet

Since the beginning of the space age, several Mars exploration missions have been undertaken by NASA and other international space agencies. The planet is a popular object of study. Let us find out why Mars has caught the attention of so many.

▶ *The OSIRIS instrument and filters on the European Space Agency's Rosetta spacecraft generated the first true-colour image of Mars when it did a fly-by of the planet in February 2007*

⭐ Why Explore Mars?

Mars is a **terrestrial planet** similar to Earth in climate and atmosphere. Like Earth, it has a complex **geology** and is the only other planet with signs of having supported microbial life. It will most likely be the first planet, other than Earth, that human beings inhabit. Important unanswered questions about the solar system can also be revealed by exploring Mars.

⭐ Mars Exploration Programme Mission

NASA's Mars Exploration Programme uses advanced technology to study the origins and early evolution of Mars, its geological and climatic processes, the biological potential for life on the planet, and the possibility of sending humans for future explorations there.

⭐ Mars Exploration Rovers: Spirit and Opportunity

Mars explorations by NASA's twin rovers—Spirit and Opportunity (launched in 2003)—are the most famous. In January 2004, the two rovers reached opposite sides of Mars and began the most extensive exploration of the planet. The rovers traversed several kilometres, sending back more than 1,00,000 high-resolution photographs. They studied the chemical and physical composition of the Martian surface and found evidence of the presence of water in the past. Opportunity discovered rocks that seemed to be part of the shoreline of an old body of salty water.

The rovers were designed to last for 90 days but lasted much longer. Both braved harsh terrain, dust storms, and climatic changes. By March 2010, Spirit stopped communicating with Earth.

Opportunity had travelled more than 45 km, and by February 2018 had recorded its 5,000th **Martian day** (or sol). The rover stopped communication after 10 June 2018 and was finally declared 'dead' by NASA on 14 February 2019, after a successful and long innings of 15 years!

▼ *An artist's rendition of the twin rovers of the Mars Exploration Program—Spirit (left) and Opportunity (right)*

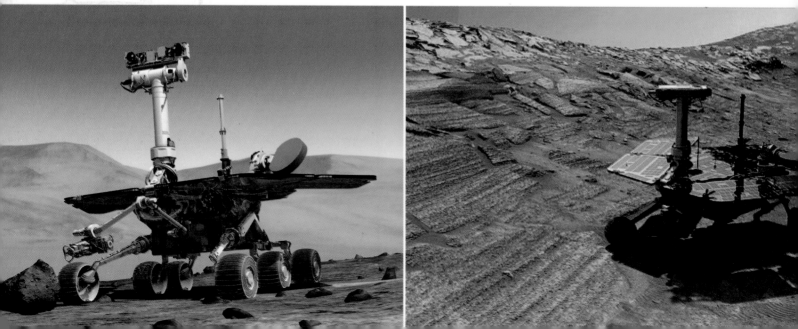

⭐ Curiosity Mission to Mars

In November 2011, NASA's Mars Science Laboratory sent Curiosity—the largest and most advanced rover—to Mars. It reached in August 2012 and sought answers about whether or not Mars had suitable environmental conditions, in the past, to support microbes. With sophisticated scientific tools, Curiosity found chemical and mineral evidence to prove that it had a habitable environment, and has been exploring the Gale Crater and collecting and analysing rock, soil and air samples.

▲ A selfie taken by Curiosity rover at Rock Hall drilling site, on the Vera Rubin Ridge on Mars

👤 In Real Life

The Mars 2020 rover mission will carry MOXIE, an instrument to demonstrate how to generate oxygen from carbon dioxide contained in the Martian atmosphere.

⭐ Salient Features of the Curiosity Rover

⊕ Car-sized, with a 7-foot-long arm and 10 advanced science instruments

⊕ Has tools including 17 cameras, a laser, and a drill

⊕ Uses a parachute and tethers for descending, which is a new and innovative landing method

⊕ Able to mount knee-high obstacles

⊕ Travels about 0.03 kilometres per hour

⊕ Carries a special power system to generate electricity, enabling it to flexibly function in all conditions.

⭐ Significance of the Mars Science Laboratory (MSL) Mission

NASA's MSL mission to Mars, with its rover Curiosity as a part of its efforts to explore the planet with a robot, is a huge milestone for several reasons:

⊕ Established the ability to put a large and heavy rover on the Martian surface

⊕ Proved the ability to make a very precise landing within a 20-kilometre landing space

⊕ Demonstrated long-range mobility on the planet to study varied environments and analyse samples found in different surroundings

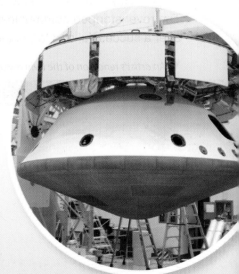

▲ Seen in the picture are all the components of NASA's Mars Science Laboratory (MSL) mission assembled together

▼ Curiosity Rover's view of Mount Sharp

Challenges and Issues in Space Exploration

Though exciting and alluring, space exploration involves multiple challenges for the astronaut, such as an isolating environment along with physical, psychological, and emotional issues. Apart from that, it also poses the danger of overcrowding space with satellites, stations, and space debris.

⭐ Impact of Space Travel on Human Beings

Human beings have evolved to live in the ideal environment provided by Earth. In space there are multiple adverse impacts. Astronauts often experience 'space sickness'—which includes vomiting, nausea, and discomfort in the stomach. Usually, it lasts only for two or three days, until the brain adapts to the new environment, but may reoccur on Earth. Due to negligible gravity in space, everything floats, leading to loss of muscle mass, particularly in the calf and thigh. Astronauts on very long missions even lose a little heart muscle. Some weight-bearing bones in the body start to decay due to reduced usage. A daily exercise routine is, therefore, a must to prevent this. Studies have revealed that astronauts can lose, on an average, 1–2 per cent of bone mass per month! While these medical issues are not so problematic in space, they do adversely affect astronauts on their return to Earth.

Exposure to high levels of solar radiation can lead to serious health problems, including deadly tumours. On long missions, astronauts also need to deal with psychological problems that are a result of being confined to a small space with people of different backgrounds and temperaments.

⭐ Space Debris

After more than 60 years of space activities, our skies and space are full of man-made objects, including the ISS, the Hubble Telescope, communications satellites, space debris, and rubble. Artificial material which is orbiting Earth but is not in use or not functional is known as space debris or space junk. A majority of space debris lies 160 to 2,000 km above Earth.

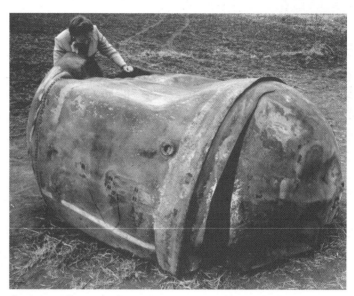

▲ *A piece of 'space junk' or debris—the propellant tank of a Delta 2 launch vehicle—landed near Georgetown, Texas, USA in 1996*

Generated by deactivated or dead satellites, burnt-out rocket stages, lost tools and fragments of particles from object collisions, space debris poses a severe threat to the safety of spacecrafts and astronauts. The ISS and space shuttles with humans on board face this danger. Even a small speck of paint travelling at great speed is sufficient to damage space shuttle windows or kill astronauts. Hence, it is extremely important to keep track of space debris to avoid such incidents. In America, the Space Surveillance Network (SSN) operated by the US Air Force monitors and records space debris and informs NASA about any foreseeable collisions with satellites or the ISS.

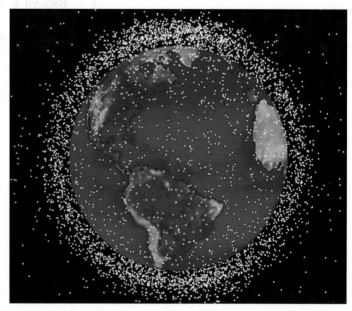

▲ *The diagram shows orbital debris floating around in space*

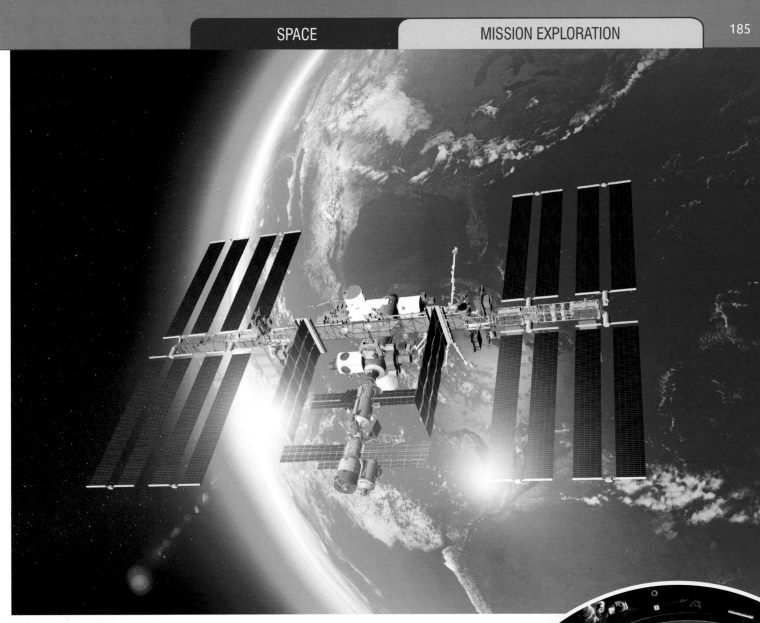

▲ *The International Space Station orbiting in outer space*

⭐ Damage Control

NASA has a set of guidelines and precautionary measures to deal with collisions with debris. When collision incidents are known beforehand, they move the station a little bit (Debris Avoidance Manoeuvre). If the tracking information is not too accurate, the crew is evacuated. Between 1998 and 2012, the ISS undertook 15 evasive manoeuvres. Since 2009, the crew has been evacuated thrice.

💡 Isn't It Amazing!

Believe it or not but over 20,000 fragments of debris the size of a softball are circling Earth and travelling at speeds 10 times faster than a bullet! Additionally, 500,000 marble-sized bits and millions of other particles too tiny to track are floating in space.

⭐ The Outer Space Treaty

The Outer Space Treaty (OST) concluded in 1967, along with other United Nations treaties, sets forth guiding principles and a legal framework for space activities and is currently the only check for curbing and preventing use of military weapons in space. The OST refers to space as "the common heritage of mankind". The challenge is how to equally distribute the benefits of this common legacy amongst all nations.

▲ *A porthole view of a space station*

Our Universe

Antiparticle: It is a subatomic particle that has similar mass to a particle, but opposite electric or magnetic properties.

Atoms: They are the basic units of matter and the defining structure of elements.

Big Bang model: It is the theory of the evolution of the universe that states that the universe emerged from a state of extremely high temperature and density, which occurred around 13.8 billion years ago.

Chemical elements: They are substances that cannot be decomposed into simpler substances by ordinary chemical processes. Elements are the fundamental materials of which all matter is composed.

Cosmic microwave background: It is electromagnetic radiation filling the universe and is a residual effect of the Big Bang.

Cosmology: It is the science of the beginning and evolution of the universe. It includes the study of theories like the Big Bang model along with astronomical subjects and particle physics.

Electron: A subatomic particle with a negative charge commonly found in the outer layers of an atom.

Fjord: It is a long and narrow area of sea lying between high cliffs found in countries like Norway.

Gravity: Also referred to as gravitation, it is a universal force by which a planet or other body attracts objects towards its centre.

Habitable zone: It is the orbital region around a star in which an Earth-like planet can possess water on its surface and possibly support life.

Interstellar: It is the region between the stars that contains vast, diffuse clouds of gases and minute solid particles.

Light-second: It refers to the distance travelled by light in one second, in a vacuum. It amounts to approximately 300,000 kilometres.

Light year: It is the distance travelled by light in one year, at a speed of 300,000 kilometres per second.

Molecule: It is a group of two or more atoms that forms the smallest identifiable unit into which a pure substance can be divided and still retain the composition and chemical properties of that substance.

Neutron: A subatomic particle with zero charge, commonly found in the nucleus of an atom

Proton: A subatomic particle with a positive charge, commonly found in the nucleus of an atom

Radiation: It is the emission of energy in the form of electromagnetic waves or moving subatomic particles, especially high-energy particles, causing ionisation.

Radio waves: They are electromagnetic waves of certain frequency used for long-distance communication.

Solar wind: A continuous outflow of solar subatomic particles from the outer regions of the Sun into the solar system

Singularity: In reference to a black hole, when a star dies, the crushing weight of constituent matter falling in from all sides compresses the dying star to a point of zero volume and infinite density called the singularity

Volume: It is the amount of space that is occupied by any substance or object.

Solar System

Astronomical unit (AU): It is the average distance between the Sun and Earth, which is approximately 150 million km.

Chromosphere: It is the layer of the solar atmosphere that is located above the photosphere and beneath the transition region and the corona. The chromosphere is hotter than the photosphere but not as hot as the corona.

Convective zone: It is a layer in a star in which convection currents are the main mechanism by which energy is transported outwards. In the Sun, a convection zone extends from just below the photosphere to about 70 per cent of the solar radius.

Core: In solar astronomy, it is defined as the innermost part of the Sun, where energy is generated by nuclear reactions.

Corona: It is the outermost layer of the solar atmosphere. The corona consists of a highly rarefied gas with a temperature greater than one million kelvin. It is visible to the naked eye during a solar eclipse.

Coronal mass ejection (CME): They are huge bubbles of radiation and particles from the Sun. They explode into space at a very high speed when the Sun's magnetic field lines suddenly reorganise.

Crater: It is a circular depression in the surface of a planetary body. Most craters are the result of impacts of meteorites or of volcanic explosions on the surface.

Galaxy: It is a system of billions of stars (sometimes millions) grouped with dust and gas particles that are held together by gravitational attraction.

Globular clusters: They are old systems containing hundreds of thousands of stars closely packed in a symmetrical, roughly spherical form.

Heliosphere: It is the region surrounding the Sun and the solar system that is filled with solar magnetic field and the protons and electrons of solar wind.

Interplanetary medium: It is thinly scattered matter that exists between the planets and other bodies of the solar system, as well as the forces (e.g., magnetic and electric) that pervade this region of space.

Magnetic field: It is the area of influence of a magnet. It covers the whole area in which the attraction or repulsion of a magnet can be felt. Magnetic fields such as that of Earth cause magnetic compass needles and other permanent magnets to line up in the direction of the field.

Nebula: It is a large cloud of gas and dust that is formed in outer space.

Open cluster: It is a group of around 1,000 or more stars formed from the same giant molecular cloud. The stars are still loosely bound to each other by gravity.

Photosphere: It is the visible surface of the Sun. It consists of the zone in which the gaseous layers change from being totally opaque and blocking light, to a radiative condition, and then to being transparent and allowing light to pass through. It is the layer from which the light that we actually see is emitted.

Planetary system: It is a group of smaller bodies, like asteroids and planets that orbit around one or more stars. The solar system is a planetary system.

Prime Meridian: It is the 0 degree longitude near the middle of Earth, dividing it into the western hemisphere and eastern hemisphere.

Prograde rotation: It is the counterclockwise movement of rotating and orbiting celestial bodies when viewed from a point above the North Pole.

Prominences: These are dense clouds of incandescent ionized gas projecting from the Sun's chromosphere into the corona.

Radiative zone: It is the interior layer of the Sun, lying between the core and the convection zone, where energy travels outward by radiation.

Retrograde rotation: All planets except Venus and Uranus rotate like the Sun, in the counter-clockwise direction. The two planets Venus and Uranus rotate in a clockwise direction, this is referred to as retrograde rotation.

Stellar association: It is a loose cluster of 10 or 100 stars that move together and share a common origin.

Stars and Galaxies

Astrophysics: It is a branch of astronomy concerned primarily with the properties and structures of cosmic objects, including the universe as a whole.

Binary system: It refers to two stars bound together by gravitational forces and orbiting around a common centre of mass.

Black hole: A huge amount of matter packed into a small area that results in a gravitational field that is so strong that nothing, not even light, can escape from it.

Constellation: In astronomy, it refers to any certain groupings of stars that were imagined to form conspicuous configurations of objects or creatures in the sky.

Convection: It is a process by which heat is transferred by movement of a heated fluid such as air or water.

Globular cluster: They are large groups of old stars that are closely packed in a symmetrical, somewhat spherical form.

High-mass star: It is a star that is three times the mass of the Sun.

Hypervelocity: It refers to extremely high velocity or speed. Velocity is the speed at which something moves in a particular direction.

Intergalactic: It means to be situated in or relating to the spaces between galaxies or relating to or occurring in outer space.

Intermediate-mass star: It is a star with a lifespan of between 50 million and 20 billion years.

Kuiper Belt: It is a flat ring of icy small bodies that revolve around the Sun, beyond the orbit of the planet Neptune.

Light year: In astronomy, the distance that light travels in one year is called a light year.

Low-mass star: It is a star with a mass that is less than half the mass of the Sun.

Luminosity: It is the amount of light emitted by an object in a unit of time.

Main sequence stars: Like the Sun, these exist in a state of nuclear fusion during which they emit energy for billions of years by converting hydrogen to helium.

Nebula: It is a cloud of gas and dust in which a star is generally born.

Neutron star: It can form after the core of a high-mass star collapses. The impact crushes the protons and electrons into densely packed neutrons.

Nuclear fusion: It is a process by which nuclear reactions between light elements form heavier elements.

Open cluster: In astronomy, it is any group of young stars held together by mutual gravitation.

Proper motion: It is the motion of an individual star relative to other stars.

Protostar: It is the beginning of a new star and is the first step in the star's evolution.

Radiation: It is a flow of atomic and subatomic particles and of waves, such as those that characterise heat rays, light rays, and X-rays.

Red giant star: It is a star that is larger than the Sun and is red because

it has a lower temperature.

Self-luminous: It refers to a body having, in itself, the property of emitting light.

Stellar classification: It is a scheme for assigning stars to types according to their temperatures, as estimated from their spectra.

Supernova: A massive stellar explosion resulting in a brief increase in luminosity and the ejection of matter.

White dwarf star: It is a small star, about the size of Earth. It is one of the last stages of a star's life.

Constellations

Astrology: It is the practice of interpreting the movements and relative positions of celestial bodies and their alleged influence on human affairs and the natural world. It does not have any scientific basis.

Astronomical map: It is a scientifically drawn chart of stars, galaxies, surfaces of planets, and the Moon in the night sky.

Augmented reality: In computer programming, it is a process of combining or 'augmenting' (making greater in size or value) video or photographic displays by overlaying the images with useful computer-generated data.

Cartography: It is the science of drawing maps.

Circumpolar constellations: They are the constellations that never set below the horizon when seen from a particular location on Earth.

Constellations: They refer to the groups of stars that form an imagined pattern in the sky. These constellations are imagined by those who named them to form conspicuous configurations of objects or creatures in the sky.

Deep-sky objects: They are celestial objects that exist outside our solar system.

Ecliptic: It is the great circle representing the apparent path of the Sun among the constellations in the course of a year.

Electromagnetic radiation: In physics, it is defined as the flow of energy at the universal speed of light through space or through a material in the form of electric and magnetic fields that make up electromagnetic waves such as radio waves, visible light, and gamma rays.

Gamma rays: They are a type of electromagnetic radiation which have the shortest wavelength.

Horoscope: It is a birth chart created according to theories of astrology.

Light pollution: It is the inappropriate or excessive use of artificial lights on Earth.

Light year: It is the distance travelled by light moving in a vacuum in the course of one year.

Mythological: It refers to something that is based on a myth or legend.

Pulsars: They are pulsating radio stars. These cosmic objects were first discovered because they had an extremely regular pulse of radio waves. Other such similar objects sometimes also emit short rhythmic bursts of visible light, X-rays, and gamma radiation; and some others are 'radio-quiet'.

Wavelength: It is the distance between corresponding points of two consecutive waves.

Astronomy

Algorithm: It is a systematic procedure that produces—in a finite number of steps—the answer to a question or the solution of a problem.

Arcsecond: It is 1/3,600th of a degree and the unit to measure parallax.

Artificial Intelligence (AI): It means making machines that can reason, take decisions which usually require human expertise, and carry out human-like tasks.

Astrology: It is a type of divination that involves the forecasting of earthly and human events through the observation and interpretation of the movement of the stars, the Sun, the Moon, and the planets. It has no basis in science.

Astronomical Unit (AU): It is a unit of measurement equal to 149.6 million kilometres, which is the mean distance from the centre of Earth to the centre of the Sun.

Astrophysics: It is a branch of astronomy concerned primarily with the properties and structure of cosmic objects, including the universe as a whole.

Biomass burning: It refers to the burning of living or dead vegetation including grassland, forest, agricultural waste, etc., for fuel. Burning can be natural (caused by lightning) or man-made (due to the burning of vegetation for land clearing, fuelwood, etc.).

Diffraction: It is the phenomenon of light bending when it passes around an edge or through a slit.

Geocentric model: According to this theory, Earth lies at the centre of the solar system or universe. It has now been debunked.

Global Positioning System (GPS): It is a space-based radio-navigation system that broadcasts highly accurate navigation pulses to users on or near Earth.

Heliocentric model: According to this theory, the Sun is considered to be the central figure within the solar system, around which Earth and other planets revolve.

Light year: It is the distance travelled by light (moving in a vacuum) in one year, at 29,97,92,458 miles per

second.

Oxidiser: A type of chemical (like oxygen) required for a fuel to burn.

Parallax: It is the difference in direction of a celestial object as seen by an observer from two widely separated points.

Parsec: It is used to measure interstellar distances. A parsec is the distance at which a star has a parallax of 1 arcsecond.

Propellants: It is a substance that propels or pushes something forward.

Propulsion: It means producing a force that pushes or drives an object forward, like moving an aircraft forward through air.

Sextant: It is an instrument used to determine the angle between the horizon and a celestial object like a star, the Sun, or the Moon.

Spectroscope: It is an instrument designed for visual observation of spectra. In optics, spectrum is the arrangement of visible, ultraviolet, and infrared light according to their wavelength.

Trigonometry: It is a field of mathematics concerned with functions of angles and their application to calculations.

Mission Exploration

Aeronautics (also aeronautical/ astronautical engineering): It is the science of designing, building, operating, and testing aircrafts or vehicles that are used to travel in Earth's atmosphere or in outer space.

Aurora: It is an atmospheric phenomenon caused by the Sun, which results in dazzling and brilliant light shows in the sky. Auroras can happen not just on Earth, but also on other planets that have an atmosphere and magnetic field. They have been seen on Jupiter and Saturn.

Extravehicular activity (EVA): Whenever an astronaut gets out of a vehicle while still in space, it is known as an extravehicular activity or spacewalk.

Geodesy: It is the science of accurately measuring and understanding three fundamental properties of Earth: its geometric shape, its orientation in space, and its gravitational field as well as the changes in these properties with time.

Geology: It is a science that deals with the study of Earth, rocks, and other substances that form the Earth's surface.

International Space Station (ISS): It was set up in low-Earth orbit mainly by the USA and Russia, with help and components from a multinational association.

Interstellar space: It is the place where the Sun's constant flow of material and magnetic field stops affecting its surroundings.

Martian day: Also known as Sol, a Martian day is only 39 minutes and 35 seconds longer than an Earth day. There are 668 Martian days in a Martian year.

Meteorology: It is the scientific study of atmospheric phenomena, particularly of the troposphere and lower stratosphere. Meteorology entails the systematic study of weather and its causes, and provides the basis for weather forecasting.

Moonquake: It refers to seismic activity or lunar ground vibrations that can be measured by seismometers installed on the Moon's surface.

Microgravity: It is a measure of the degree to which an object in space is subjected to acceleration. It is more commonly used synonymously with zero gravity and weightlessness.

Payload: It is the load (passengers, astronauts, instruments, etc.) carried by a vehicle, like an aircraft, that

is required for the purpose of the journey. It excludes what is required for its operation.

Rocket booster: One of the main parts of a space shuttle, it looks like a thin rocket and gives it a thrust to escape from Earth's gravity.

SAFER (Simplified Aid for EVA Rescue): It is a self-contained manoeuvring unit worn like a backpack. The system relies on small nitrogen-jet thrusters to let an astronaut move around in space. It serves the purpose of a 'life jacket' for astronauts while spacewalking and helps them return to the spacecraft in case they get untethered.

Space shuttle: It is a partially reusable rocket-launched vehicle that transports astronauts and cargo to and from spacecrafts that are orbiting in space. It is capable of landing on a runway when it comes back to Earth.

Suborbital flight: It is when the flight path (of a rocket, missile, etc.) is less than one complete orbit of Earth or any other celestial body.

Terrestrial planet: Also known as a rocky planet, it is a planet with a rocky surface primarily made up of silicate rocks or metals. In our solar system, the four planets closest to the Sun are referred to as terrestrial planets.

Virtual reality (VR): It is when computers are used to model and simulate real-life situations or events. It allows people to engage with an artificial 3D visual or sensory environment using interactive devices like headsets, goggles, gloves, and bodysuits.

(Elements of some of these images were furnished by NASA)
a: above, b: below/ bottom, c: centre, f: far, l: left, r: right, t: top, bg: background

Cover

Shutterstock : Front: Pike-28; Vadim Sadovski; Bjoern Wylezich; Andrey Armyagov; Nerthuz; Tomasz Bidermann; 19 STUDIO; TaraPatta; aappp; Dotted Yeti; taffpixture; M.Aurelius; 3DMI; FreshPaint; 3Dsculptor; robert_s; Albachiaraa; **Back:** 3d_man; Surasak_Photo; NASA images; Yurij Omelchenko; Valeriya Fott; Vadim Sadovski; 3DMI; Vladi333; Dja65; Vadim Sadovski

Wikimedia Commons: Front: File:Computer-Design Drawing for NASA's 2020 Mars Rover.jpg/ https://commons.wikimedia.org/wiki/File:Computer-Design_Drawing_for_NASA%27s_2020_Mars_Rover.jpg; File:Voyager spacecraft model.png/ https://commons.wikimedia.org/wiki/File:Voyager_spacecraft_model.png;

Our Universe

Shutterstock: 3b/pixelparticle; 4tl/MaraQu; 4br/Alexandre.P; 4tc/Zakharchuk; 4tr/Vadim Sadovski; 7c/Designua; 8br/Jiri Vratislavsky; 8cl/snapgalleria; 9t/Jurik Peter; 10&11 t&b/Marcel Drechsler; 11cl/Jurik Peter; 12bl/NASA images; 12cr/vectortatu; 13tr/NASA images; 13tl/AZSTARMAN; 14cl/Giorgos Karampotakis; 14br/muratart; 16tr/IgorZh; 16cl/Jurik Peter; 16bg/Irina Devaeva; 18br/Pyty; 18b/730203652/Vadim Sadovski; 18b/1232095255/i7pu3pak; 18cl/Orla; 18tl/Dotted Yeti; 19t/Vadim Sadovski; 19br/Maksimilian; 20b/solarseven; 20cr/Designua; 21t/shooarts; 22bl/MU YEE TING; 22br/Pi-Lens; 22c/muratart; 22 &23bg/Elymas; 23tr/671824837/robert_s; 23tr/1015055890/Nerthuz; 23cl/Stephanie Buechel; 23b/Fotos593; 24b/Dotted Yeti; 24cr/sdecoret; 26t/MaraQu; 27b/367913519/Michal Sanca; 27tl/Crystal Eye Studio; 27tr & 27b/602784188/Golden Sikorka; 27tc/robert_s; 28cl/Claudio Divizia; 29t/Vadim Sadovski; 30cl/Nicku; 30cr/Everett Historical; 30tl/A.Sych

Wikimedia Commons: 5r/End of universe.jpg/wikimedia commons; 6cr/Aleksandr Fridman.png/Russian mathematician and physicist Aleksandr Aleksandrowitsch Fridman (also: Alexander Friedmann)/ wikimedia commons; 6cr/Georges Lemaître 1930s.jpg/wikimedia commons; 9br/CERN Globe of Science and Innovation.jpg/Adam Nieman / CC BY-SA (https://creativecommons.org/licenses/by-sa/2.0)/ wikimedia commons; 10cl/Collage of six cluster collisions with dark matter maps.jpg/ESA/Hubble / CC BY (https://creativecommons.org/licenses/by/4.0)/wikimedia commons; 11tr/CL0024+17.jpg /NASA, ESA, M.J. Jee and H. Ford (Johns Hopkins University) / Public domain/wikimedia commons; 11br/Vera Rubin.jpg/NASA / Public domain/wikimedia commons; 12br/Messier59 - SDSS DR14.jpg/ Sloan Digital Sky Survey / CC BY (https://creativecommons.org/licenses/by/4.0)/wikimedia commons; 13cl/Irregular galaxy NGC 1427A (captured the Hubble Space Telescope).jpg/NASA, ESA, and The Hubble Heritage Team (STScl/AURA) / Public domain/wikimedia commons; 14cr/The Center of the Milky Way Galaxy.jpg/NASA/JPL-Caltech/S. Stolovy (Spitzer Science Center/Caltech) / Public domain/wikimedia commons; 15bg/Panoramic Large and Small Magellanic Clouds.jpg/ESO/Y. Beletsky / CC BY (https://creativecommons.org/licenses/by/4.0)/wikimedia commons; 15tr/Bmutlupakdil.jpg/ Catty 018 / CC BY-SA (https://creativecommons.org/licenses/by-sa/4.0)/wikimedia commons; 15br/Large Magellanic Cloud.jpg/ESA/NASA/JPL-Caltech/STScl / Public domain/wikimedia commons; 15tl/ Dr.BurcinMP.jpg/Catty 018 / CC BY-SA (https://creativecommons.org/licenses/by-sa/4.0)/wikimedia commons; 16br/SGR 1806-20 108536main NeutronStar-Print1.jpg/wikimedia commons; 17cr/Eros, Vesta and Ceres size comparison.jpg/NASA/JPLImage modified by Jcpag2012 / Public domain/wikimedia commons; 17tr/Eros - PIA02923 (color).jpg/NASA/JPL/JHUAPL / Public domain/wikimedia commons; 17b/OSIRIS-REx artist concept.jpg/NASA/Goddard/University of Arizona / Public domain/wikimedia commons; 19bl/Leonid Meteor.jpg/Navicore / CC BY (https://creativecommons.org/licenses/by/3.0)/ wikimedia commons; 20br/1829 Melchior Gommar Tieleman, Ölgemälde Caroline Herschel Hannover.tif/Ölgemälde: Melchior Gommar Tieleman; Foto des gemeinfreien Gemäldes: unbekannt / Public domain/wikimedia commons; 21br/Edmund Halley. Mezzotint by J. Faber, 1722, after T. Murray, Wellcome V0002531/See page for author / CC BY (https://creativecommons.org/licenses/by/4.0)/wikimedia commons; 21cr/Murray, Thomas, 1663-1734/Wellcome Library no. 3948i/ See page for author/ CC BY (https://creativecommons.org/licenses/by/4.0)/wikimediacommons; 22cl/Black hole - Messier 87 crop max res.jpg/Event Horizon Telescope / CC BY (https://creativecommons.org/licenses/by/4.0)/wikimedia commons; 24cl/Kepler-22 diagram.jpg/NASA/Ames/JPL-Caltech / Public domain/wikimedia commons; 25c/PIA21422 - TRAPPIST-1 Planet Lineup, Figure 1.jpg/NASA/JPL-Caltech / Public domain/wikimedia commons; 26cr/William James b1842c.jpg/ MS Am 1092 (1185), Houghton Library, Harvard University/ Public domain/wikimedia commons; 28br/Moons of the Solar System.jpg/NASA / Public domain/wikimedia commons; 29bc/Eris and Dysnomia art.png/ja:user:West / CC BY-SA (http:// creativecommons.org/licenses/by-sa/3.0/)/wikimedia commons; 29br/Haumea and two moons art.png/José Antonio Peñas/SINC (edited by PlanetUser) / CC BY (https://creativecommons.org/licenses/ by/3.0)/wikimedia commons; 29bl/Pluto and moons art.png/NASA / CC BY-SA (http://creativecommons.org/licenses/by-sa/3.0/)/wikimedia commons; 30br/Justus Sustermans - Portrait of Galileo Galilei, 1636.jpg/Justus Sustermans / Public domain/wikimedia commons; 31cr/Albert Einstein Head.jpg/Photograph Orren Jack Turner, Princeton, N.J. Modified with Photoshop PM_Poon and later Dantadd/ wikimedia commons; 31tl/Bertini fresco of Galileo Galilei and Doge of Venice.jpg/Giuseppe Bertini / Public domain/wikimedia commons; 31tr/Sir Isaac Newton (?) showing an optical experiment to an aud Wellcome V0015818.jpg/See page for author / CC BY (https://creativecommons.org/licenses/by/4.0)/wikimedia commons; 31cl/frontispiece to Ernst Mach, The Science of Mechanics (supplementary volume), Open Court Publishing, Chicago and London, 1915/ woodcut by an unknown artist after a portrait by Kneller, ca. 1689 / Public domain/ Wikimedia commons; 31bl/Studio portrait photograph of Edwin Powell Hubble.JPG/Johan Hagemeyer (1884-1962) / Public domain/wikimedia commons

The Zwicky Foundation: 11/bc

Solar System

Shutterstock: 3b/SumanBhaumik; 4c/Vadim Sadovski; 5t/hydra viridis; 5b/tuntekron petsajun; 5bg/agsandrew; 6tr/Dja65; 6br/Tomasz Bidermann; 7cr/Denis Belitsky; 7b/John A Davis; 8tr/AlexLMX; 8&9 c/Mopic; 9tl/AlexLMX; 9tr/VectorMine; 9br/muratart; 10tr/Vadim Sadovski; 10bl/Vadim Sadovski; 11cr/Diego Barucco; 12c/RikoBest; 12bl/Jesse Nguyen; 12bc/Kevin McKeever; 12br/SergeUWPhoto; 12&13tc/zffoto; 13br/Rassamee Design; 14tr/trentemoller; 14c/vectortatu; 14b/By Benson HE; 15b/D1min; 16tr/Siberian Art; 16b/Hannamariah; 16&17bg/TWStock; 17cr/Konstantin Tronin; 17cl/Designua; 17br/Nopphadon Jantranapaporn; 17bc/Murat An; 18&19tc/VINCENT GIORDANO PHOTO; 18tr/Dotted Yeti; 18cl/Castleski; 18br/Andramin; 18&19c/VINCENT GIORDANO PHOTO; 19tr/AstroStar; 19b/ Kelly Headrick; 20tr/kdshutterman; 20bc/Castleski; 21b/Sasa Kadrijevic; 21tr/Dotted Yeti; 21c/Fabiobispo3D; 22cl/Vadim Sadovski; 22&23c/NASA images; 24tc/Diego Barucco; 24cl/Dotted Yeti; 24bg/ Vadim Sadovski; 25tr/Vadim Sadovski; 25cl/Everett Collection; 25c/Vadim Sadovski; 26tr/Diego Barucco; 26&27bc/NASA images; 27tr/Simon Wendler; 28c/shooarts; 29bl/Dotted Yeti; 30tr/NASA images; 30&31bc/Diego Barucco; 31tl/Marc Ward; 31cl/Andamati

Wikimedia Commons: 4br/Artist Concept Planetary System.jpg/NASALater versions were uploaded by WilyD at en.wikipedia. / Public domain/wikimedia commons; 5cr/ Raphael/ Public domain/ Wikimedia commons; 6cl/Cellarius ptolemaic system.jpg/Jan van Loon / Public domain/wikimedia commons; 10br/File:Edmund Halley.gif/Thomas Murray / Public domain/wikimedia commons; 11tr/File:Venus globe. jpg/NASA / Public domain/wikimedia commons; 11bl/File:Maxwell Montes of planet Venus.jpg/NASA/JPL / Public domain/wikimedia commons; 13bl/ Armael/ CC0 1.0 Universal (CC0 1.0)/ Public Domain/ Wikimedia commons; 21br/Johannes Kepler 1610.jpg/Unidentified painter / Public domain/wikimedia commons; 22br/File:Jupiter from Voyager 1.jpg/NASA, Caltech/JPL / Public domain/wikimedia commons; 23cr/Jupiters_iconic_Great_Red_Spot/NASA/JPL-Caltech/SwRI/MSSS/Gerald Eichstädt/Seán Doran / Public domain/wikimedia commons; 23br/File:Voyager.jpg/NASA / Public domain/wikimedia commons; 23b/File:Galilean satellites noborder.jpg/NASA / Public domain/wikimedia commons; 24bl/B00F yWCYAEBblz.png/Personale / Public domain/wikimedia commons; 25cr/Voyager spacecraft.jpg/NASA/JPL / Public domain/wikimedia commons; 25bl/Johann Elert Bode.jpg/Unknown author / Public domain/wikimedia commons; 26cl/Neptune, Earth size comparison 2.jpg/NASA (image modified by Jcpag2012) / Public domain/wikimedia commons; 27c/PIA00064 Neptune's Dark Spot (D2), 1989.jpg/NASA/JPL / Public domain/wikimedia commons; 28br/UltimaThule-NewHorizons-20190222.png/NASA/Johns Hopkins Applied Physics Laboratory/Southwest Research Institute, National Optical Astronomy Observatory / Public domain/wikimedia commons; 29cr/Comet Siding Spring.jpg/NASA/JPL-Caltech/UCLA / Public domain/wikimedia commons; 29cl/Professor Doctor Jan Hendrik Oort (1900-1992) Sterrekundige, Bestanddeelnr 119-0508.jpg/Fotograaf Onbekend / Anefo / CC0/wikimedia commons; 29br/Comet ISON (C-2012 S1) by TRAPPIST on 2013-11-15.jpg/TRAPPIST/E. Jehin/ESO / CC BY (https://creativecommons.org/licenses/by/4.0)/wikimedia commons; 30br/Artist's impression dwarf planet Eris.jpg/ ESO/L. Calçada and Nick Risinger (skysurvey.org) / CC BY (https://creativecommons.org/licenses/by/4.0)/wikimedia commons; 31cr/951 Gaspra.jpg/English: NASA / Public domain/wikimedia commons

NASA: 3b/NASA/JPL

Stars & Galaxies

Shutterstock: 3b/233235862/pathdoc; 3b/1145100833/Stock-Asso; 3b/526761331/Triff; 4&5c/Vadarshop; 4bl/shooarts; 5tr/Nasky; 5cr/Zakharchuk; 6bl/Allexxandar; 7cl/dimpank; 7tr/Triff; 7b/Icecronic; 8&9bg/Alex Mit; 8cl/Catmando; 8br/CHAINFOTO24; 9tl/Giovanni Benintende; 9c/3DMI; 10t&11tl/Jasmine_K; 10br/NASA images; 11tr/NASA images; 11b/GiroScience; 12&13bg/VectorMine; 12bl/Vadim Sadovski; 12br/Jurik Peter; 13tr/yurchak; 13cr/Alpha Footage; 13bl/muratart; 14c/Egyptian Studio; 15tl/Outer Space; 15cl/NASA images; 15cr/NASA images; 16tr/NASA images; 16cl/Vadim Sadovski; 17t/ Petr Malyshev; 18&19bc/Maxal Tamor; 18bl/Reinhold Wittich; 19br/Jurik Peter; 20t/Pedarilhosbr; 21tr/mapichai; 22bl/muratart; 23cr/iurii; 23br/Vector FX; 24&25bc/Vadim Sadovski; 26&27tc/Diego Barucco; 28background/Stefano Garau; 29tl/Tragoolchitr Jittasaiyapan; 29tc/Tragoolchitr Jittasaiyapan

Wikimedia Commons: 13br/File:Stephen Hawking.StarChild.jpg/NASA / Public domain/Wikimedia Commons; 14&15bc/File:P200 Dome Open.jpg/Coneslayer at English Wikipedia / CC BY (https:// creativecommons.org/licenses/by/3.0)/Wikimedia Commons; 16bl/File:Accretion Disk Binary System.jpg/Wikimedia Commons; 17bl/File:NuSTAR spacecraft model.png/NASA/JPL-Caltech / Public domain/Wikimedia Commons; 19tr/File:US 708.jpg/Credit: ESA/Hubble, NASA, S. Geier / Public domain/Wikimedia Commons; 20&21 bc/File:Star-sizes.jpg/Dave Jarvis (https://dave.autonoma.ca/) / CC BY-SA (https://creativecommons.org/licenses/by-sa/3.0)/wikimedia commons; 21br/File:The Sun by the Atmospheric Imaging Assembly of NASA's Solar Dynamics Observatory - 20100819-02.jpg/NASA/ SDO (AIA) / Public domain/Wikimedia Commons; 22c/ ESA/Hubble / CC BY (https://creativecommons.org/licenses/by/4.0); 22br/File:Edwin-hubble.jpg/Wikimedia Commons; 24c/File:Charles Messier. jpg/Ansiaume (1729—1786) / Public domain/Wikimedia Commons; 24cr/File:William Herschel01.jpg/Lemuel Francis Abbott / Public domain/Wikimedia Commons; 25tl/File:EdwardEmersonBarnard.jpg/ The original uploader was SITCK at Luxembourgish Wikipedia. / Public domain/Wikimedia Commons; 25cl/File:Brahe.jpg/Wikimedia Commons; 25bl/File:Cecilia Helena Payne Gaposchkin (1900-1979) (3).jpg/Smithsonian Institution from United States / No restrictions/Wikimedia Commons; 25cr/File:Subrahmanyan Chandrasekhar.gif/Startchild Project NASA / Public domain/Wikimedia Commons; 25tc/ File:Hans Bethe.jpg/Los Alamos National Laboratory / Attribution/Wikimedia Commons; 26cl/File:PIA22569-SuperNovaRemnant-G54.1+0.3-20181116.jpg/NASA/JPL-Caltech/CXC/ESA/NRAO/J. Rho (SETI Institute) / Public domain/Wikimedia Commons; 26br/File:NGC1898 - HST - Potw1840a.tiff/ESA/Hubble / CC BY (https://creativecommons.org/licenses/by/4.0)/Wikimedia Commons; 27cr/File:Spitzer space telescope.jpg/NASA/JPL-Caltech/ R. Hurt (SSC)/Public domain/Wikimedia Commons; 27tr/File:Betelgeuse captured by ALMA.jpg/ALMA / CC BY (https://creativecommons.org/licenses/by/4.0)/ Wikimedia Commons; 29cl/File:Sirius A and B Hubble photo.jpg/NASA, ESA, H. Bond (STScI), and M. Barstow (University of Leicester) / CC BY (https://creativecommons.org/licenses/by/3.0)/Wikimedia Commons; 29c/File:Vega Spitzer.jpg/Courtesy NASA/JPL-Caltech/University of Arizona / Public domain/Wikimedia Commons; 29cr/File:Witch head nebula.jpg/NASA/STScI Digitized Sky Survey/Noel Carboni / Public domain/Wikimedia Commons; 30bl/File:John Flamsteed.jpg/George Vertue / CC BY (https://creativecommons.org/licenses/by/4.0)/Wikimedia Commons; 30r/File:Uranometria titlepage. jpg/Wikimedia Commons; 31tr/File:Barnardstar2006.jpg/Steve Quirk / Public domain/Wikimedia Commons; 31bl/File:Refractor Cincinnati observatory.jpg/Wikimedia Commons

Constellations

Shutterstock: 3b/ Mike Ver Sprill; 4tr/ angelinast; 4br/ Iron Mary; 5t/ Olha Polishchuk; 5bg/ isarescheewin; 6bg/vectortatu; 7c/ Lalnspiratriz; 8tl/ Marzolino; 8&9b/ BLUR LIFE 1975; 8cr/1165976269/ osteriori; 8cr/325658792/ NoPainNoGain; 8cr/371943640/Pozdeyev Vitaly; 9tl/ Foxyliam; 9tr/ Anton Jankovoy; 9cl/ Foxyliam; 9bl/ Navakun Suwantragul; 9bc/ sripfoto; 10tl/ ANAID studio; 10&11c/By Aleksandra Bataeva; 11br/ Paolo Gallo; 12tl/ Marzolino; 12bl/ Mykola Mazuryk; 12c/ Valeriya Fott; 12&13c/shooarts; 13tl/ Yganko; 13cr/ Pozdeyev Vitaly; 14c/ angelinast; 14br/ Foxyliam; 14&15c/shooarts; 15br1/ N.Vector Design; 15br2/ Miceking; 15tl/ Peter Korbas; 15cr/ Jazziel; 16cr/ Jazziel; 16b/ delcarmat; 17tl/ Polii; 17cr/ Masterlevsha; 17bl/ Iron Mary; 17br/ Foxyliam; 18tr/ Foxyliam; 18cl1/ Foxyliam; 18cl2/ antonpix; 18cr/ Foxyliam; 18bl/ NASA images; 19c/ Yganko; 19cr/ antonpix; 19br/ ingenium; 19b/ Pozdeyev Vitaly; 20cl/ IHelly; 20br/373028203/Foxyliam; 20br/490170580/Svitlana Holovei; 21 bg/ Redcollegiya; 21tr/ Hollygraphic; 21cl/ yoshi0511; 21bl/ Kgkarolina; 22tl/ Iron Mary; 22tr/ Natalia Hubbert; 23tl/ olegganko; 23tc/ muuraa; 23tr/ Olha Polishchuk; 23bl/ olegganko; 23bc/ Valentina Razumova; 23br/ olegganko; 24tl/ Taeya18; 24tc/ Jazziel; 24tr/ MariPo; 24bl/ RATOCA; 24bc/ RealCG Animation Studio; 24br/ Valentina Razumova; 25tr/ Dermot68; 25bl/ Hibrida; 26tr/ Yurumi; 28&29t/isarescheewin; 28cl1/ olegganko; 28bl/ Bosavang; 28br&28cl2/Fleur_de_papier; 29cl1&29tr/Fleur_de_papier; 30b/ Ketan Kadam

Wikimedia Commons: 5br/File:Friedrich Wilhelm Bessel.jpeg/Johann Eduard Wolff / Public domain/wikimedia commons; 6bl/PSM_V78_D326_Ptolemy/Unknown author / Public domain/wikimedia commons; 6br/Regiomontanus_Epitome_of_the_Almagest_frontispiece/Regiomontanus / Public domain/wikimedia commons; 7br/Lacaille/Melle Le Jeuneux / Public domain/wikimedia commons; 11tr/ File:Uranometria orion.jpg/Johann Bayer / Public domain/wikimedia commons; 18bc/File:NGC4038 Large 01.jpg/W4sm astro / CC BY-SA (https://creativecommons.org/licenses/by-sa/4.0)/wikimedia commons; 20tr/File:Sidney Hall - Urania's Mirror - Hercules and Corona Borealis.jpg/Sidney Hall / Public domain/wikimedia commons; 25br/File:Benjamin Apthorp Gould (Harper's Engraving).jpg/Harper & Brothers / Public domain/wikimedia commons; 27t/File:Four Symbols.svg/RootOfAllLight / CC BY-SA (https://creativecommons.org/licenses/by-sa/4.0)/wikimedia commons; 27bl/File:星象图.svg/ Trinhhoa at Vietnamese Wikipedia / Public domain/wikimedia commons; 27br/File:Vm-4358-Beijing-1439-Armillary-sphere.jpg/User:Vmenkov / CC BY-SA (https://creativecommons.org/licenses/by-sa/3.0)/ wikimedia commons; 28br/File:HR 5183-starmap.png/Tomruen / CC BY-SA (https://creativecommons.org/licenses/by-sa/4.0)/wikimedia commons; 29cl2/File:RedDwarfNASA.jpg//wikimedia commons; 29cl3/File:Screenshot from IMAX® 3D movie Hidden Universe showing the Helix Nebula in infrared.jpg/ESO/VISTA/J. Emerson / CC BY (https://creativecommons.org/licenses/by/4.0)/wikimedia commons; 29tr2/Gunung Bromo di Indonesia.jpg/Falinka / CC BY-SA (https://creativecommons.org/licenses/by-sa/4.0)/wikimedia commons; 29cr/File:Belgrade Planetarium theatre night.jpg/Vlajko / CC BY-SA (http:// creativecommons.org/licenses/by-sa/3.0/)/wikimedia commons; 30cr/1200px-IAU_logo/International Astronomical Union , Vectorised by User:Joowwww / Public domain/wikimedia commons; 31tl/Fermi_ Gamma-ray_Space_Telescope_spacecraft_model/NASA / Public domain/wikimedia commons; NASA: 31cr/Screengrab from NASA

Astronomy

Shutterstock: 3b/Gorodenkoff; 4cl/PTZ Pictures; 8tl/3DMI; 8cl/Morphart Creation; 8cr/Everett Historical; 8&9bg/muratart; 10c/Fouad A. Saad; 10&11c/Vera Larina; 13cl/paulista; 15cr/Vadim Sadovski; 15bc/Everett Collection; 19tl/Andrey Armyagov; 19bl/Frontpage; 19br/DenPhotos; 22b/Boris Rabtsevich; 23bg/FahimS; 25tl/Vadim Sadovski

Wikimedia Commons: 4tr/1600_Himmelsscheibe_von_Nebra_sky_disk_anagoria/Anagoria / CC BY (https://creativecommons.org/licenses/by/3.0)/wikimedia commons; 4bc/Madrid_rosny_bb_0033/ Unknown Mayan author / Public domain/wikimedia commons; 4br/Anaxagoras_Lebiedzki_Rahl/Eduard Lebiedzki, after a design by Carl Rahl / Public domain/wikimedia commons; 5tc/Sanzio_01_Plato_ Aristotle/Raphael / Public domain/wikimedia commons; 5tr/File:Francesco Hayez 001.jpg/Francesco Hayez / Public domain/wikimedia commons; 5cl/Aristarchus_working//wikimedia commons; 5cr/ Heraclides_Ponticus_-_Illustrium_philosophorum_et_sapientum_effigies_ab_eorum_numistatibus_extractae/Girolamo Olgiati / Public domain/wikimedia commons; 5bl/File:Eratosthenes Teaching in Alexandria (Bernardo Strozzi, Montreal)/Bernardo Strozzi / Public domain/wikimedia commons; 5br/File:Retrato de Julio César (26724093101) (cropped).jpg/Museum of antiquities / Public domain/ wikimedia commons; 6c/Jan_Matejko-Astronomer_Copernicus-Conversation_with_God/Jan Matejko / Public domain/wikimedia commons; 6cl/Tycho_Brahe/Eduard Ender (1822-1883) / Public domain/ wikimedia commons; 6br/Johannes_Kepler_1610/Unidentified painter / Public domain/wikimedia commons; 7tr/Galileo_Donato/Henry-Julien Detouche / Public domain/wikimedia commons; 7cl/Galileo_ moon_phases/Galileo Galilei / Public domain/wikimedia commons; 7cr/Justus_Sustermans_-_Portrait_of_Galileo_Galilei,_1636/Justus Sustermans / Public domain/wikimedia commons; 7b/Galileo_ Galilei;_Galileo_Galilei_at_his_trial_at_the_Inquisi_Wellcome_V0018716/See page for author / CC BY (https://creativecommons.org/licenses/by/4.0)/wikimedia commons; 9c/Pierre-Simon,_marquis_de_ Laplace_(1745-1827)_-_Gu€rin/Jean-Baptiste Paulin Guérin / Public domain/wikimedia commons; 9cl/ Murray, Thomas, 1663-1734/Wellcome Library no. 3948i/ See page for author/ CC BY (https:// creativecommons.org/licenses/by/4.0)/wikimediacommons; 9cr/Joseph_Louis_Lagrange//wikimedia commons; 10tl/File:Busto di c.d. archita, da villa papiri ercolano, copia romana da orig. del III sec ac., MANN.JPG/Sailko / CC BY-SA (https://creativecommons.org/licenses/by-sa/3.0)/wikimedia commons; 11tl/Rocket_warfare/Charles H. Hubbell (1898-1971) / Public domain/wikimedia commons; 11cl/ William_Congreve_at_Copenhagen_1807/James Lonsdale (1777-1839) / Public domain/wikimedia commons; 11c/Tsiolkovsky/Unknown author / Public domain/wikimedia commons; 11cr/File:Hermann_ Oberth_nel_1961.jpg/Public domain/Wikimedia commons; 11bc/Dr._Robert_H._Goddard_-_GPN-2002-000131/NASA / Public domain/wikimedia commons; 11br/Goddard_and_Rocket/Esther C. Goddard / Public domain/ wikimedia commons; 12tl/Galileo_galilei,_telescopi_del_1609-10_ca./Sailko / CC BY-SA (https://creativecommons.org/licenses/by-sa/3.0)/wikimedia commons; 12tr/Hans_Lipperhey/

Mission Exploration